TIME
TO
HEAL

Michael Dixon has been a country general practitioner in Cullompton, Devon for thirty-six years. His experiences during this time have taken him from being a conventional family doctor to having an increasing interest in complementary medicine and social prescribing, all influenced by his patients' colourful stories.

Dixon has written extensively on medicine and the health service and was previously President of the Guild of Health Writers and the health columnist for SHE magazine. Today, in his late sixties, he continues as a part-time GP and is Chair of the College of Medicine, Visiting Professor at University College London and Health Advisor to The Prince Charles, former Prince of Wales.

TIME
TO
HEAL

Tales of a Country Doctor

DR MICHAEL DIXON

FOREWORD BY THE PRINCE CHARLES,
FORMER PRINCE OF WALES

UNICORN

First published by Unicorn in 2020
First paperback edition 2023
an imprint of the Unicorn Publishing Group
Charleston Studio
Meadow Business Centre
Lewes BN8 5RW

www.unicornpublishing.org

10 9 8 7 6 5 4 3 2 1

ISBN 978-1-911397-76-2

Cover design Unicorn Publishing Group
Typeset by Vivian Head

Printed and bound in the United Kingdom

CONTENTS

DEDICATION

To Joanna, Finn, May and Liberty

This record of a life devoted to healing appears at a time when health has been at the forefront of people's minds as never before in living memory.

As the world devotes immense resources of scientific endeavour and public commitment to tackling the global pandemic which has caused such disruption, we are all reminded of the precious gift of health, and how it can never be taken for granted. As we witness the dedication of those helping fight this invisible threat, we have all, I am sure, found renewed respect and admiration for the medical profession and all who devote themselves to the wellbeing of their fellow human beings.

For Dr. Michael Dixon, the mission of promoting health has been a lifelong passion. 'Time to Heal' is about science, but it is also about sympathy. It is about research, but it is also about relationship – about treating the whole person, not just the disease.

This account of four decades spent in the medical profession has the doctor-patient relationship is at its heart. Having known Michael for many years, I was touched, but not surprised, to find that the stories and anecdotes which illuminate this thought-provoking memoir are marked by the same empathy and humanity which I have long admired, and which make him such an inspiring example of what a family doctor should be.

This personal journey unfolds from medical student days to the fullness of a career devoted to the wellbeing of others, and it includes reminiscences ranging from the bizarre to the benign, without neglecting either appropriate clinical acumen or an essential sense of humour.

Few people can fail to be moved by such a record of care, empathy and sacrifice and none, surely, could dissent from the statement that what people want from their health service is 'good service, that is easy to get, compassionate, provided to people by people they trust'.

However, while traditional values of human contact are central, this book is not a manifesto for the 'good old days'. Its author recognises the enormous improvements that have been achieved in health, in the safety of medicine, in the promptness of diagnosis and the efficiency of treatment. The art, as always, is to keep the best of the traditional personal approach while making full use of the scientific knowledge and opportunities that we now have. As he says: 'tales of this book are about relationships and don't need to belong to the past'. Medicine is to some a science and to others an

art form. 'Time to Heal' shows that it should be a balance of both. For instance, the recent introduction of 'Social Prescribing' is an excellent example of an integrated approach 'offering the sort of professional care that doctors were previously able to offer when the pressures were not as great as they are today'.

Compiled over a long and rewarding career, 'Time to Heal' is a fascinating record of community life in Devon, as viewed from the unique perspective of the local doctor. Presented with great sensitivity and insight, it tells a story of steady clinical advance facing the constant challenge of the fragility of human life. Its message could be summed up in the quotation, 'the good physician treats the disease, the great physician treats the patient who has the disease'.

I am sure that all who read this book, whether they are in the medical profession or not, will find themselves agreeing that they have been in the presence of a remarkable physician – and a great storyteller.

PREFACE

This is the story of my life as a country doctor. It is about relationships. Especially the relationship between doctor and patient. My story is as relevant to city dwellers as to country people. Healing relationships matter wherever you live.

As doctors we are fortunate to live as close to the reality of existence as anyone. We see our patients undressed in every sense – physically, mentally and spiritually. Sometimes it may seem as though we know our patients almost as well as they know themselves. We treat and diagnose illnesses but we must also understand our patients through and through – producing answers for every question and solutions for every eventuality. We must recognise when their symptoms are simply metaphors of an underlying problem and respect the symbolic status of many of the treatments that they choose. Above everything, we must value and refine our skills as healers over and above the pills and procedures that we may offer.

Scientific medicine has made stunning progress in treating diseases such as cancer and heart disease. In my early years as a GP these led to the premature death of many of my patients. Patients that would have died before sixty-five now live until eighty-five. The progress of the last forty years has been phenomenal, but times are changing.

Today, life expectancy is no longer improving. We are faced with an increasing epidemic of long-term diseases such as depression, stress, obesity, diabetes and cancer. These are not the fault of medical science. Their cause is far more human. In many cases they are the result of our catastrophic failure to care for the environment, the planet, ourselves and each other.

General Practice itself is facing extra challenges. Historically

high rates of patient satisfaction are now beginning to fall. An increasing number of GPs now find their work stressful and far from fulfilling. This is not the fault of medical science either. It is because we are ceasing to value the importance of **human** medicine. Patients, doctors and communities are becoming less connected. One result of this is that ever fewer patients have a personal advocate and confidant whom they can call 'my doctor'.

These things matter less to those with episodic or minor illness, where virtual medicine may play a larger role in future. They do matter very much to the elderly, the very sick and those with long-term disease who represent 80 per cent of a GP's work. They should also matter to NHS accountants. Much research has shown that less personalised medicine leads to much greater costs yet, in the face of such evidence, we continue to increase our rate of spending on hospitals at twice the rate of spending in General Practice.

Future medicine will need to embrace both the wonders of medical science and mysteries of healing relationships. It must aim for a better mix of information and evidence with intuition, experience and emotion. The philosopher, Bertrand Russell, predicted that 'unless men increase in wisdom as much as knowledge, an increase in knowledge will be an increase in sorrow'. The evident sorrows of today's patients and doctors suggest that it is now time to think again.

Much of what follows is about the true-life stories of my patients. You must make of them what you will. Are they simply of historical interest or are they relevant to medicine of the future? I believe that they carry some serious messages that have been made all the more relevant by the Coronavirus pandemic, which began to sweep through this country as I was completing this book. Time was already running out for General Practice

but the pressing need for radical solutions can now no longer be ignored.

Time to Heal is about restoring humanity to medicine. It is about allowing our doctors sufficient time and supporting them to rediscover their role as healers. It is about enabling them to reconnect with their patients and local communities. COVID-19 has, if anything, made this message all the more urgent; demonstrating the crucial importance of such connections to the resilience of individuals and communities and the impact of social isolation. In future, we must enable our patients to play a far larger part in their own well-being and the well-being of their families and their communities. 'Lockdown' has given us the time to reflect and evaluate. Let us hope that we have learnt its lessons and that we use them wisely.

GIVE ME A DOCTOR

W. H. Auden 1907–1973

Give me a doctor partridge-plump

Short in the leg and broad in the rump

An endomorph with gentle hands

Who'll never make absurd demands

That I abandon all my vices

Nor pull a long face in a crisis,

But with a twinkle in his eye

Will tell me that I have to die.

Chapter 1

THE BEGINNING

*Men make their own history, they do not make it as they
please: they do not make it under self-selected circumstances,
but under circumstances existing already, given and
transmitted from the past.*

Karl Marx

Is any family normal? Ours certainly wasn't. Being normal was
not even an aspiration. Generosity, tolerance and loyalty –
they *did* matter. For my parents, the worst sin, apart from
showing off, was to be sentimental. "We can leave that to the
Americans" they would say. The psychiatrist, R.D. Laing, said,
'Our relatedness to others is an essential aspect of our *being*'.
Early childhood experiences are such an important factor in
our later happiness and ability to form fulfilling relationships.
My loving and large family – certainly by today's standards –
prepared me well.

My mother went into labour with me while making jam
tarts. Her midwife and GP, both local snobs, irritated her by
discussing their social diaries while she struggled to bring me
into this world. Once that had been achieved, she describes
having had an extraordinary experience of feeling totally at
peace and understanding everything. Whether this was due to
low blood pressure after bleeding or to divine intervention, we
shall never know.

It was only at this stage that my father was allowed upstairs to

meet his fifth child before being dispatched to register me. The pub intervened on his journey and by the time he got to the registry office, he had completely forgotten what he and my mother had agreed to call me. They had previously decided at an early stage that they were going to name their boys after the British Patron Saints – hence my older brothers had been called Patrick and Andrew. My mother didn't like the name George so the next one was to be called David. Shortly before my birth, my father's RAF pilot brother, Michael, had been tragically killed in an air crash. He and my mother decided that instead I should be called Michael but in the confusion of my birth and his bereavement, not to mention the visit to the pub, he registered my name as 'David' though ever since I have been called Michael. It was a secret that he kept sheepishly from my mother and myself. I only saw my own birth certificate several years later. It was well after my youngest brother, also called David, had been born. It must be a rarity for two brothers in the same family to be called David. Anyway, when the General Medical Council saw it they insisted that I should be registered as Dr David Dixon even though everyone knew me, by then, as Michael. This has enabled my critics to say that 'Dr Michael Dixon' is an impostor and a quack.

My father's real love had been the navy and the sea. He had spent the Second World War flying Swordfishes in the Royal Navy's Fleet Air Arm. Most pilots of this antiquated biplane did not live for long – there were only two survivors from my father's original squadron. As it was unlikely that he would survive the war, he and my mother were married aged twenty-two and nineteen respectively, in 1940. After the war, physically well but mentally scarred, he took to drink. I was fortunate to be born towards the end of his drinking days.

After the war, he stood as a Conservative Party candidate for

Scunthorpe in Lincolnshire and though he increased the vote in his constituency, it was the election when Winston Churchill was discarded and he did not get elected. My maternal grandfather had made his fortune by running dealerships for American tractor companies – John Deere and Caterpillar – and had been extremely successful at it. My father took on the business and became a company director. I don't think he really wanted to sell tractors, and alcoholism was his response to the pressures that he had endured during the war and a feeling of emptiness afterwards. We always got on terribly well except for my late teens when his views as a member of the Conservative Party were at odds with my left-wing views. When we went fishing though, we could agree to differ, and we were united by our passion for being on the river bank.

My mother was the best sort of matriarch, ensuring that the family stayed together. She was glamorous and had many secret admirers but devoted every ounce of her life to my father and her six children. She had to endure much unhappiness during my father's drinking years but remained ever loyal in spite of many around her suggesting that she should leave him. It was she who would organise our holidays to Devon or Scotland and our outings to pick primroses in the spring and blackberries in the autumn. She was a very good cook and every year she would go to the Ideal Home Exhibition in London to pick up new tips. Increasingly, she had to protect us from my father, which was why she bundled us off to boarding school at an early age.

My eldest brother Patrick was the eternal protector. After one of my father's worst atrocities, he declared that we had to blow up our house as punishment. There was a miniature canon in our garden and Patrick went off to the ironmongers to fetch the ingredients for gunpowder. When all was ready, we three younger boys lined up behind him and the canon waiting to take

our revenge on whatever my poor father had done. There was quite a satisfying bang after he lit the taper but then our missile trickled out of the canon and dropped with a small thud on the grass just in front of us.

It was Patrick who drove me, aged fourteen, to the cinema with my first girlfriend Liffy. He then sat in the row behind us giggling, while we held hands. He was generous to the extreme. My elder brother Andrew was a rebel, always getting into trouble and with a dry sense of humour, while David, my youngest brother, was artistic and vulnerable.

I also had two elder sisters: Daphne and Penny, both of whom took on an extra mothering role for David and I. Daphne, together with Patrick, had caught the brunt of my father's drinking days and both had gained an inner strength. She also had the softest heart for anyone that was struggling. I shall never forget the terrible pain of a boil in my nose and the utter relief, when Daphne carefully punctured it with a needle.

My elder brother Andrew, the rebel, was outspoken. Not afraid to question authority or challenge traditional thought. I remember him quizzing me on all manner of things, and being the younger, impressionable brother, I would look up to him and take his opinions seriously. One day he asked me "Michael, what do you think is the most disgusting part of the body?" It was a simple question with an obvious answer – or so I thought. My grin betrayed ignorance. "Most people get it wrong," my brother continued with kind authority. "It is, in fact, the feet."

I realised then that facts were odd things. Slippery and too often the reverse of what you might first think. The more that I pondered on my brother's certainty, the more I began to wonder if there were any real facts. What if all presumed facts were just opinions? If truth was just simply a case of just building up a convincing story? It was this and other large questions to do with

life and its meaning that were to keep me occupied through my long years at school and university.

Like Christopher Robin, I was dispatched to prep school at seven years of age, despite having been so happy at home with my mother, brothers and sisters. I was very homesick, crying myself to sleep each night, and never much good at being part of gangs and groups. Penny would bicycle over to my school bringing sweets and biscuits. We were allowed home three times a term and I so much looked forward to these occasions and well remember the misery of returning to school after them. In those days, the radio programme on Sunday evenings as we drove back was called *Sing Something Simple*. It brought little comfort to a 'condemned man' simpering during his last moments of freedom. I remember lining up for the lice checks by matron, the radio malt that we were given each morning as she asked us how our bowels had worked and the humiliations on the sports field, where I was always a disaster. The school was run by the 'Major' – Major George Pike who had a moustache and had apparently self-promoted himself from captain. He ran the school as his private army, giving us wooden rifles each morning to parade around the school grounds before going to our breakfast of invariably burnt porridge. Surprisingly perhaps, I rather liked him and never felt threatened by him. Even then I was well aware that he was bonkers and school even became tolerable by the time I had got to my twelfth year. But then I had to start all over again at public school.

If Andrew can be given some of the credit for inspiring me to question and challenge the status quo, my secondary education has to be given some as well, I attended a reputable public school; well-known for providing intellectual rigour and discipline where I succeeded academically. I didn't like boarding school because my rebellious streak made me ever-allergic to institutions – I hated the restrictions and the competitive, testosterone-fuelled

group behaviour of the boys around me. I was fortunate, however, to have been part of a large intake of nine or ten boys in my particular house and we managed to protect each other and frequently enjoy ourselves in spite of a rigid system of rules and values that we didn't share.

There were plenty of good bits though – instead of games I was allowed to opt for social services and I used to bicycle off to a nearby town to teach English to young Pakistani children and help at youth clubs there. Whilst at school, I also, somewhat unfashionably, joined the St John's Ambulance and would volunteer to attend at football matches and other events. Each term there would be a compulsory cross-country run, which thankfully, in its early stages, went past the weir pool of a river lock containing some large pike. Two of us would peel off to collect our tackle, hidden in a nearby bush, to enjoy a few hours fishing before muddying our knees and rejoining the run on its way back. Those were the times that I really felt free.

When asked to complete a careers form in my last year at school, I ticked the box saying 'The Ministry'. My education thus far, both formal and familiar, had taught me to question and probe and I was not afraid to carve my own path, or be bundled along with the crowd. In my opinion, no one was better at that than those inscrutable civil servants. They were experts when it came to influencing the thinking of Government Ministers and without them even realising. Yes, I decided, I wanted to become one of those men from the Ministry!

There was some interest in my application and a special careers' advisor was sent down from London to interview me. I thought it was odd that he was wearing a dog collar but dismissed this as yet another diversion created by those men from the Ministry. He seemed a bit perplexed when I asked him whether Ministers were really quite so gullible. I was equally puzzled

when he started asking me about my religious beliefs – which were, at that time, slightly vague. Then, almost simultaneously, we both realised.

This whole area of truths and beliefs, fact and fiction became a sort of obsession and I applied, and was accepted, to read Philosophy and Psychology at Oxford. However, before embarking on my degree I took a gap year and went to South Africa on a Union Castle ship – *The Windsor Castle*. In those days, travelling coach class by ship was a much cheaper option than flying. The journey took eleven days and during the voyage various encounters took me from being a seventeen-year-old boy to a seventeen-year-old young man. I had gone to join my brother-in-law who was selling kosher butter and had a small factory with six or seven people and a conveyor belt that was about five feet long producing this butter from vegetables. It tasted awful and would stick to the palate like lard. My job was to try and encourage the non-Jewish community to buy the butter but the sales campaign, in spite of having girls in mini dresses fronting various supermarkets, was a total flop. I was quickly out of a job.

Then I was introduced to someone called Dave in Johannesburg who had a company that sold ballpoint pens. In fact, they were the rejects from the Scripto factory (Scripto was a well-known brand in those days). He used to send two of us – a bit like Fagin – in a car each week to various parts of South Africa to sell these leaky pens. Though we had many hilarious experiences, it was also a very serious lesson in how to persuade people to do something they might not otherwise want to do. It also taught me to understand and use the vanities and weak points of my potential customers.

On the ship to South Africa I had met a friend who had a job running an autoclave (sterilisation) machine in a missionary

hospital in Zululand. We got in contact with each other and, as I had made a small fortune selling leaky ballpoint pens but didn't feel that it was particularly useful to anyone, and he had really enjoyed his work but wanted to earn some money, we swapped jobs. It was while working in the missionary hospital at Nqutu in Zululand (the Charles Johnson Memorial Hospital) that I developed a complete fascination and passion for medicine. The doctor in charge, Dr Anthony Barker, was a cheerful and charismatic role model who always wore bow ties (possibly why I adopted them later when I became a doctor) and his hospital was near the site of Rorke's Drift and Isandlwana of the Zulu war. He was an enthusiastic Christian and Marxist and had a strong influence on my thinking. He was also a rebel and it was the time of Apartheid repression. We were closely observed by the police and authorities and Dr Barker was constantly in trouble. I remember accompanying him one day to court because he had operated on a native Zulu in a 'White designated' operating theatre. I wasn't allowed into the court because I didn't have a tie and so we went next door, where a tailor cut us a thin strip of yellow cloth from which we made a makeshift tie. Returning to the court, though guilty in law, Dr Barker provided such an emotionally-charged and powerful defence of his actions that he shamed the prosecution and the case was dismissed.

Life in the hospital was utterly romantic, even though there would be four people to a bed – two each end (a single bed). After the morning ward round we would eat breakfast, which was a form of porridge, to the sound of Simon and Garfunkel's *Bridge over Troubled Water* at full volume on his gramophone. The whole atmosphere was so full of compassion and caring that I suddenly discovered that this was exactly what I wanted to do. I applied to Oxford to change from Psychology and Philosophy to Medicine but they rejected my appeal.

At Oxford, I studied the great philosophers of the past, such as John Locke, who unsettled me by reasoning that you couldn't say that a table was square or rectangular or even smooth or rough as it all depended upon where you were standing and how closely you looked. Emmanuel Kant put a further spoke in the wheel by pointing out that there were logical limits in our ability to think or ever reach the truth at all. A bad situation grew worse with psychologists adding that we are restricted still further in our depth and breadth of thinking by the nature of our biological thought processes and the limitations of our learnt languages.

These reflections begged the question of whether thought and reason mattered at all. After all, it was the philosopher David Hume, who declared that 'Reason is, and ought only to be, the slave of passions, and can never pretend to any other office than to serve and obey them'. I concluded that there was probably no point in trying to think too much. A conclusion that was reinforced as I tried to answer the first question of my finals examination in Philosophy – 'What is the difference between Rodin's *Le Penseur* and a ballet dancer?' I knew then that I was never going to progress more than a few millimetres along the path of infinite knowledge and following the exhilaration of my time in the African hospital, I was only more convinced that a life of action and practicality was what I wanted.

In a bid to offset the heady intellectuality of Oxford, I did seek some more practical experiences by joining the Oxford University Air Squadron. I wanted to be a pilot but was hopeless at navigation and on one occasion got lost over Marston Moor. I was only able to find my way back to the air base by following the main roads beneath me. The official reason for my discharge was 'dogfighting' – two of us had been doing battle darting up and down through the clouds in our aeroplanes. It was strictly not

allowed. I pleaded guilty but Marston Moor had already taught me that I would never be a successful pilot. It was an abrupt end to my flying dreams, which had been fueled by Biggles, St Exupery and the previous generation of Dixon pilots – my father had torpedoed the great German Battleship, *Bismarck*.

I had to accept this particular defeat gracefully but kept on returning to the thought of becoming a doctor. Saving lives, relieving suffering and having something to show for a day's work. It was the Russian country doctor and writer, Anton Chekhov, who said that knowledge is useless unless it is put into practice. I shocked my kind philosophy tutors, for whom 'practical' was something unimportant done by those with lesser brains, and applied to Guy's Medical School.

Guy's were perplexed as to what to do with a philosophy student with no medical background, who had never studied any science. They demanded that I should get a first-class degree as a condition of entry. I argued that no one ever got first-class degrees in the philosophy and psychology course because the philosophers didn't like the psychologists and vice versa. They relented and then asked me to get an upper second. In those days Oxford did not offer upper or lower seconds – just seconds. Notwithstanding, exams over, I reported to them that I had got an upper second. My career as a doctor had at last begun.

Chapter 2

MEDICAL SCHOOL AND FIRST YEARS

Education is not the filling of a pot but the lighting of a fire.
W. B. Yeats

The first days of medical school were not as I had expected. I had arrived full of confidence: I was an Oxford graduate; I was well-acquainted with the demands of pushing myself intellectually, to studying hard and learning great swathes of information and was eager to get started on my chosen career path. But my confidence was shattered the week before lessons started when I had to attend a medical checkup – something required of all medical students before entry. "Go behind the screen and take your clothes off," the rather beautiful but bored doctor had instructed. When she came behind the screen, she gave me an unforgettable look of total contempt and disgust. "I did not mean *all* your clothes, Mr Dixon!" This humiliation was also a well-learnt future lesson on what not to tell patients undergoing examination. Much later, I was to learn another lesson about examinations – never ask questions when a patient is undressing. Most of us are incapable of undressing and answering questions at the same time. It has to be one or the other – that is unless you want your consultations to go on forever.

I imagined that on arrival at medical school I would be ushered into an operating theatre to witness lives being saved, with the rest of the day being spent patrolling the wards enlivened

with moments reminiscent of *Carry On Doctor*. Instead, I spent the whole of my first morning looking at flower petals under a microscope. No blood, no patients, no wards, no nurses or white coats. What on earth had I let myself in for? Having completed a colourful array of A-Levels, including French, Latin, Maths and Economics, together with my degree at Oxford, I had absolutely no experience of studying the science subjects. Therefore, I had to spend my first year working on the First MB course which provided a thorough introduction to all the sciences including Biology, Chemistry and Physics. Only on completion of this could I then embark on the traditional two years of rigorous non-clinical studies (the Second MB). I was, of course, also extremely conscious that I was several years older than the rest of my cohort and therefore keen to apply myself and prove my worth. Having previously concluded that there were no truths or facts, I was to spend five years having to parrot vast reams of them from biochemical pathways to the detailed anatomy of the body – 90 per cent of which I have never used to this day and most of which I have forgotten. But it was important to learn it all and have the information available: those first few years were a hothouse with endless examinations and vivas followed later by the nagging fear of being shown up on the ward rounds. It was also of crucial importance to make good relationships with the nurses and junior doctors who could help you to swim or sink.

Coming from a non-medical family, I had assumed that doctors (and nurses and others for that matter) were all 'good' and wanted to save lives and make the world better. Perhaps I should not have been surprised that medics – especially hospital medics – are as bitchy, competitive, ambitious and sometimes ruthless as anyone else. Much of those first two non-clinical years was spent on anatomy. One of the professors of anatomy would annually claim his 'droits de seigneur' and choose the most willing girl in

each year for 'extra tuition' with a high probability that she would get the best marks at the end of the year. I could not complain as I had quite a crush on one of the anatomy demonstrators. She had a wide smile and natural blonde hair worn in a sleek bob. To my great fortune she was almost invariably my examiner during our many anatomy vivas. She looked uncharacteristically stern during these examinations – an image amplified by her wearing thick tortoiseshell glasses, which she never wore at any other time. Nevertheless, she seemed to have a twinkle in her eye and I was fortunate enough to pass the vivas.

The consultants were generally encouraging and affable, except for one. He looked severe and threatening in his black-rimmed spectacles and was widely known to have examined prisoners during the postwar Nuremberg trials before their execution. He reduced most medical students to tears at one time or another. Yet, being a stickler for detail, he was probably the best teacher I ever had – enforcing in us the skills of careful observation and thorough examination.

Despite the sheer volume of work and study, those first few years of being a medical student in London were extremely happy ones. I was fortunate to be the theatre reviewer for the medical school journal. This entitled me to two free seats in the front of the stalls of most new theatrical productions. Indeed, we sat so close to the actors and actresses that you could actually smell their Max Factor make-up. I was equally fortunate, at the time, to be going out with a young woman who happened to be the restaurant critic for magazine *Harpers and Queen*. So we progressed from the front seats of the theatre to some of the best restaurants in London with fawning waiters plying us with champagne, smoked salmon and endless other delicacies previously unknown to a medical student of small means.

At the same time, Paul, a medical school friend of mine and I

were volunteers on Monday evenings at the 'Good Fellows Club' in Marylebone. This was a club for people in the community with serious mental health problems, run by a compassionate GP well into his eighties, whose own brain was well on the downhill run. We would hold quizzes, play charades, organise debates and dance, sing and read. Cheerful and portly George was a schizophrenic. He had flushed cheeks, an infectious grin and avoided any eye contact. He would frequently burst into fits of giggling as if enjoying a private joke. He also knew the whole train timetable off by heart and if you wanted to go somewhere he could tell you exactly which train to take and when. Gilbert was a thin and wizened old man who looked permanently anxious with a furrowed brow. He stuttered and trembled and spent most of the time looking at his feet but appeared to quietly enjoy our proceedings. Mavis would simply tap her feet, mumble and hum – never entirely joining in but mostly seeming content. There were about twenty of us in all including myself, Paul and the doctor. It was a constant challenge to think of new things to do each week.

One evening, using my theatrical contacts, we took the Good Fellows to see a play produced by a visiting Belgian stage company. The Good Fellows occupied the whole back row. It was a new experience for them and they became totally absorbed and involved in the performance. Only a little too much so. In the middle of the play, there was a feast scene and one by one the Good Fellows marched down the stairs barging past other members of the audience and on to the stage to help themselves to the various tasty bits of the theatrical food on offer. This culminated in a fight between them and the Belgian actors over a loaf of bread. It took some time to get our protesting group back to their seats but not before I had received an angry dressing down from the 5ft-high theatre manager with a flamboyant waxed moustache. He was flushed and bristling with rage.

Later on, the kindly GP leading the group died. The powers that be behind the Good Fellows Club decided that we needed modernising. In place of the late GP came a rather intense young psychiatric doctor with a Germanic accent. On the first evening, and in full hearing of all of us, he sat down beside Gilbert and asked, "Gilbert – how often do you masturbate?"

◙ ◙ ◙

Medical school itself was a mix of high emotion, hard work and strong camaraderie. Perhaps this was due to the enormous pressure we found ourselves under coupled with a shared purpose and passion for our vocation. We drank too much and developed lasting relationships with our peers. Romantic attachments and high jinks were essential elements of the heady mix.

I will never be able to forget one birthday when my friends really dropped me in it. By this time I had progressed to accompanying a leading professor on his ward rounds, proudly wearing my white coat. I was excited, if a little daunted, that the Professor had asked me to 'present' one of the patients on his ward. Imagine my disappointment when we heard that the Professor was in America and the ward round had been cancelled. "No problem," my friends said, "let's go and celebrate your birthday with a piss-up in the pub." That we did, with rather too much alcohol but comforted in the knowledge that there was not going to be a ward round that afternoon. That was until we returned to the Medical School in an alcoholic haze only to be told that the Professor was not abroad after all but on the ward and waiting for us. Walking was possible. Speech more difficult – slurred at best but mostly unintelligible. The Professor was standing by the bed of a patient. "Mr Dixon, tell me about this patient." I felt every bit like Jim Dixon in Kingsley Amis's

Lucky Jim only far worse. I became acutely aware as I gave my slurred history that I was finding it difficult to move and, every time that I did so, the sheets started to come off the patient's bed. My 'friends' had safety-pinned my white coat to them. Things went from bad to worse. The Professor asked me to listen to the patient's heart and I found that my stethoscope had been similarly safety-pinned to the pocket of my white coat. The rest was a blur. Memory of that scene still fills me with misery.

Around this time, I received an unexpected letter from Helen Mirren. Particularly surprising because in my fantasy world, I had switched allegiance from the anatomy demonstrator to the equally unobtainable great actress. I had written to her, in no expectation of an answer, asking if she would like to come and speak at our debating society. She wrote back, almost immediately, saying that she would love to come and suggesting that she might take me out to dinner beforehand to discuss exactly what she was to say. She told me that she could tell from my letter that I was a kind and sensitive person and that she would like to get to know me more. Even better, she had also cut off a considerable amount of her hair and inserted it into the envelope 'to remind me of her'. Love, as they say, is blind and vanity knows no limits. Perhaps I should have been a little bit more suspicious because the enclosed hair was red and I was pretty sure that Helen Mirren was blonde. Paul was the only person who knew that I had written the letter and his girlfriend happened to have red hair. On balance, the utter exhilaration of receiving the letter, fueled by blind infatuation, was well worth the low of realising that I was an idiot of self-deception.

I continued with my early student placements in and around the hospitals of London. The patients in Bermondsey and Southwark were ever-accepting, cheerful and long suffering. Those who had to wear glasses had often bought them from a stall in Borough market. They were very cheap largely because

they were chosen at random by the stallholder without any pretence of an eye examination. Consequently, his victims were instantly recognisable from the multiple bruises up and down their bodies from walking into lamp posts and each other. Our patients were also plain spoken and practical. On my gynaecology attachment, I asked a lady well under thirty about her marital relations. She told me rather firmly that there was no point in having sex as she had finished having children. Patients were unphased by the silliest of medical questions. While preparing an elderly lady for admission, I ran down the usual check list – how are your waterworks, are the bowels working normally and do you have any problems with your back passage? In response to the last question, she paused for a few seconds to think and then replied in a matter of fact way, "Well there is just one – I wish my brother would stop leaving his bicycle there."

I should add that it is not only medics that confuse patients with these expressions. A Devon patient recently telephoned me in a state of high anxiety to say that she was having 'trouble in the basement'. Images of rising damp or rats came to mind until she added that it was itchy and sore. Quite by coincidence on the very same day, I asked another woman about her hospital investigations for pelvic pain and she told me, "The x-ray showed that I have got some subsidence but I can live with that."

□ □ □

Eventually, the time came to put a hold on the high jinks and prepare for the final exams. An ordeal in those days, which involved numerous written papers and vivas in front of the frequently hostile professors of other medical schools. These didn't seem to be going so well for me and halfway through a friend of mine, who had taken finals the previous year, came round to commiserate. We retired to a pub, where he told

me about the difficult 'long case' that he had been given at St Thomas' Hospital the previous year. It was an Irishman with a large liver, diabetes and a rare diagnosis of a disease apparently called hemochromatosis. He reassured me by telling me that he had messed it up completely but still got through.

The next day was my 'long case' at St Thomas's and on arrival they ushered me through to see 'the patient'. He spoke with an Irish accent, he had a large liver and when I tested his urine it was full of sugar. He had diabetes. I could not believe my good fortune. Finally, the great Professor arrived to grill me. "I don't expect you to get the diagnosis but I just want you to tell me what you have found." I gave him the history and examination faultlessly and then he asked me what I thought the diagnosis was.

"Well, I have been putting all this together. I am not entirely sure. I can only think of one diagnosis but it is extremely rare and so I think it is unlikely." I knew I was treading dangerously but wanted to play this fish gently.

"So what do you think it is?"

"Well I thought about X, Y and Z but one by one I had to rule them out because…."

"Yes, yes – so tell me what do you think it is?"

"It is clear that he has got diabetes."

"Yes. Yes. Yes." The Professor was getting impatient.

"He has got a large liver," I continued.

"Why do you think that is?" the Professor asked.

I hesitated. "Well there is only one thing that this could possibly be … this patient must have a very rare blood disease called hemochromatosis!"

The Professor was surprised – most likely shocked – and changed persona from inquisitor to smiling, avuncular friend. He told me that I had been the only student that year to make the correct diagnosis.

A few days later I received a telephone call to say that I was going to be given an interview for a highly coveted award given to the best graduating London medical student each year. Each London medical school proposes two or three candidates for what is called the University of London Gold Medal. Then, the 'best' twenty or so medical students face a panel of six professors to determine the winner. The competing medical schools propose their best candidates with the hope of winning the award and thus bringing prestige on the medical school. I am sure my candidacy was due to the Irishman at St Thomas' incident and to be honest, I wasn't remotely bothered about the Gold Award as I did not appreciate its importance or significance at the time. However, I was overjoyed at the news because being interviewed for the Gold Award automatically meant that you had passed finals and therefore, I was now a doctor.

The evening before my interview for the Gold Award, I was invited to an old friend's birthday party. As I left the party for an early night, a young lady dropped her cigarettes on my shoes. She was an actress who was starring in one of the West End shows. After joyless months studying for exams, it was the cue that I needed to continue partying. I arrived very much the worse for wear at the Gold Medal interview the following morning. I did not understand many of the questions and was able to answer even fewer. I wasn't bothered. Fortunately, my friend and very hard worker Paul of the Good Fellows and Helen Mirren incidents was also proposed from Guy's and was the overall winner that year. I could not have been happier, for my friend and for my Alma Mater.

□ □ □

On my first day, I was so exhilarated to be a doctor, at last, that I ran up three flights of stairs to my new ward and raced through the

swing door of the ward full of exuberance and enthusiasm. I had not noticed that the highly renowned Professor Maurice Lessof had also just entered the swing door. The force and momentum of my entry led to his projectile exit with exactly the same force and momentum. This catapulted him out of the ward and down a flight of stairs. I just caught this out the corner of my eye and rushed to his aid finding him in a sorry state with broken glasses. As we picked up the pieces of glass, we exchanged expletives on the bloody idiot (unknown) who just committed this heinous crime. Swing doors, I should add, have been an almost constant problem in my life. I once got stuck in the same section of one in a London hotel with the not-underweight broadcaster Clare Raynor. We were both on our way to speak at a conference on human sexuality. Anyway, the Professor surprised me on my last day by calling me into his office and saying he had a present for me. He handed over a rather large but light parcel. It reminded me of 'pass the parcel' as a child. That was exactly what it was. I unraveled layer upon layer of paper in front of him and eventually the present was revealed – a small comb. "You may find it useful in your next job," he said.

My first two years as a junior on the wards contained the same mix of gravity, bonding and high spirits as my student days. Even in the late 1970s, the doctor on the ward could prescribe just about everything including brown ale, stout, brandy, port and sherry. It was a traditional part – even an accepted perk – of the late night round that sister would pour you a glass of 'medicinal brandy' before starting. Today this would be considered the double perjury of stealing from the NHS medical cupboard and drinking on duty. It was also quite in order for the registrar, senior house officer and junior house officer to have a drink or two before starting the evening ward round.

The relationships between houseman (the most junior doctor

in the hospital), registrar (middle grade doctor) and consultant (specialist and most senior doctor) were very close. There was so much suffering and so much dying and so much that we could not do. This led to a kind of camaraderie and Dunkirk spirit, which oscillated between feelings of desperation to feelings of joy, especially when things turned out all right in the end. What I remember most were our cheerful, supportive relationships. It is a far cry from the detachment that junior doctors have to face today when they start their first years as a doctor. No longer can consultants choose their junior doctors or vice versa and there is no time to build up the necessary mutual respect and understanding. Consequently, that bond of attachment and trust between houseman, ward sister and ward has all but disappeared. Instead, I witness fears, tears, stress and a good deal of cynicism towards an NHS that cares too little for its doctors, and sometimes too little for the patients as well. In previous years we may have been buccaneers but we were compassionate buccaneers and gave every ounce for our patients and, in return, our patients loved us for it.

◙ ◙ ◙

After six years studying, qualifying and working in London, I decided to return to my family and moved to Exeter. I had not grown up in Devon but my parents had recently retired to the West Country. It was my second junior doctor job as a house surgeon and I worked 120 hours a week. That is five days a week plus two nights and two weekends in every three. Inconceivable these days. I was happy and fulfilled even though I had very little time off. Junior doctors today have much more time off but the pressures, when they are working, mean that too often they are neither happy nor fulfilled. We carried considerable responsibility, especially when the senior staff weren't around,

which meant that we learnt quickly. The downside of this was, perhaps, that too often we had to learn from our mistakes.

Long hours spent on the ward enabled us to get to know some patients very well. Two particularly stand out in my memory. One was the last of Devon's clatters. Clatters were eel fishermen, who would thread worms onto a length of cotton and then wind this round a pole, which was then left in the river or lake overnight. Eels eating the worms would get their teeth stuck in the meshes of cotton wound round the pole with several being harvested each time the pole was lifted out of the water. Sadly, today, eels are now almost as rare as clatters. This particular patient was only thirty-five and had terminal pancreatic cancer. He bore his impending death with calm grace and resigned cheerfulness. Spending time with him prepared me for the premature death, aged forty-eight, of my own brother Andrew, who later developed pancreatic cancer. I knew by then, that it was all but impossible to escape the consequences of late pancreatic cancer.

Andrew's consultant had rather blithely told him that there was no cure and that he should enjoy as many sunsets as he could with a glass of wine. We tried everything to avert the inevitable, however ludicrous, including sending off for shark's cartilage, which was all the rage in the media at the time. Patients and particularly their relatives are blackmailed by the popular press and unauthenticated research to pay for these often expensive remedies that are not proven but might just help. Simply accepting the inevitable on behalf of a relative or patient at too early a stage carries the implication of not caring properly for them.

Another patient on the ward was called Don. He was quite a bit older. He had emigrated from Canada and had a tumour of the gullet. This had to be removed and then the gullet was reattached to the stomach. Unfortunately, following the operation, the

gullet and stomach had become separated and he was far too ill for a further operation. Nothing could be done and he just lay in bed waiting for the inevitable. On Saturdays, I was left to run the ward on my own with a mixture of pride and terror. With his pain at last under control, I spent most of Don's last Saturday afternoon distracting both of us from events to come. We discussed everything from the meaning of life to his war time experiences and speculating wildly about the sex life of our ward sister. After he died, his wife gave me some beautiful green and gold cufflinks imprinted with a little bird. She told me that he had specifically instructed that I should have them. I still wear them.

My boss was a respected young surgeon with, unusually for those days, a good bedside manner as well. I learnt much but that did not stop me having more 'Jim Dixon' moments.

We had operated on a lady with breast cancer and all had gone well. To make sure that the cancer didn't come back we were going to try a completely new treatment – Tamoxifen – which had to be given by injection (today it is a routine treatment given orally to most patients after treatment for breast cancer). The 'new' treatment arrived specially from the pharmacy that evening and, as it was still an experimental treatment, I read the instructions very carefully. It was written in bold: 'Keep in the Dark'. Not leaving anything to chance, I gave the injection and explained what needed to be done to the patient as I drew the blinds, turned off the lights and instructed the evening staff that she should only be given her supper by dim torchlight. No television, no visitors and a notice was placed on her door 'Keep in the Dark'.

The next morning, I realised that though the instructions had said 'Keep in the Dark' they hadn't specified for how long. I guessed that it must be for around twenty-four hours – guessing was a large part of medicine in those days. Intuition and a persuasive personality were the predecessors of today's rather

linear 'evidence-based medicine' that does admittedly save more lives than the old order. Our rotund ward sister came storming towards me, "Why is that patient in the dark, Dr Dixon?" she asked.

Rather self-importantly, I showed her the instructions on the new treatment which I had specially kept in the top pocket of my white coat. "See," I said, "only it doesn't say for how long."

She looked at me. It was a slightly odd look. I knew that she liked me but she always made me feel as though I had more than one screw missing. "Are you sure that 'Keep in the dark' refers to the patient rather than how you store the medicine?"

I felt sudden panic. The consultant was due on the ward to start his morning round in only half an hour. There was no time to lose. I ran into the patient's room, turned on the lights and cheerfully told her that her stay in the dark was now over as the medicine had passed through her system. She looked puzzled. In those days admitting mistakes and losing face had to be avoided at all costs. Doctors stood on pedestals and we still wore ties and white coats. Straightforward honesty did not have the laudable priority that it does have today. Shortly afterwards, the great man arrived on the ward and we entered the patient's room. Behind him, sister made a 'slit throat' sign at me. The patient never mentioned her twenty-four hours of enforced darkness.

As house surgeon I had my own 'lumps and bumps' surgery list on Friday mornings. These would vary from draining abscesses and removing sebaceous cysts to biopsies and fatty lumps (lipomas). On one occasion matron brought in some clinical visitors to demonstrate how junior doctors in the NHS gained operating experience. I was removing a rather large sebaceous cyst from the head of a middle-aged woman. Head operations often bleed heavily but this just happened to be the worst ever. As I asked my operating sister to fetch a bag of fluid to replace

the blood loss – which was now causing a drop in blood pressure – matron hastily ushered our visitors out of the operating room.

Such experience stood me in good stead for operating sessions during my early years in general practice though sadly, today, I no longer operate because the system has created all sorts of obstacles and the hospital now does this work, though far more expensively. This is an example of the rhetoric of the health service saying that it wants to move work from the hospital to the community but the system rigidly managing to prevent it.

The Mount Everest of every surgical house job was to perform your first appendectomy supervised by the registrar. When my turn came, everything seemed to have gone without a hitch. Afterwards, however, I had a sleepless night worrying that my stitches might have come undone or I had missed a bleeding point before sewing up. The following day I reached another conclusion in my life – I would never be a surgeon.

It was during my halcyon days as a house surgeon in Exeter that I received a telephone call from an old friend. Joanna and I had been good friends for many years – well a bit more than that. I had fallen madly in love with her as a teenager but she had fallen for and married a much more handsome and interesting lawyer. Nevertheless, we had maintained our friendship as the years passed and I had continued to hold a secret and ever-lighted candle for her.

"He's left me and run off with a busty blonde. Can you help me to get him back?"

"Of course," I said, "Come down to Exeter" (she did). "I have got a plan" (I hadn't).

Gradually the wounds and bitterness of betrayal faded. Brick by brick the walls of my own fierce self-dependence, which had served me well for thirty years, began to crumble. The flame of unconditional love was lit. Three years later we were married.

Her father was dying so we decided to get married in my parents' village. The vicar met us: "Of course, this can only be a blessing because Joanna has been married before. There can't be any hymns and you won't be allowed to have more than six people at the blessing." I was furious that Joanna should be treated in this way when she had been the injured party. For my own part, I had hoped that our wedding was going to be a bit more of a celebration than the 'sackcloth and ashes' proposed.

So we then asked the vicar in Alphington (Exeter), where we were living. Ben was an inspirational vicar – a retired American marine – and said we could have the works. His wife was having a baby. Shortly before we got married, a villager mistaking Joanna for the vicar's wife congratulated her on her pregnancy. Joanna, not realising the mistaken identity, thanked her and asked how on earth she had known about it. Our special secret was out. Ben did us proud and wanted it to be a great celebration. He even wanted to bless the unborn baby until I explained that this might get the wrong reaction from some of my more straight-laced great aunts. The wedding in Exeter was followed by a reception at my parents' home and a party in the village hall. During the conga, Joanna started to be very sick. The cause of that sickness was to become my first-born son – Finn – now a doctor in Gloucester.

At the time of our wedding, I was working on the special care baby unit in Exeter. It was intense work and we had to know our own blood groups so that we could give our blood to babies that needed it. Joanna, my new wife, would come and help the nurses feed the tiny babies. It was a rare chance for us to see each other as the shifts only allowed me to get home one in two nights and one in two weekends. We saw more of each other during my next job in psychiatry when Finn was born and we then had to move to Brighton for six months for an obstetrics and gynaecology job.

By this time I had decided to become a GP. I wanted to understand and cope with all physical and mental disease and not just some specific diseases or parts of the body. My final year's experience as a trainee in general practice cemented this decision as I came to understand both the complexities and deep rewards of my now chosen profession. My last GP practice attachment was with Dr Denis Pereira Gray. He was a supreme teacher – showing me the importance of the doctor listening carefully, putting himself in the patient's place and being able to understand his or her hopes and assumptions. Then using the relationship between doctor and patient to provide reassurance, significance and meaning to heal a patient's problem, as well as using the physical and psychological treatments that I had been previously taught in hospital. I began to appreciate that my journey – a colourful family life, loneliness at school, my failures on the games field, learning to sell leaky ballpoint pens, then studying philosophy and psychology – had equipped me as well as any to face the emotional and intellectual challenges of my future job.

Then came the mounting excitement and fear of 'going solo' as a GP with my own list of patients. All the exams and preparation were over.

I received an unexpected telephone call. It was from a doctor that I had met while working in dermatology a couple of years previously. "We are looking for a new GP partner in Cullompton. Why don't you apply?"

BAPTISM OF FIRE

Good judgement comes from experience and
experience comes from bad judgement.

Rita Mae Brown, Alma Mater

And so it was that on a late November day in 1984, punctuated by some early snow flurries, my life as a Devon country GP began.

Our main surgery was in Cullompton, a small historical market town about fifteen miles from Exeter. In those days the town had a wide range of shops which included two butchers, bakers, greengrocers, jewellers and chemists and a fishmonger, shoe shop, antique shop and 'gentleman's outfitter'. All are gone today apart from one butcher and the chemist. Just off the main street was a small road leading to St Andrew's Church. It was known as 'The Last Journey'. On the left you passed by St Patrick's, the home of my predecessor, who used to hold surgeries there before the days of the new health centre. If you were unlucky, you ended up with Mr Hellier the undertaker on the other side of the road. He would then take you down to the church and its churchyard. Our GP practice of six partners looked after a population of a little over 10,000 patients covering 150 square miles of mainly villages and open countryside. From then until today, I was entirely responsible for the care of the 1,800 patients that were personally registered with me on 'my list'.

My first consulting room was inside the town's rather faded 1960's Health Centre. It measured 8ft x 8ft; there were no medical fixtures and the three of us sharing had to bring our own medical equipment in and out in plastic bags. When it rained the room required at least four carefully placed buckets to avert a flood. The centre was a pre-fab building in the light blue and white livery of the NHS and had once been state of the art. It was now endearingly scruffy.

Meanwhile, hardly 100 yards down the road my new family – wife Joanna, two year-old son Finn and new baby May – were settling in. My wife's attempts at intimacy with the neighbours – "Call me Joanna" were rebuffed with, "We can't do that! You'm Mrs Dixon, you'm doctor's wife." Like all country doctors' wives, patients expected her to know everything and nothing about them. We were renting a house on the main street. It had previously been a butcher's shop with a small slaughterhouse behind it. The latter had been converted to make a yard and small garage. The garage was so small that we lost both wing mirrors on our yellow Morris Mini Metro within the first month.

Being next door to the pub, there was plenty of shouting, singing and scuffles with empty crisp packets and half eaten fish and chips frequently being deposited through our letterbox around closing time. On the worst nights these were joined by used condoms. No sooner had the sounds of the night quietened down than the first juggernaut lorries started thundering through the town shaking the house so much that we feared it might come down on us.

Eventually it did. It was an evening, soon after we arrived, when we had invited our GP partners and their wives to dinner. We were very much in awe of them and, in those days, moving from the traditional first year or two as an underpaid salaried partner and being promoted to becoming a full partner was by no means guaranteed.

Joanna was hoping to impress by cooking a beef stew in the galley kitchen, when from the sitting room, we heard an ominous crash. I went out to investigate. The whole kitchen ceiling, plaster and all, had collapsed. Worse still, much of it was now in the stew that we were about to eat. It was not a time to panic. I quickly rushed back and filled our guests' glasses to the brim and then rushed out again to help Joanna remove fragments of plaster and concrete from the fated meal. We sat down to dinner as if nothing had happened, though what *had* happened was all too obvious. Miraculously, no one broke their teeth on the crunchy stew but I don't remember anyone asking for seconds. Equally miraculously, I was asked to stay on as a full GP partner after my first years' probation.

Our shaking house was not designed for peaceful nights. Our new baby, May, was a poor sleeper at the best of times. This was not helped by her having to sleep in the bath due to lack of space in the house. Street noises apart, we were also 'on call' every fifth night and fifth weekend (we were five male GP partners and a female). Our baby and our patients seemed to be part of a mutual plot to ensure that we never slept and were permanently exhausted. My own medical doubts made things even worse. I would often wake in the middle of the night worried that I had got a diagnosis wrong and rush off in the early hours to check a patient's condition. The patients themselves were almost invariably well and asleep and surprised when I turned up for my 'routine follow-up check visits' in the middle of the night.

Extreme fatigue led to some precarious medical behaviour. I had programmed my brain with all sorts of 'advice tapes' for patients ringing in the middle of the night so that I didn't always have to wake up altogether. One patient during those early weeks disturbed our sleep complaining, apparently, of chest pain. In my

half sleep I turned on my automatic advice for acute diarrhoea until my wife jogged me into full wakefulness shouting "He's got chest pain!" Another evening, I remember coming home and was half-way up the stairs still holding my medical bag before realising that I was in my own home and not visiting a patient's house.

One night the telephone rang at two in the morning. Woken by the call, baby May started screaming. "Hello, what's the problem?" I asked sleepily.

"There is no problem," came the answer.

"So why are you calling?" I asked.

"I had terrible stomach pain last night and called Dr Martin at two in the morning. He gave me some excellent advice and asked me to call back in twenty-four hours and say how I was getting on."

"So how are you getting on?"

"I feel fine now."

Bewildered, I must have left too long a silence because he added, "I am only doing what Dr Martin asked me to." It was true. Taking what doctors said literally was something that I would soon have to get used to.

A fortnight or so after I had started, another patient called from one of the villages. He told me that he had developed terrible back pain a month previously and my predecessor had advised strict bed rest. He had told him quite firmly that he was not to move from the bed until the doctor said that he could. Meanwhile my predecessor had retired. The patient apologised for calling: "I haven't had any back pain for the past two weeks. Do you think I could get out of bed now?"

I quickly came to understand that many patients like to be 'told', in the old style, rather than 'consulted' in the new style in which I had been taught. One female patient illustrated the power of medical pronouncements. She told me, "Every time I

get up I feel dizzy and fall over. But the doctor says it's alright. So I am not worrying about it anymore."

My predecessor, who had to practice from a wheelchair in his later years, had well-developed personal skills. He had left me with a long list of his favourite prescriptions, which would be expected by his patient, and many of them were placebos with long Latin names. *Mist Opium et Cretae* was one of his favourites – a mixture of opium and chalk, which worked wonders for diarrhoea and many other disorders as well. His favourite 'nerve tonics' were either Mist Gent Alk or Mist Gent Acid. There was no evidence for either and both tasted equally awful. The only difference between them was that the Alk (the alkaline one) was blue and the Acid (acid one) was pink. He had another remedy for sore throats, which one patient described as paint stripper, and whose effects were so much worse than the original problem that few came back for more apart from seasoned masochists.

In those days, people expected medicines if they were going to get better. Preferably coloured, thick and foul tasting. During one of my first consultations, I spent considerable time explaining to an elderly farmer why he was getting heartburn due to reflux of acid from his stomach using special diagrams to illustrate my message. After all, the Greek equivalent of 'doctor' means 'teacher' and I had learnt that what the modern doctor said was as important as the medicine that he offered. Instead of reassuring my patient, however, my explanation had quite the opposite effect. He looked totally exasperated. "What's the trouble with you new doctors?" he said. "You go gabbling on, when all we want you to do is to give us the right medicine – like the old doctors."

These were the days long before 'evidence-based medicine'. 'No win/no fee' did not yet exist, lawyers were less hungry, doctors were more trusted and patients were more tolerant. Provided

that you did your best, neither patients nor society held it against you. Ignorance was not yet a sin. The idea that patients might be able to see their own notes was inconceivable and still more than two decades away. My first days in general practice were livened up by some of the irreverent comments and pictures left in patients' notes by my predecessor. In the notes of one rather grand but very large middle-aged lady, there was no writing – just a picture of a large spotted cow eating grass. As if she had seen it, she told me one day, "He always called me his little old cow". She was a pompous woman, who thought that she was rather grander than her henpecked husband and everyone else in the village. Like so many, she revealed her greatness, when her weight and good living led to premature heart failure. Death is a terrible but sometimes magnificent equaliser. This particular lady's graceful fall to becoming a fellow sufferer among the rest of us was noble and turned her, in my mind, from being a stuck-up old cow into a friend.

They were also the days of heroic or, whichever way you look at it, risky medicine, when we all had to work well beyond our capacity and knowledge. On my first day, Neil – the partner one up from me – who had joined the practice a year before showed me the 'obstetric bag'. It had four sorts of forceps and a whole set of anaesthetics and other instruments, which I barely recognised – let alone knew how to use. It was expected of a country GP that most babies would be delivered by him or her either in the local cottage hospital or, quite a few, still at home. You couldn't say that you felt inadequate and didn't know what to do – you just had to cope.

My first experience of a home delivery came unexpectedly and only a few weeks after I had joined the practice. It was three in the morning (it invariably is) and I received a very worried call from a man phoning from a telephone box. "My partner is in

agonies of pain." It is never just 'pain' it is always 'agonies of pain'. "Her stomach's all blown up and she looks terrible – you must come quick!" I sensed his urgency and said I would come right away. This was before the days of paramedics, air ambulances or even fast ambulances, which can now get to a patient's house within half an hour. As GPs, *we were* the emergency service. I eventually arrived at a row of terraced council houses. A terrified young man, holding a torch, was waiting for me on the doorstep.

The house was in darkness and he explained that they hadn't any money for the electricity meter. Fortunately, I had come equipped with my own torch and I also noticed, passing the WC, that it was unpleasantly full and suspected their water had been cut off as well. He showed me to his 'partner's' bedroom. There on the bed was a young girl, who was bent double in terrible pain. A quick examination, even by torchlight, revealed that she was in the second stage of labour. "You are having a baby," I told her.

"I isn't," she replied.

I pleaded with her. "You will have to take your trousers off."

"I won't!" she shouted defiantly. Then she burst into tears.

Our standoff was finally resolved by another set of painful contractions, which ended with mother-to-be finally conceding defeat and gallantly removing her trousers as the baby's head began to appear.

Her partner – now expectant father – was meanwhile getting into a state of increased agitation. It was clear that he was going to be useless. By this time, I had learnt that, in emergencies, country doctors need to give orders. I sent him off to the kitchen, where at least the gas was still working, to boil up some string. We would use it to tie off the umbilical cord. "Cut a piece of string exactly the length between your elbow and the tip of your fingers. You must then boil it for precisely ten minutes – no

more, no less. "Don't take your eyes off the pan for a second." Only after he had gone did I realise that I hadn't asked him if he had got any water but I had more important things on my mind.

With father safely distracted in the kitchen and with mother's trousers finally removed, I was now ready for the unexpected challenge of my first home delivery. The girl in front of me was striking with her long jet black hair tumbling over a marble white face. Perhaps I should have paused to think why she was quite so pale. She was certainly brave and with no pain relief she eventually produced a baby girl. Her partner triumphantly arrived at the right moment with the boiled string and I then cut the umbilical cord. A few minutes later I delivered the afterbirth congratulating myself on my first successful home delivery.

Only it wasn't to be. The delivery of the afterbirth was followed by a horrifying torrent of fresh blood, which soaked me right down to the pyjamas, which I was wearing inside my trousers. I had originally hoped that this was going to be a short visit. In spite of abdominal pressure, injections to clamp down the muscles of the womb and everything else that I had in my medical bag – nothing seemed to work. The heavy bleeding just went on and on. Eventually I lost my nerve and sent the young man off to the telephone box to order an ambulance. These were the days before mobile phones and the wait seemed interminable. She did get to hospital – just in time. The baby of that night is today a successful local beautician with her own children.

Extraordinarily, only two years later, I was called to exactly the same scene and with the same girl. She was living in a different village and it was the middle of the night. On this second occasion, she conceded that she might be having a baby rather sooner and delivery of another baby girl was uneventful. Though she denied any knowledge of having been pregnant, I concluded that she must have simply been terrified of having a

baby – possibly not helped either by the events of that first night. She confirmed this when she recently consulted me. "I sort of did know that I was pregnant but decided that if I didn't think about it then it might not happen! I was very young." These events have led me to have a soft spot for her and her sisters, who have had to face almost unbearable challenges that I will describe later. Challenges, I should add, that they met with similar courage and resignation.

Unexpected babies still occur today. The pregnancy of a bright young care assistant had gone unnoticed by her, her partner and her mother. When labour started, she had assumed it was simply constipation. Sitting on the loo and using her iPhone to look up other causes of abdominal pain, she had phoned a paramedic to discuss her fears. It was clearly a very useful conversation as it ended with the paramedic insisting that she must get off the loo immediately and set off for hospital. She did so and just in time. The mother's sunny disposition and the miracles of that night were reflected in the name that she gave her daughter – Hope.

Following my first home delivery, I was now learning quickly not to judge my patients. If people denied things, were ignorant or didn't listen – then that was their prerogative. If those of us who cared for them couldn't love them – who else could? Those who had the least often seemed to be among the gentlest and the kindest.

My first consultations were punctuated with patients hoping that they would get the same service as they had got from my predecessor – like the old man who just wanted his medicine. Some of my patients asked, "Where are the fags, Doc?" John had frequently offered cigarettes in the consultation. Yet he was (at least otherwise) a good doctor. He called his patients 'my lover' and his secretary 'young maid'. Before handing over, he had told me that he believed that a two-week course of penicillin

could cure some patients of stomach ulcers. His belief in this made him the laughing stock of all other local doctors, who knew perfectly well that only a major operation (in those days cutting the vagus nerve and operating on the stomach) could do so. Yet history exonerated him with the discovery of a bug in the stomach that does cause stomach ulcers and which can often be cured by penicillin. Today we give penicillin and other antibiotics for stomach ulcers and the then 'modern operation' is long extinct. He was ahead of his time but there is never any credit in that.

□ □ □

The current received truth may not always be the real truth. I had learnt that many years previously from my elder brother Andrew and also from my naval father, whose views were invariably of the unreceived type. In answer to any foreign conflict and quite a few domestic ones, his stock answer was 'send a naval destroyer'. He then paradoxically surprised me, shortly before he died, by saying that the Anglo/American intervention in Iraq would be a disaster and we would all end up paying for it in the end. The contradictions and eccentricities of my own background prepared me for the unorthodox views of my Devon patients. Many, for instance, were seeing complementary therapists. One told me about how he had been completely cured by his 'homotherapist'.

Language itself was frequently a major obstacle during those initial months in a Devon rural practice. I would come home to find Joanna confused and perplexed following conversations with patients for whom she was (as an arts teacher) their only source of contact and advice 'out of hours'. Returning from an evening visit, she told me that she had just had a call from a patient, who said, "I lives in Bowley Meadows…."

She had asked him, "Where is Bowley Meadows?"

"You don't know where Bowley Meadows is?" he boomed back in exasperation. "It's just Bowley Meadows!" And then he slammed the phone down.

Another patient's wife, asking for a home visit, filled me with trepidation. "Can you visit him doctor? He's been quite poorly for some time. In fact, he has been on a ventilator for five years." I dreaded what I was going to find on that home visit, until it became clear that the house had not been converted into an intensive care unit but her husband was simply having to use a Ventolin inhaler for his bronchitis.

Understanding the language of ordinary Devonians was nothing as compared with the farmers, who would tell me about their 'yores yenning' (sheep having lambs) and use other similar unintelligible phrases. Not infrequently they would ask me to see their animals as well. This threw up all sorts of dilemmas for which medical school had not prepared me. A farmer asked me one day: "I put mustard all over the door because our dog kept on chewing the wood on it. The problem is far worse now because he thinks that I put it there to make it taste nicer. What do you think I should do?"

Seeing animals could have become something of a growth industry, but I was saved by my own incompetence. When farmers asked me to see their moribund farm cats, I would give them some liquid paracetamol and other assorted medications from my bag. For some reason, most of them seemed to die. Country doctors worked closely with vets in those days (as they did with vicars, funeral undertakers and pharmacists) and one day I asked Don – our excellent local vet – about my singular lack of success with farm cats. "Well," he said in his usual thoughtful but understated way, "Perhaps it's because paracetamol wrecks their livers."

Shortly after I had arrived I got an emergency call in the middle of surgery. "Please come quickly, I need to see you right away." I set out hurriedly for a deserted farmstead only to be met by a smiling, friendly and thoroughly well seeming farmer.

"What's wrong with you?" I asked.

"Nothing," came the reply. "John liked me to call him out of surgery for a quick tot of malt and I presumed that you would like that too?"

With that, he led me into the kitchen and showed me an ancient bottle of malt whiskey with my predecessor's name on it. I was to find out that there were several local farmers with similar bottles and similar instructions from my predecessor. They all regarded me as rather wet – refusing a whisky mid-morning, and probably thought it even stranger that the doctor wasn't pleased to be called away from his work to share time with them.

◫ ◫ ◫

Talk was now spreading about the new doctor – "Very nice and thorough and even examines you, but not quite like the old ones." It was clear that knowing the textbooks and trying to be kind and caring was not enough. Somehow I had to prove myself. To gain a reputation in those days required a feat of heroism, a miracle cure or an act of outstanding courage. Something that would set the doctor apart from other people and turn him from a mere clinician into a healer. How was I going to do that?

Another partner had won his spurs by means that could never be equaled. It had been a hard winter. There was at least a foot of snow on the ground. He was called out as an emergency from one of our village surgeries to find a man, seemingly unconscious or dead, lying in the snow. After his 'thorough' examination and in front of a fast assembling throng, he announced that the

patient was dead and went off to organise an undertaker. He had only walked a few paces away when the 'dead' man got up and staggered off in the opposite direction. The doctor hadn't known that the walking corpse was a drug addict who had overdone it the night before. Neither did the assembled throng who watched the whole scene with wonder and amazement. Henceforth, the doctor concerned was feted not only in that village but also for miles around, earning the enviable title of 'Lazarus'. Far from being castigated for making the wrong diagnosis and pronouncing premature death, he was celebrated as the very cause of the corpse's miraculous revival.

I was learning quickly that, when it came to earning a reputation as a young doctor, myth mattered every bit as much as truth. This was reinforced a few years later in an incident, which I shall call 'the case of the succussion splash'.

Ted and Nora lived for many years, suspended between this world and the next, in their specially adapted bungalow. Both were virtually immobile in their retractable chairs. Nora had heart disease and continuing chest pains, while Ted suffered from a perpetual cough and breathlessness due to a chronic lung condition. They could just about get to the WC but all other things such as preparing meals and cleaning the house had to be done by others. They required constant visits for urine and chest infections and both had leg ulcers. Their living room smelt of rotting flesh emanating from Nora's leg ulcer.

One day Ted called me because he had a 'bad stomach'. There was so much wrong with him and he was so large that it was difficult to make any sort of a sensible examination. Nevertheless, from his symptoms, I assumed that he had an inflamed stomach. For some reason, which I will never remember, I put him on his side and shook him. This is a very old-fashioned examination and the shaking sometimes produces a satisfying sloshing sound

inside the tummy, which is said to signify stomach acidity and partial blockage of the valve (pylorus) coming out of the stomach. The splash is called 'the succussion splash' and the test is called 'eliciting the succussion splash'. Shaking Ted produced exactly the desired sound. He was curious about my examination and asked what I had found. I explained to him all about the succussion splash. I always had an eager ear for medical explanations with Ted, quite unlike most of my other patients. I explained that this was an old-fashioned test, which few doctors used nowadays but could sometimes provide a diagnosis, when other tests failed. Confidently prescribing the stomach tablets that my examination suggested, I was slightly horrified a couple of days later to find that another GP partner had had to admit him as an emergency to hospital for what turned out to be a completely different diagnosis – inflammation of the large bowel (diverticulitis).

Having got my diagnosis exactly wrong, I wasn't looking forward to visiting Ted when he came out of hospital a week later. Instead of the expected reprimand, Ted greeted me cheerfully as a long-lost friend. "You are bloody good, doc, I owe you my life!" Before confessing my mistake, I thought I should find out more.

"How was that?" I asked.

"That succussion splash test – doc – you are bloody brilliant. No one in the hospital seemed to have heard about it. I have been telling them all. You saved my life – I wouldn't be here if it wasn't for you."

Ted was quite a talker and I quickly found out that, in that village at least, patients felt that they had been short changed in my examination if I didn't subject them to a good shaking and at least try to 'elicit a succussion splash'.

Some of my partners had won their spurs through fair means rather than foul. I knew that I could never better Neil, the

partner above me, who achieved a spectacular feat that is still the talk of the village today.

He had been called to a scene of horror. A man had fallen asleep at the wheel of his Land Rover. This had then veered off the road and into a field, landing on top of a fence. One of its stakes had been thrust through the floorboard of the Land Rover passing through one side of the man's chest and out the other. There was a dead body in the backseat.

When Neil reached the site with the man stuck in the land rover, in agonizing pain and with a wooden stake appearing on both sides of his body, there was no textbook to tell him what to do next. Well, perhaps there was in the sense that the golden rule is never to remove a penetrating obstacle – but how he cut both ends and safely got the man out of the Land Rover defeats the imagination.

An ambulance would not have been able to reach the accident, so Neil had called the police helicopter. There was no such thing as an air ambulance in those days. He was busy pumping fluid into the patient with a drip (intravenous infusion) in each arm when help arrived. The pilot, Neil and patient then flew to Exeter with the patient wide awake, screaming in agony the whole way. Neil felt that it was too dangerous to give morphine in the cramped and noisy confines of the helicopter because of the risk that the patient might stop breathing.

There was no hospital landing site in those days. The helicopter eventually arrived 300 yards or so away from the hospital and an ambulance was called to transfer doctor and patient to hospital. Happily, no major arteries had been punctured and the patient survived. Neil's swift and effective action was all the more surprising as he had received his call to action while sharing a stiff gin and tonic with our senior partner. Each Sunday the latter would provide us with the background of all the patients

that we had been visiting that weekend, and the gin and tonic was an all but compulsory part of that briefing – none of us wanted to be regarded as wimps.

Neil managed to perform a similar miracle a few years later. He was on call, when we had just got our first mobile phone and he just happened to be passing the house of a relatively young patient of mine, who was having a heart attack. His heart had stopped and he had effectively died. Neil was in the house within a minute of the call and successfully defibrillated and resuscitated the patient. His heart attack had occurred during the European Cup Final (not the first time that a patient had a heart attack during a football match – see Chapter 9). Bringing someone back to life in this way is the ultimate medical drama. This story also had a happy ending, as the same patient is very much alive and well more than twenty years later and now leading a far healthier lifestyle. He, his wife and two daughters remain a close-knit family and important members of the local community. One of his daughters is an excellent hairdresser and today cuts the hair of my wife, daughter and grandson.

Neil had set the bar high and I could not see how I was ever going to equal his achievements. Making a few rare diagnoses and even saving the life of the young, unexpected mother who would not remove her trousers were not enough. Nor was empathising with mothers whose babies would not sleep. I was a little surprised that quite so many people came to see me about this when it was well-known that we were having difficulty getting our own baby, May, to sleep. Then it dawned. They weren't coming for solutions but I made them feel better because even the doctor couldn't get his own daughter to sleep. Empathy was OK but it was hardly heroic and doctors, in those days at least, made their names from acts of heroism.

Far from being a hero, I was still continuing to get things

wrong. A very nervous middle-aged man came to see me one morning, shaking all over. It was clear that he was worried about something. I launched into what I thought was a flawless modern consultation – a mix of reassurance and amateur psychotherapy ending with the inevitable prescription of 'Mist Gent Alk'. This was definitely a medical situation that required calming blue medicine rather than the inflammatory pink one. Far from being grateful, the patient was outraged. "That's no good," he screamed. "The only doctor who ever knew how to deal with me was Dr Shove."

"What did he do?" I asked, acutely aware that Dr Shove was about fifty years my senior. I couldn't help but wonder what medical phenomenon he had known about that I didn't.

"He was a bloody professional."

Oh dear, perhaps my decision to prescribe the calming blue medicine was rather too flippant. The patient continued: "I came in to see him a few years ago just as I have come to see you today. I sat down. He was reading a newspaper. I told him all the things that I have told you today and, not for a second, not for one single second, did he look up or stop reading his newspaper. Eventually, when I had explained how I felt, he looked over the top of his newspaper and asked, 'Have you finished?' I said 'Yes.' 'Good,' he said. Then ever so slowly, he rolled up his newspaper – just like this – and hit me on the head with it as hard as he could three times. Then he said, 'Pull yourself together man, you're just a jibbering wreck!' It was the best advice that any doctor ever gave me."

❑❑❑

My chance to prove myself did eventually come unexpectedly, as these things do. Two or three months after I arrived, we received a call one night from a very worried woman. "Father's fallen out of bed, his ear is falling off and there is blood everywhere."

"Have you called an ambulance?"

"No – he won't go to hospital and anyway mother won't let him because she says he is too old and his brain's gone."

Many local people, in those days, thought that hospital was where you went to die, which was often the case as people tended to present late in their disease and we didn't have the early screening and diagnostic tests that we have today. Consequently and quite logically, they thought that if you wanted to avoid dying then the best thing was to avoid hospital. I rather suspect that many would have opted for surgery on the kitchen table if I said that there was a reasonable chance of success. Some did.

Anyway, I trudged out to the village with no clear plan in my mind. It was mid-winter and there had been a power cut and, once again, whatever I was going to do would have to be by torchlight. The situation was hopeless. There was blood everywhere, the ear was only attached to the head by a thread and the patient was exsanguinating fast. All this wasn't helped by my assistant, the patient's daughter, having nervous shakes as she held the torch for me to examine her father. There was only one thing to do: I had to stem the bleeding and stitch it up myself. Fortunately, in those days, we carried all the necessary instruments and sutures. My attempts at stitching were interrupted by my unable assistant collapsing in a faint half-way through and dropping the torch. I had to stop the stitching and revive her before propping the torch against the end of the bed, which gave me just about enough light to continue the work. A couple of hours later and twenty-six stitches, the bleeding had at last stopped.

I went back the following two days fully expecting disaster. I was amazed to find the ear both pink and healing and the patient propped up in bed and cheerful. Neighbours and people from far away popped in to witness this surgical wonder. I had, at last, proved myself in one village at least!

Shortly afterwards, in a nearby village not famed for the good behaviour of all its residents, I was called by a young lady on one of the housing estates towards the end of an evening surgery. "*You will* have to come and give me one of those bloody coils." I was aghast.

"*You will* have to come down to the surgery and make an appointment," I replied.

"I can't – I have got a baby, two children and two dogs here – I can't leave them. I've got a new partner and we had sex three days ago. It will be your fault if I have another baby!"

The conversation rapidly progressed to stalemate. It was obvious that there was going to be another not-terribly-wanted child if I wasn't proactive. I did something that I have never done before nor would ever consider doing since. On my way home, I dropped in and fitted a coil (intra uterine device) during a home visit. That would certainly make me a laughing stock today, if not get me struck off and, quite frankly, it did surprise my partners at the time. Nevertheless, I felt then and I still feel now that we should not allow ignorance, desperation and lack of motivation to be an excuse for not helping – especially those (in this case the unborn baby), who cannot help themselves.

It was in this spirit of mind that I decided early on to devote an hour a week to seeing especially complicated patients with half hour appointments. These were patients for whom I felt that I needed time to unravel exactly what was going on. We would describe these patients today as having a functional disorder or 'medically unexplained symptoms'. I had a particular interest in psychotherapy and had done a course on sexual counselling. The unfortunate victims of this new endeavour were perplexed by my psychological bombardment, having peacefully enjoyed their multiple and insoluble melancholies for many years and without interference.

One of my first failures was a couple, whose husband (a wealthy businessman) was depressed – explicitly because of his wife's lack of sexual interest in him. This was the sort of challenge that I relished. Having explored and overcome the reasons for this sexual disharmony, I was horrified to find the tables had turned and he was now even more depressed because her awakened interest had led to his feelings of sexual inadequacy. For me, it was yet another lesson that things are sometimes rather more complex than they seem and, furthermore, that they are sometimes exactly as they are meant to be. Interfere at your peril! Or as the doctor's saying goes 'Do no harm'.

As time went by, I began to realise that there are some people that come to see you and want to be helped but there are quite a few that don't. I wasn't entitled to barge in simply because their seemingly incessant physical symptoms, helplessness and demands frustrated *me*. That was entirely my problem and not theirs. In these days of a more literal interpretation of medicine and when we often have only time to look at the presenting symptom and problem, I suspect that we may have less time to pause and reflect on why the patient has come to see us in the first place.

Nor did all patients want 'whole person medicine'. A patient came to see me one day and said all in one breath, "Doc – I have got a sore throat. It's only a sore throat. Please don't try to psychoanalyse me."

◘ ◘ ◘

We were now approaching the end of our first winter in Cullompton. It had been one of those worst of Devon winters – endless rain and mud everywhere. It was tempered only by two days of snow when the children had been able to make a snowman in our little yard.

Everything changed dramatically on a wet Saturday morning in March. Gloom had settled on the town. Particularly on its new doctor, who was holding an emergency morning surgery for the second Saturday in a row. It was with some relief that I realised that my next patient was the last of the morning.

He was a genial, stooped, elderly man with a moustache and leathers on both elbows of his tweed jacket. I looked at his notes – he was a retired Brigadier. "I have got two problems," he said. "You will only be able to help me with one of them. It's a terrible cough and it has been going on for three weeks and getting worse."

"And the other problem?" I had to ask.

"The other problem is that my wife died a year ago and I can't stand living in the house anymore. I want to move."

"Perhaps I can help you with both of your problems," I replied.

The noise, the cramped surroundings and the proximity of my work to our rented butcher's shop were beginning to affect the whole family. Within a few months we had bought the Brigadier's house. He, meanwhile, moved to a house in Sidmouth promisingly called 'Elysian Fields'. He became a lifelong friend, who our now four-year-old son called 'my Brigadier'.

Chapter 4

SEX IN THE VILLAGE

*He said it was artificial respiration but now
I find I am to have his child.*

Anthony Burgess, *Inside Mr Enderby*

Moving from our rented town house in Cullompton to the Brigadier's house in a village changed our lives completely. Our new home was a small and rather rundown old vicarage – affectionately known as 'The Old Rec'. We arrived on a sunny day in early summer. Sid and his team of removal men were hampered by Finn, our son, making a long line of pebbles, collected from the drive, along the tailgate of their van. Consequently, the men and much of our furniture slid or crashed out of it – including our piano that never really recovered.

We now had neighbours. On our left was an elderly lady called Ivy. She had been a Bluebell Girl, though you would never have believed it. She was ever welcoming and immediately became a surrogate grandmother for the children. The only downside was her completely inedible cooking which she kindly brought us whenever she felt that we needed help. Her middle-aged son Ant (Anthony) spent most of the day smoking and drinking coffee at her kitchen table. When the children visited her, she would usher Ant out of the kitchen. If they asked her where he was she would reply, "Ant has gone shopping." This happened so frequently that little May would rush round to Ivy's house shouting, "Where is Antgoneshopping?" Ivy and Finn were picking mushrooms one day. As they walked across the field, Finn was looking up at the sky and remarked, "When I die, an angel will take me up to

heaven." He then looked at Ivy, who was a little bit overweight, and added "You'll need at least three."

On the other side of the fence was the vicar. I met him shortly after our arrival, entirely by chance, while mowing our new lawn. The Brigadier's highly unreliable lawnmower had broken down and not for the first time. As I tried to bring it back to life with expletives – "Bugger, bugger, bugger" – the vicar popped his head over the fence and said, "Can I help?" His offer was more than noble as we were soon to find out that he had two real hates in life – alcohol and swearing.

It seemed right to live in a village where so many of my patients lived. The downside was being asked to 'have a quick look at my knee' while shopping in the post office or, more understandably, being called to emergencies when I was off duty. I did get irritated when people knocked on the door on a Sunday evening asking me to sign certificates, passport photos or a gun licence. The intruder would add helpfully, "I didn't want to bother you in surgery." As time went by, the village began to reveal its secrets. I had a double take on them being both doctor and villager myself. Which brings me to the subject of this chapter. The country GP has a window into the most intimate parts of people's lives and can sometimes know more about a patient than the patient's own spouse or partner. Nowhere more so than their sex lives. Of all the things that we see in rural general practice, perhaps it is their sexual practices and arrangements that are the most unpredictable of all. There are no norms.

◻◻◻

My own curiosity had been first awakened around the age of six or seven when my parents were away. I had to share a bedroom with the daughter of friends of theirs, Chippy. She and I decided it would be interesting to see what the other looked like. Chippy

gave me a penny and I dropped my pyjama trousers. She looked satisfyingly intrigued. When I pulled them up, I returned her the penny and asked her to do the same. I was shocked. Nothing! Or nothing as far as I could see. I tried my best to hide my disappointment. Anyway, I had paid my penny.

It was my brother Patrick, who provided me with an opportunity to see if there was anything more to girls. I must have been around ten years old by that time. He asked Andrew, David and me if we would contribute sixpence each (5p today) to buy a blue film. We paid up our dues and he nobly contributed a shilling. In a few days the film arrived in a promising blue cardboard cover. When my parents were out, we pinched my father's projector to watch our new treasure. It was called 'Naked Venus'. Silent and in black and white, it opened up promisingly enough with a very much clothed Venus standing in front of a rather large haystack. It was clearly a very windy day as bits of hay were flying all over the place. She seemed to be talking to someone, for quite a while – possibly the cameraman – but of course the film was silent. Eventually, looking very embarrassed, she started to remove her bra. Meanwhile, behind her, the haystack was disintegrating in what was fast becoming a force ten gale. In the last few seconds of the film, when I might have learnt what did go on 'below', there was too much hay flying about and it was getting too dark to see if there was anything at all. However inadequate my own early sexual education may have been, it was quite unlike that of my own children who, I should add, had picked up just about everything that they needed to know on the school bus by the age of ten.

□□□

In our village, where most of my patients lived, many were employed by the local slaughterhouse. In those days it was a

skilled profession with all sorts of sub-specialties, and the local people were well looked after by the family firm. Comparatively few locals are still employed there today. It is now a corporate enterprise and, then as now, the work was hard and almost medieval. It was intensely physical, cold and possibly barbaric to an outsider, who may never have paused to wonder too deeply how their meat is produced. What impressed me most, when I spent a day there, was the size and speed of the whole process. Women in the chicken section frequently got repetitive strain injury of the arms and wrists, while cuts and bruises were commonplace for those working with the larger animals.

Each shift was twelve hours long. Consequently, there were many couples who had to work alternate twelve-hour shifts – especially those with children. This meant that they would hardly ever meet each other. Adapting to this way of life, some had organised complex sexual arrangements which were mostly mutually convenient and rarely led to breakup of the family. All of this was, however, a cause of bewilderment to our kind but unworldly vicar. He would frequently ask me why a neighbour was in someone's house wearing pyjamas when he had arrived on one of his unscheduled visits.

To fill the gap, for those who hadn't made 'other arrangements', there was Doris. She was the last 'lady of the night' in the village and married to Jim. When I first met her, she had seen better days and was now reminiscent of Ena Sharples in Coronation Street. She always sported a hairnet and housecoat and would complain and swear about everything. Jim would dance around her, keeping his distance, always as cheerful and welcoming as Doris was eternally glum.

In their younger days, they had run the business from their council house. The current state of play for potential customers was signified by a carnation in the living room window. White

meant 'open for business', while red signified 'wrong time of the month'. During rush hour, clients would have to wait and Jim would entertain them downstairs with a choice of brown ale or stout before taking their turn with Doris upstairs. There were many wild stories of what happened in those days – none of which I can confirm. It seems that Doris's outstanding feature had been her two 'pups' and occasionally it is said, these 'pups' – or at least one of them – would pop out during heavy drinking sessions in the local bar to the admiring gaze of her drinking partners.

Shortly after I arrived, Jim contracted pneumonia and died. In those days, we treated everything from pneumonia to heart attacks at home and would often leave late-evening visits wondering if the patient would be alive the next day. Jim's death left Doris on her own – still swearing like a trooper and increasingly lame. Her worst problem, however, was incurable incontinence. After years of invaluable public service, her lower regions were worn out. They could no longer hold back the floods. We tried tablet after tablet (the clever operations of today had not been invented) but without success. "Those tablets you gave me doctor, they not done a bit of good," she would say tersely, frustrated by the incompetence of this new doctor. Doris also suffered a double injustice as she was also one of the last in the village to have an outside lavatory. This meant that her nights and days were spent journeying to and fro from house to garden. This made it particularly difficult when it rained. Eventually, the district nurses persuaded her to have a commode in the house. As she got older, she got grumpier and grumpier – eventually confined night and day to her rather damp armchair but commanding great affection and loyalty from the village – especially from two unemployed young local girls, who cared for her on a voluntary rota.

In her last months, the village had a whip round and organised for our local chemist to deliver her a case of stout each week. Chemists, in those days, catered for all sorts of personal needs: alcohol, as on the wards at Guy's, was just another means of relieving suffering. Doris was, explicitly, not the slightest bit grateful for all this help and continued to curse and swear at everyone around her, but none of us took it personally. Not even the staff in the local nursing home, where she spent her last days having given up all my useless tablets but continuing with the stout until her last breath. For all her bad temper, her service to the village community had earned her its affection, which was unwavering to the end.

Several people in the village did not need Doris's services as they had already made their own arrangements for free. Jock McFadgen, a dour Scot, was one of these. As a farm labourer, he didn't have the excuse of having to work twelve-hour shifts. Nevertheless, he and his wife Elsie had packed up the sexual thing at an early stage in their marriage and Jock would drop in on the lady who lived nearby at the end of the road (whose husband did work in the slaughterhouse) for mutual comfort on his way home. This arrangement was still holding when I first met Jock and Elsie in their seventies.

They lived in an untidy and disheveled bungalow whose gloom was temporarily alleviated during the summer when Jock grew brightly coloured sweetpeas and hollyhocks outside. They had to live on one floor because of Elsie's 'problems', which were as much imagined as real. They always demanded home visits because Elsie was unable to leave the house. This was a mixture of her fear of going outside and her perceived physical incapacity in being able to do so. Whenever I visited, she would be sitting in her dressing gown in an armchair with a small table in front of her, piled up with all her medications. I called her the tortoise.

She always wore a woollen bobble hat. When I first arrived in their sitting room, all that I could see was the bobble hat perched on top of a dressing gown. Then, when she had realised that it was the doctor visiting and not some alien force, the bobble hat would slowly rise above the dressing gown like a tortoise's head coming out of its shell. Out would come a face with a persistent look of misery and suffering. I don't remember her ever smiling.

There wasn't much actually physically wrong with Elsie from the medical point of view. For her, though, life was a constant struggle to control her bowels. The medicines that sat on the table in front of her armchair were her only allies in this battle – each one designed to make her bowels move either faster or slower. On the left was lactulose and fybogel for constipation and on the right codeine and imodium for diarrhoea. Sitting in her armchair, she was the captain on the bridge, her table with its medicines was the engine room. Like the labours of Sisyphus, she faced an impossible task. Sailing her ship through the Scylla and Charybdis of going too fast, going too slow or not going at all. Elsie knew nothing of Greek mythology but she did know that she could never win.

We never discussed anything other than her bowels and it was never even a conversation in the ordinary way of things. She would terminate her consultation each time with "... so what do you think I should do doctor? Rest a bit more? I thought so...." all before I could say anything. Then the bobble hat would disappear once again down into the dressing gown.

As Jock watched Elsie trying to coast her bowels into calmer waters, he began to morph into her twin. Instead of meeting me at the door, when I visited, the door would be on the latch and he would be wearing his pyjamas in the armchair next to her with his medications lined up on the table in front of him. In his case, it was a mixture of water tablets and blood pressure

pills for his heart and, like her, he never kept to the instructions but simply fed himself from the bottles according to his own instincts. In spite of the seeming incapacity of both Jock and the tortoise sitting in their armchairs watching the television, Jock did slide out from time to time to visit the lady at the end of the road until well into his eighties.

He surprised me one day by arriving at the surgery rather than requesting a visit. He was clearly on a serious 'quest. "The damn thing's not working anymore. Can you give me some tablets doc?" Unfortunately, it was before the era of Viagra and we had nothing to offer that was likely to work. That did not stop inventive GPs from trying. With my own increasing interest in complementary medicine, I suggested that Jock might try an ancient Chinese remedy for impotence called 'Horny Goat Weed'. Its beneficial effects had been discovered by a goat herder, who had noticed that his goats became far more sexually active after eating the weed. It seemed to work for some people – possibly because of its hopeful-sounding name.

A much more experienced partner in the practice would give out his famous 'gold' pills for the same purpose. These pills had the promising Latin name of 'Potensan Forte'. The small gleaming gold balls were a mainly herbal preparation designed to improve sexual performance which had been subject to clinical trials published in the *Irish Medical Journal* in 1973. The tablets had a number of ingredients including, testosterone, but it was thought that their main action was due to some of the components directly affecting the brain and one of these was strychnine! They were as close as it got to an evidence-based treatment at that time. As important were the manner in which they were given. My colleague was very explicit in his instructions: "You must take one at exactly eight o'clock each evening for three days," he would say, "… and you must not

even think of sex during that time. On the fourth evening, you can resume relations and you should find everything in perfect working order." It often was – especially if anxiety or lack of confidence were holding back their performance.

Unfortunately, my Horny Goat Weed did not provide the same beneficial effect for Jock. He returned in a determined almost threatening state: "Those tablets haven't done a bit of good – what are ye going to do now?" That was a good question. Any other doctor looking at Jock, slowly dilapidating in his mid-eighties, knowing Elsie and witnessing perpetual NHS shortages would probably have replied, "Nothing!" I was a coward. There was, at this time, an 'Androgen Clinic' in Taunton that dealt with such things. Fortunately, it had an extremely long waiting list and I knew that referring Jock would get him off my back for six months at least. It did.

Seven months later my sins returned to haunt me. A very irate Jock came crashing into the surgery and sat down in my consulting room, shaking with anger. His face said it all. "How did that visit to Taunton go Jock?" I asked cheerily. I wasn't looking forward to the answer.

"Terrible," he said. "It was one of those young doctors and he just said to me – 'Jock ye had a good innings. It's time to draw stumps'. That was all he said – I was disgusted!" Jock's impotence was, in fact, a sign that his heart was beginning to go rapidly downhill. On my further visits, Jock would be sitting, panting in his armchair, with swollen legs and continuing to take his own counsel as to which tablets he took and when. Meanwhile, as I was examining him, the bobble hat in the armchair next door to him would slowly rise above the dressing gown and the tortoise would blink as the daylight hit her. Then, looking left and right, she would offer advice to Jock and me on what tablets he should be taking.

Shortly afterwards, Jock died and there was much nostalgia as people remembered 'good old Jock'. As so often happens, things were not quite as they seemed. It turned out that the tortoise had been repressed and quite fearful under Jock's thumb for many years. She had also found out that he had been spending her pension on the horses without her knowing. When I visited her two weeks or so after he had died, the medicines and the bobble hat had all gone. She was shuffling around like a much younger woman and even seemed relatively cheerful. Shortly afterwards she moved to live with her daughter and I never saw her again.

Those living on isolated farms sometimes had to make arrangements that were closer to home. On one local farm, the farmer and his wife had taken in a lodger who helped them with odd jobs on the farm. The lodger's name was Mr Bright. His full name was Henry Bright but for some reason that I never quite fathomed, no one ever called him by his first name. It was always Mr Bright. The farmer and his wife had difficulty conceiving children so Mr Bright, the lodger, extended his repertoire of odd jobs to this department of their lives as well. A child was born. He had what we now call a learning disorder and was called George. Just as Henry Bright was never called Henry, George was never called George. From birth to death he was simply 'the Nipper'.

The four of them – the farmer and his wife, Mr Bright and the Nipper – lived in comparative peace and happiness for many years. Eventually the farmer died, soon followed by his wife and Mr Bright and the nipper were left on their own. This was when I got to know them best. Mr Bright was gruff and monosyllabic, while the nipper was just monosyllabic. Having been looked after for many years by the farmer and his wife, neither were capable of looking after a house or each other. Consequently, the farmhouse had to be sold and they moved into the old people's home in our local village.

By that time Mr Bright was in his eighties, although the Nipper was barely sixty. Whenever I visited them in the home, they would always be sitting next to each other in the sitting room. Mr Bright, solid, upright and gruff, and the lean Nipper bent forward with a permanent expression of puzzlement. They were inseparable, though neither hardly ever said or did anything at all unless someone spoke to them and even then their reply was a monosyllable. In time this twosome became a threesome as Maud, a wiry and deaf lady with advanced dementia, invariably chose to sit next to Mr Bright. He clearly had something about him as she would gaze lovingly into his eyes and didn't seem to mind that he totally ignored her. Mr Bright, for his part, was happy because she spoke very little and did very little apart from getting up occasionally to dance to an illusory band. When she did so the Nipper would lean over to Mr Bright and mutter "'Er's dancing again". On one occasion I visited Mr Bright in the day room. The Nipper was on one side of him and Maud on the other. Much to my surprise Maud was reading a book. On closer inspection I saw that the book was upside down. Trying to be helpful, I turned it round the right way. Only then did I notice its title, *How to Pass Your Driving Test*.

Their demise was quiet and without complication. In his late eighties Mr Bright developed pneumonia, which carried him off in forty-eight hours with the Nipper keeping a twenty-four hour vigil at his bedside. Five days later, the Nipper developed a cough and though he was a man only in his mid-sixties, he seemed to have neither the will nor the means to live. I gave him the strongest antibiotics that I had and, today, would undoubtedly have admitted him to hospital. He died the next day.

◻ ◻ ◻

Consultations on sexual matters varied with age. To begin with there would be the young girl with heavy, painful periods, mother in tow and some ambiguity as to exactly why I was prescribing the pill. Then, there was the more direct consultation with a young lady requesting the pill as contraception for the first time and, more frequently these days, below the age of consent. For girls of fourteen and fifteen attending with their mother, this was usually an easy decision in spite of some angry phone calls from their fathers when they found out. The fifteen-year-old attending with her geeky partner was not so difficult either. If the deed had already been done then it was a *fait accompli*. If it hadn't, then at least they were both thinking ahead and I generally saw my role as being protective rather than complicit. The fifteen year-old attending on her own or with a rather knowing twenty-five-year-old boyfriend was a much more complex consultation.

At the other end of life, things were changing fast. When I first arrived in the practice, many men over fifty would complain that their wives had lost interest in sex. Then came hormone replacement therapy and often the boot was on the other foot. Men would start coming into surgery asking for something to help out their sex life and Viagra and related drugs changed things altogether. Today I am allowed to give patients up to four Viagra tablets a month and many of my elderly males are on Viagra or something similar, while many female patients are continuing hormone replacement therapy into ripe old age.

Sometimes the demands were totally unreasonable. One Saturday morning surgery, a young man came in and sat down. "I want the morning after pill."

"Why didn't your partner come and request this herself?" I asked.

"Because it's me that wants it."

"You are going to take the morning after pill?"

"No, there's a girl that I fancy and if I get lucky tonight, I want to be prepared. Anyway, you don't have a surgery on Sundays."

Consultations for the teens and twenties were mostly straightforward – thrush, vaginal discharge, premature ejaculation and transmitted infections. Other consultations, especially around gender identity, could be very complex. A local dental nurse, who had had quite a lively sexual history came to see me one day saying that she had a new partner. "So you will be needing contraception?" I asked.

"No I won't," she answered.

"You are planning on getting pregnant?" I asked naively.

"No."

"He has had a vasectomy?" I asked.

She watched me struggle before telling me that, for the first time, she now had a female partner. They would continue to live together for the next twenty years. After she left, I wondered why she had come at all. Perhaps telling me her story after a number of unhappy relationships had provided her with closure.

Pregnancy and post-pregnancy represent a challenging time in our sexual lives. Discussing it at all is taboo. Yet it clearly can be a big problem area. Kinsey, the well-known but possibly not always reliable American sexologist, claimed that in almost half of his couples, the male partner was having an affair in the last part of pregnancy. Listening to the experiences of my patients, it became clear that this could be a vulnerable time for both partners, with the demands on each having never been greater.

In my early years as a GP, I was fortunate as there were all sorts of funds available to do an afternoon's research a week on topics that were of particular interest. My first project was to investigate the sexual activity and relationships of couples following their first and second childbirth. My reason for doing so was because, as a young doctor, I was witnessing issues in

couples after their first and second baby that seemed important but there was no useful research in this area. There were only two available sources of evidence at this time. One study that had looked at Hispanic couples in the USA and another that had observed patients following childbirth at a London teaching hospital. Both suggested that sexual relationships were restored to normal relatively quickly after childbirth and there wasn't much of a problem. This did not seem to fit with what I was seeing in my young couples in Devon.

My research, on over a hundred couples in Cullompton, confirmed my suspicion that things were not so simple. Sexual relationships could take up to six months to return to anything like normal after the first child. Things were often better with the second child – at least as far as relationships were concerned – largely because both partners knew what they were in for. Nevertheless, a poor relationship before the first pregnancy followed by difficulties after it would often lead to deterioration in the relationship, a great deal of unhappiness and sometimes separation. My research led me to think that pregnancy and childbirth were the 'Beecher's Brook' (the Grand National's most difficult leap) of any relationship. It seemed important that people should know that they were not alone in facing these challenges.

When I published my paper in the *Journal of the Royal College of General Practitioners*, one or two angry letters from female correspondents claimed that a male doctor had no right to research and make conclusions on such issues. Thankfully, I received a much larger postbag of letters again from mainly female correspondents, including one that had written a book on the subject, thanking me for liberating this whole field as an issue for discussion. Meanwhile, I have found that being able to inform my patients about the experiences of the average Cullompton patient

can be helpful and prevent feelings of failure, inadequacy and not being wanted on the part of both female and male partners.

□ □ □

'Women's things' and 'women's parts' were always a source of mystery to the male section of the farming population and medical terminology often confused the women themselves. One farmer's wife told me about a consultation in the hospital where "Dr M said that I had a thyroid on my womb – I didn't know you could get them down there". Of course, she had a point and fibroid does sound rather like thyroid.

Another told me that her consultant had "shoved a telescope up my doofer and said he wanted to take out the fallopian tubes to stop them waving in the wind". Consultant letters can be equally perplexing. One reported on a patient of mine, saying that "Vaginal examination was unrewarding so I performed digital examination of the rectum".

Quite apart from confusing our patients, we medics can sometimes be the very cause of sexual disharmony. I was called to see one elderly couple who had requested a visit due to the husband's infectious disease. When I arrived, the anger and tension was palpable. The old man was sitting in an armchair gazing at the floor with a defeated expression, while his angry wife danced around him. She was waving an empty tube of cream. "Doctor X came to see us a few weeks ago and he took one look at Alan's rash – just one look – and he told us that he had got syphilis. You can imagine what I thought of that! Anyway, he's used the whole tube of cream and he's still got it." I examined the tube of cream. It was the standard treatment for the skin disease psoriasis. When I had explained what Alan actually did have, his wife still looked suspicious but gradually the atmosphere in the room began to lighten.

Another rather 'Type A' farmer's wife provided me with rather more information than I needed about the size of her husband's penis and what had happened. "It's only three and a half inches long. I can't feel it and it slips out half the time. They say that size doesn't count. They only say it to cheer the men up. I have now found out what it's like with two other men. My husband has met both. He liked them but he only felt bad about himself. I tried to help him but what can I say? It's really useless but at least I have found out what it is really like. Before he used to last only about ten seconds. Now he has learnt those techniques it keeps going flabby." Another farmer's wife had a similar attitude to the marital bed when I asked if her persisting vaginitis (soreness of the vagina) was affecting her relationship with her husband. She replied, "I am not worried about that. It's the horse you see – I haven't been able to ride him for ten weeks."

Sexual problems often had a much sadder side. There was a couple, whose wife had a phobia of sexual intercourse and their marriage was never consummated. In spite of my best efforts to help and their refusal to see a specialist, they remain a devoted and seemingly happy couple. Frequently men would come to see me for a trivial rash in the groin or on some other pretext and the real reason would be revealed, when I approached them on the examination couch. "Do you think the size of my penis is normal doctor?" Perhaps sometimes the request was a bit more explicit – "Would you say my old man is a little small?" One middle-aged farm labourer told me that his doctor had told him as a teenager, "You must keep pulling on your foreskin otherwise you will need a circumcision." He had done that ever since. My examination very many years later revealed an entirely normal penis. He was relieved to know that he definitely did not need a circumcision and even more relieved to hear that he could now discontinue the unnecessary

exercises that he had faithfully performed over so many years.

Today, an almost equally frequent consultation is a young lady concerned with the appearance of her vulva. Not long ago a sixteen year-old came to me in tears, accompanied by her mother, asking for plastic surgery because her friends had told her that she was abnormal 'down below'. Examination revealed a normal vulva and vagina with labia, which were no more prominent than average. The need for our young people to conform to a 'standard norm' that has been invented by dubious role models is truly horrifying and an enormous cause of unhappiness and serious mental disease.

The consultations that I dreaded most were when a mother told me that her child was being abused by a friend, neighbour or babysitter. Children were not protected by the complex and sometimes more effective arrangements that exist today. There would be long conversations with the mother followed sometimes by equally long conversations with the perpetrator, with the doctor being placed in the role as judge and jury. Sometimes, I would advise the mother to telephone the police, while others were simply keen that I kept a very close watching brief, with the threat that the police would be called if anything ever happened again. In many cases that was the end of it.

In a rural community, both perpetrator and victim were often my patients. One young man, who had been severely handicapped in a car crash many years earlier, exposed himself to a young girl on the local bus. His father came to see me saying that the police had had him up on a charge of 'decent insult' (it turned out to be indecent assault). The father and traumatised son were both decent people themselves but there was also a victim and things had to be done. My job was made easier because things were already in police hands. I visited the perpetrator and his father and was able to advise on how to avoid such incidents in future.

I then visited the mother and young girl, who appeared to be thankfully unharmed – both seemed more concerned as to what was going to happen to the young man. It is bad enough having to witness such tragedies but it became a moral maze trying to sort them out.

Equally complicated were the consultations with a mature adult, who would tell me of a parent, step-parent or sibling that had abused them many years previously. In most cases they would be adamant – indeed as a condition for telling me – that they did not want any action taken against the person concerned. They simply wanted help for themselves. I was fortunate because, on my list, there were two very generous patients who had had to work through similar situations and who had volunteered to see others facing the same ordeal of having to cope with past events. On the whole, they were more effective than the professional services available. With the connection between doctor, patient and community less close than before, it may be less easy for patients to make such revelations to their doctors and less likely that other patients will be available to help them. Hopefully, this is compensated by the greater availability of helplines and, in an open society, things are less likely to be dusted under the carpet. In spite of the bureaucracy of today's safeguarding arrangements for both children and adults, I suspect they are safer today, though this may have led to more families breaking up and children being taken into care. In the past this was lonely work and, as in so much of general practice in those days, you simply did your best.

When I first came to the practice, most of the farmers and their wives would consider that only a male doctor could possibly know his stuff. A far cry from today, when there are more female than male GPs and most women are happier to see a female GP than a male. I sometimes shared patients with our sympathetic

female partner. She would look after the bits below the tummy button, while I looked after the bits above.

There are so many sexual secrets that patients have revealed to me over the years, which I could not possibly put into print. For instance, there is more than one child in the practice, where only the mother and I know who the real father is. In most cases these secrets will die, and rightly die I think, with both of us.

Times are changing. People are living far longer. They are searching for 'quality of life' and are not prepared to live for years and years with an incompatible partner – sexual or otherwise. Today, husbands and wives come to see me saying that they have 'fallen out of love' with each other. The consequences of this – including many broken marriages – fall not only on the children but also the elderly. The extended families of the past and interrelationships within the village are beginning to break down. Things may seem to have been simpler in the past. Perhaps they weren't quite as simple as they seemed. They were just unspoken.

DEATH AND DYING

*Whenever I am reminded of death – and it happens
every day – I think of my own, and this makes
me try to work harder.*

Dr John Sassall in John Berger's *A Fortunate Man*

Two years after moving to the village, we were on the move again. Developers had been granted permission to build houses to within ten yards of 'The Old Rec'. Any privacy would be lost. Ivy and the vicar had got used to their medical neighbour mowing the lawn in his underpants, but there might have been reputational issues if my foibles were to be witnessed by a wider audience of my patients.

Several years previously my wife, recently abandoned by her husband, had met a fortune teller. She was accompanying a journalist friend from *Time Out* magazine, who was writing an article on him. He told her that she would meet a man wearing a white coat and live by a river. This prophesy was now to come true.

In a neighbouring village, there was a beautiful tumbled down house beside the River Culm. As a fisherman and keen gardener, I had an ambition to live there from the first time that I had seen it. It was owned by Michael, an ever-smiling, lean retired farmer with red cheeks who had serious chest disease which he bore with immense courage. He had let our local estate agent know that he wanted to sell the house. We met him. By that time he was feeling too ill to move house. A few months later he became critically ill. His own doctor was away and I was covering for

him. He told me he wanted to die at home and not in hospital. The following day he did. Shortly before he died he told his wife, "Make sure that the doctor buys this house." She invited me over the following afternoon and I did. She became a good friend and patient as did her son, William, who is godfather to our youngest daughter. I have written this book in the room where he died. It was once a medieval buttery then became Michael's makeshift bedroom and is today, my study.

◘◘◘

They say that all political careers end in failure. As all our patients succumb in the end, the same could be said for the career of a family doctor. One of the first specialists that I met at Guy's said, "The British are at their best, when they are ill." He was right. Many of the deaths that I have witnessed have been noble and heroic. Today, we are lucky to be supported by experienced district nursing teams with subcutaneous morphine pumps to control pain, and our excellent hospices. Yet, strangely, many more people die now in hospital in spite of these wonderful advances. In the past around three quarters of my patients died at home.

Most people want to die in their own bed but few perhaps put it quite as forcefully as Michael, the previous owner of our house. Patients and relatives fear that there will be insufficient support during a crisis. In spite of the excellence of our hospice and district nursing services, our current system is rarely able to provide personal medical continuity, which is also an important factor. Our hope that technology can somehow eke out a few more days and months and a system that is generally risk adverse means that far too many people die in hospital. I have witnessed dying patients with morphine (for controlling their terminal pain) going in one arm, while chemotherapy

(to attack the cancer) is fed into the other. In a modern, more secular world, we are perhaps less accepting of our fate. Dying has become taboo.

In the farming community, death was simply part of the cycle of life. An inevitability that its members took in their stride. Indeed, many made an occasion of it. In my early days, I would visit farmsteads where an elderly dying patient might be tucked up in bed, attended by wife and one or two children, while next door in the parlour the extended family and friends sat dressed in black holding posies and talking cheerfully as they waited for the end. My job, in these circumstances, had gone beyond that of prolonging life and become one of simply easing death. I quickly realised that I also had an even more important role.

When a patient made his or her last breath I was often there – that is how it was then. There would be a silence. Then everyone's eyes would turn to me. It wasn't enough to simply say the patient had died and do the usual physical examination to confirm it. I was also expected to round things off, a bit like the Duke that arrives to speak on stage at the end of a Shakespearean tragedy. I had to make sense of the patient's life and all that had happened. If there was a wake, I would have to make a different rendering of the same speech in the parlour next door. I found out that it was the quality of these proclamations – repeated by patients' relatives down the years – that were every bit as important for a doctor's reputation as any technical expertise. As time went by, whatever I said would be altered into something far better and more consistent with what people would have liked to have heard. It was an important part of closure, bereavement and healing.

In those times, the doctor was expected to give his dying patients his home telephone number, whether or not he was

on call. We were kind to our patients but less kind to our families. One way of compensating for this was to take one of my children with me on my weekend visits.

One Saturday afternoon, I was called to the largest house in one of the villages to see an elderly farmer with pneumonia. I took my four-year-old son, Finn, who was carrying his toy Fisher Price doctor's bag. When we arrived at the impressive stone house, the farmer's wife had everything in good order. He was propped up in bed with freshly ironed sheets wearing a clean white nightshirt. He seemed resigned to his fate with a toothless smile and a knobbly face reminiscent of W.C. Fields. I knew both of them quite well as he had been slowly declining over a period of months but was now clearly near the end. I asked Finn to examine Tom and tell me the diagnosis. Finn listened to his heart with his toy stethoscope with the same look of seriousness that he had witnessed during my own heart examinations. He then looked into Tom's eye with his toy ophthalmoscope and used his toy blood pressure monitor before proceeding prematurely to treat him giving him an injection with his toy syringe. Both patient and wife helped him with his examination and we were all impressed with his serious concentration. "So what's wrong with Tom?" I asked finally.

Finn looked at Tom then at his wife and then at me and finally passed his judgement. "He's only got one tooth," he said. Tom couldn't hear him but his wife laughed and clapped. The old man studied his wife's face carefully and then broke into a glorious one-toothed grin.

It was, however, obvious from the end of the bed that he had pneumonia, and equally obvious that he was not going to get better. I had forgotten my own stethoscope at a previous patient's house but my son's Fisher Price stethoscope was an excellent substitute and proved the diagnosis. It was a windy

autumn day and it would soon be winter. "I could give Tom antibiotics but…" Happily, I was interrupted by his wife who said, "I don't think that would be right."

Meanwhile, Finn had got bored and was twirling himself in the long blue curtains by the window. I shall never forget that knobbly, red face betraying a mind that, in his wife's words, was "not quite what it was". Nor the concerned but calm look of his white-faced wife and the three of us watching Finn as he danced with the curtains. Neither did she. Thirty years later, aged one hundred, I visited her in an old people's home. She was now as deaf as a post. She shouted to me over her lunch. "Do you remember that day when you came to see us and Tom was dying and your son got lost in the curtains? He was a lovely boy. What's happened to him now?" I was able to tell her that he too had become a doctor, in Gloucester. "A doctor in Gloucester," she laughed and repeated, "A doctor in Gloucester!" clapping her hands. Every time I visited her she said, "I do hope the good Lord will call me soon." Shortly afterwards, he did. Today, taking a child to visit a terminally ill patient would be inconceivable but I am convinced that Finn did more to relieve the suffering of Tom and his wife than any medicine might have. Proven, perhaps, by her happy memory of Finn on that day some thirty years later. The country doctor is no longer part of village life, but this should not stop him or her playing a leading role in the health and welfare of the local community.

◻◻◻

Our new and only neighbour was a very renowned Dark Ages historian in his nineties. A wise owl. Whenever I was unable to answer my children's questions, they would give up on me and then race round to see him. He would always have an answer. One day we discovered a bat in our attic. Rather than seek my

advice, the children put it in a shoe box and went round to see the old professor. Without any hesitation, he took them round to his barn and placed the bat on one of the beams explaining that there was a family of bats there already.

I was to discover later that there weren't many known facts from the Dark Ages so he had to become an expert in producing authoritative answers. Given the paucity of facts on that period, these could never be contradicted. He was the epitomy of an absent-minded professor. Answers to our questions would start with a very long and high-pitched "Ahhhh…." Then he would choose his words carefully, while looking upwards as if receiving direct knowledge from the Almighty. As he grew older and more doddery, he began to take increasing comfort from the bottle.

On many sunny days, after a heavy lunchtime drinking session, he would fall into a bush outside his house flailing around like a beetle on his back only to be discovered by my wife. They would always go through the same routine. "Nurse, Nurse," he would say. "Please let me die." He was shortsighted but always called Joanna 'Nurse' even though she was a schoolteacher. He would still be saying "Let me die" as she carried him up to his medieval four poster bed.

He came to lunch with us one Christmas Day when I was on call. We'd had a bottle of wine, of which he had drunk most. Joanna and I had only had a glass each as we were on duty. In those days if I did go out on a visit or two, I might be out for one or two hours leaving Joanna answering the telephone and thus entirely responsible during this time for the ten thousand patients that our GP practice cared for. It was a considerable responsibility for someone who was an artist and a schoolteacher with no medical experience, and was also trying to care for a young family at the same time. Inevitably I was called out during our Christmas lunch. Before I went out, I asked the

Professor if he wanted a glass of Madeira. "Just one small glass please," he said. I poured a small glass leaving the newly opened bottle on the table, only to find on my return that the bottle was completely empty and yet he was still quite able to walk home.

Extraordinarily for a man of such independence, he took very well to the later routine of a nursing home, where he spent his final days. I would visit him in the odd role of both a friendly neighbour as well as a doctor, but he always made sure that even I kept to the fixed regime of the home. After my examination and conversation and sometimes a shared sherry, he would look at his watch and say, "The nurse will be bringing my tablets at six and then I will be having my dinner."

It was the signal that I should leave. It was a good and dignified death of a great man.

Quite by coincidence, his colleague and fierce competitor – another Dark Ages historian (there were only three or four of them altogether) – ended up in exactly the same nursing home during his last few days and under my care. I went to see him. He had cancer and the beginning of pneumonia. His first words were, "I'm dying, aren't I?"

And I had to say, "Yes, I am afraid you are."

"How long?"

"Days… a week perhaps. It is impossible to say."

"Damn!" he said as if he had been hammering a nail into a wall and then hit his thumb. "You see I have got this rather special case of Claret." He then waved his arm vaguely at a cardboard box sitting on the chair by his bed, which must have contained at least six full bottles of wine. "I was rather hoping to finish it before I popped me clogs." I was doubly impressed by his attitude to death and the 'waste not, want not' ethic. Perhaps Dark Age historians reach so far back in time that neither time nor death are of much consequence to them. Anyway, he pressed

on with the job because when I was called to certify his death, only two days later, there was only one bottle left in that box.

Another patient with an equally casual perspective on death was Jane. She had developed a rare neurological condition in her thirties, which had caused partial paralysis of one leg leaving her with a limp and listing to one side as she walked. She also had attitude. She didn't like doctors and she didn't like the establishment. Now in her early fifties, she was 'allocated' to my list after a neighbouring GP had asked her to re-register following endless battles and a formal complaint by her against him.

When I first met her she was prickly and angry and I was defensive, hoping to avoid further formal complaints and all the other issues that had dogged her previous relationships with doctors. It became rapidly clear that Jane saw herself as an outsider. She had been constantly belittled by authority and felt that she was surrounded by enemies. She wasn't beautiful but could have been handsome if she had ever bothered with her appearance. We formed a conspiratorial relationship which changed our conversations from mutually antagonistic to jubilantly anarchic. Over several years, she became happier in her skin. Still a loner with a limp, but far more tolerant of other people and of her doctor in particular.

One morning after surgery she asked me to visit. She had a lump in one breast. In the early days of our relationship and with a long list of complaints about doctors, I would have been reticent about examining her on my own – especially at home. After knowing her for a few years, I knew that whatever it was, she was worried and it could be serious. It was. She had a large hard lump in one breast and admitted that she had had it for many months. "Breast cancer is quite curable these days," I told her. "But you will need an operation and probably some radiotherapy and chemotherapy as well."

"I am not going near the hospital," she replied.

"Without treatment you will die," I pleaded.

After two or three weeks of debate, I persuaded her to see a surgeon. The interview didn't go well. "He treated me like a child – he told me that I needed an operation and that was that," she told me. An operation date was eventually fixed but a few days beforehand she rang me up and said she had decided not to have it. Her refusal could not be attributed to any mental health disorder. Her decision not to go for surgery was entirely consistent with the Jane that I had known over many years. She had no relatives and no-one to care for her and I asked the district nurses to visit her to see if she could be persuaded to have some treatment that would save her life. She wouldn't. She would let the district nurses look after her when she was dying but was adamant that she was going to have no operation and no visits to hospital. Eventually she accepted hormone treatment, which delayed the inevitable by a year or so and she met her fate with extreme bravery and with the same caustic sense of humour that I had learnt to enjoy, rather than take personally. All of us grew to like her, possibly because she lived entirely by her own rules. When I pulled the sheet over her face for the last time, I realised that in an inadequate way, I had probably known her better than anyone else. She had been let down in early life and refused to allow anyone – or any system – close enough to care for her in later life. What a shame and what a waste. She frequently infuriated me with her obstinance but, as a fellow rebel, I also had the greatest admiration for the way that she went it alone.

<center>▣ ▣ ▣</center>

The timing of most deaths is fairly predictable. These days I am able to reassure my patients that we can successfully treat pain

and that, for many, death comes when they are ready rather than creeping up behind them. One patient, a retired bank manager, had planted a vineyard unaware that he had terminal cancer. Producing the first grapes was everything for him and he then survived, miraculously, for two years until just after his first harvest had begun. Another patient and a good friend was able to plan her wedding following a terminal diagnosis and another, in similar circumstances, survived until after a long-planned fishing holiday. Having something to live for is sometimes as effective a medicine as many of the chemicals that we throw at people who have a short time to live.

Death, unfortunately, is not always peaceful or timely. Too often it was difficult to contain the pain or the fear or the desperation of relatives. The very worst were the young deaths and almost all of them are firmly imprinted in my memory. A brave young man, who died fighting in Afghanistan and had a grief stricken but magnificent town funeral. I had known him since he was a baby. Shortly before he died, he had been back at home on leave. I had heard from a relative that he was not himself and so I left a message asking him to come and see me. He never did. Quite apart from feeling a corporate responsibility for his death, I felt that I had let him down on a personal level.

Another young man died when his car fell on him while he was repairing it. He was a particularly nice young man and had just got engaged. As his family's GP, I needed to help his fiancée and his family through this terrible event. Its consequences were lifelong for all concerned. I rarely attend the funerals of my patients. It is not a question of 'caring for the living' but more simply a question of time and trying to be fair to everyone. I could not attend every funeral. The exception to my rule has always been the young deaths. They are so devastating and leave so little room for hope.

The s were among the most harrowing deaths. The rate of suicides among farmers is far higher than the rest of the population. Though they are wise about life and death and 'careful' (as my father would have said) with their money, certain areas of life such as 'women's problems' and 'mental illness' are often taboo issues. The majority of suicides in the practice thirty years ago were farmers and some memories will haunt me forever – the dark, lonely, wet barn, the cold spring wind blowing through it and the clunking sound of two gumboots banging together. They were the boots of a farmer who had hung himself from the beam above. They say that many suicides are spur of the moment decisions and I am still to this day puzzled by one young man, who had eaten half a banana and then left it on the side before hanging himself from the ceiling. Today there is a stronger blame culture around suicide: doctors are called to account if they are perceived to have done insufficient to prevent them. This may have had a positive effect as we are getting better at preventing suicide in the depressed patient who mentions suicidal thoughts, and the patient who has strong risk factors for suicide. Nevertheless, I am not sure that things have improved in the sense of us creating a more supportive community, where suicide becomes less likely. Perhaps that is the next step for general practice of the future.

Some people have such hard lives and their courage and endurance might shame us all. One of the saddest deaths that I had to experience was the sister of the very same girl who had the unexpected baby shortly after I arrived in the practice. She had come to see me at the age of twelve and it was obvious that something was very wrong. She had a rare disease that causes multiple lumps (cancers) all over the body. From being a very pretty twelve year-old – as fair as her sister was dark – she developed tumors all over her body, a drooped face and

a limp. As she entered her teens, she was utterly accepting of her disease. She never gave in to self-pity during years when she should have been out discovering life, meeting boys and using her extraordinary and surprising intelligence and motivation to make her way in the world. By eighteen, she was housebound and living in a dark, dingy upstairs flat over the main street. Given that we had nothing to offer, those home visits should have been difficult, but the contrast between all that lost promise and her cheerful courage made it strangely elevating to see her. I asked her if there was anything that might make her life better. "A television," she said. "I would love to have a television." The town charity paid for one – a colour television. The joy on her face as she watched programme after programme from her chair and, later while dying in bed as the disease progressed, was itself a celebration of life.

Another young death remains firmly in my mind, partly because of its terrible consequences. Stacey was an attractive but difficult, argumentative and opinionated young woman in her late twenties, yet could be exceptionally kind to those who needed her help. Delivering her last baby at the Cottage Hospital, the midwife rang me to say that she had found a small lump on her cervix and wondered if it was significant. I referred her to a gynaecologist but it was too late. The hospital tried treatment after treatment for her cervical cancer but she died within two years. Her heartbroken husband, with two toddlers and an elder daughter, took to drink. He later set up house with a new partner, who was also an alcoholic and their unpredictable behaviour eventually led to the young children being taken into care in another part of the country. Their heroic grandparents finally took them out of care and then proceeded, in late middle age, to bring them up. Today they are two fine children, who are now themselves parents.

Stacey's eldest daughter, Georgie, had meanwhile made her own way in life and no doubt survived because she was every bit as difficult and opinionated as her mother. Wild beginnings often lead to the most rounded adults. Things changed dramatically when she had a baby. Her first son was unexpectedly born with multiple deformities and it was clear from the beginning that he would never walk. Instead of becoming an angry young mother, she changed from the argumentative young lady, where consultations were always difficult, to become the paragon of a good and caring mother, pouring her energies into a child that desperately needed her. She has patiently comforted him through endless operations and been an effective advocate, whenever any of us have failed to meet his needs. The young boy has now grown up to become a positive and intelligent young man, as computer literate as any, though very physically handicapped. Both he and mother continue to defy all the obstacles in their way. She is now married and has another child – a daughter, Tania.

When patients see a doctor, they mostly want a mix of medical efficiency and compassion. When they are dying, they want a different sort of conversation and are rarely fooled or comforted by expressions such as "you will be up and about in no time". One patient explained this to me very clearly, when I first arrived in the practice. "Dr Dixon, I am extremely happy with your care and want you to continue looking after me, but if it turns out that I am dying I would like you to send Dr Rhys-Davies, and when I am just about to die I would like to be looking into the eyes of Dr Martin." Dr Martin was much the most handsome of us all! Thirty years later and now a grand old lady well into her nineties, I reminded her of her request. "What nonsense!" she exclaimed. "I'm sure I never said that."

Most people want company when they are very ill or dying but not all. Gordon did not seem remotely surprised or even bothered when I told him that he had terminal lung cancer. His only concern was that I should not tell his sister, who lived nearby and with whom he was not on speaking terms. He died quite rapidly spending his last few days in our local hospice. When his sister, who was also a patient of mine, heard of his death she came into see me flushed and angry. "Why on earth didn't you tell me?" she said accusingly.

"Because he made me promise not to tell you – I tried to persuade him but he was insistent."

She never forgave me. She left my list but suddenly reappeared ten years later, when she herself was terminally ill and asked me to take her on again. Neither she nor her brother ever told me what the feud was all about.

◘ ◘ ◘

Death and dying have become somewhat of a bureaucratic nightmare when it comes to filling in forms. For patients requiring cremation, for instance, what was once a four-page form is now ten pages. This is supposed to stop another Dr Shipman. How anyone ever thought it might, defeats me, but it certainly adds to the many irritants of a GP's working day. Another form is the TEP form. Its main use is to stop unnecessary resuscitation. In the old days we would put NFR (not for resuscitation) on the patient's notes – not always telling the patient. It mostly worked but some doctors got it wrong and the result has been a much more explicit though rather bureaucratic procedure that we are meant to discuss with each patient.

Sometimes the process can be too explicit. Barbara was the very efficient but not desperately sensitive carer, who worked in one of our old peoples' homes. Lucy was a very frail, anxious and

partly-deaf old lady, whose main passion was reading detective novels. She certainly did not like talking about death or dying. Mentioning her 'little problem' was taboo although the cancer had spread to her liver and lungs. As Lucy got weaker, Barbara accosted me one day saying, "Doctor, you really must get Lucy's TEP form done." She was right, of course, but I wasn't looking forward to an explicit discussion with Lucy on a subject, that she clearly did not want to talk about.

"Lucy, we have got to fill in this form, that tells us what to do when you are not so well." I proceeded with the easy questions around admission to hospital, providing intravenous fluids and giving antibiotics. Fortunately, Lucy had her wits very much about her and I didn't have to do the mental health assessment form on the next page, which can take ages to complete. Then it came to the question about resuscitation. "Lucy – if your heart was to stop would you want us to resuscitate you?"

"Yes, I think so – wouldn't I?"

"Yes, perhaps now, but when you are less well would that be a good idea?" I replied as gently as I could.

At this point Barbara interjected, "Lucy, there is no point in having people jump up and down on your chest if you are going to die anyway?"

Lucy and I looked at each other slightly shaken by the bleakness of Barbara's addition to our conversation. Lucy finally agreed and the TEP form was signed. Lucy was no doubt relieved to be able to get back to her detective books. I was just putting the top back on my pen, when Barbara's voice bellowed from behind, "Burial or cremation?"

Early in my career, I learnt the importance of making a good relationship with the undertakers. Keith, the undertaker in our local town was a very cheerful and down-to-earth Devonian. He had a bad chest and was getting breathless carrying coffins

even when I arrived. My wife once telephoned him at lunchtime one Saturday to tell him that a patient had died. "Oh no!" he exclaimed. There was a silence. She became concerned that it must have been a close friend of his. He continued. "I was just going for my lunch."

Anyway, Keith always provided a good and respectable funeral. He was perhaps only surpassed by Victor, who was the carpenter and undertaker in our own village. Victor was as tall as he was lean. The villagers said that this was because he had been rolled up in a carpet when he was young. He was gentle and had a lovely smile but an unnerving look. The latter is the trademark of many undertakers, who often seemed to be half attending to your conversation and half measuring you up for your own coffin – just in case. He was also a meticulous builder and an expert on Persian carpets. His funerals were a performance in themselves. His very tall lean figure with a top hat would walk slowly in front of the hearse from village to cemetery (about 500 yards) with the whole village watching and following. His aquiline features and deathly pale and motionless face further heightened the sense of occasion and dramatic effect.

Like all undertakers, Victor knew the rules behind the scenes and in those days patients that we hadn't seen for more than fourteen days were subjected to a postmortem. Consequently, Victor would call me on a fortnightly basis on any pretext to see his elderly, dementing mother in her nineties to ensure that no such fate should become of her. It took me some time to twig as to why I was getting these regular calls. Such is our self-deception that he swore to me that on the day that she had died, she had only just finished *The Times* crossword although it had been obvious to most of us for some time that she hadn't even known who he was.

Returning to Keith, the undertaker in our main town, brings me to one of the very worst days of my career as a GP. For some reason I was the only partner in the surgery that afternoon and already running an hour late. I had a call from our district nurse, who was with the family of a patient with terminal disease. He had just died. I told her that I would ask Keith to collect the body and then I would examine the deceased at the undertaker's after surgery. Keith was happy with this arrangement and set off to the house with his assistant.

I had an alarming call an hour later. It was from my wife. She had just been telephoned by the wife of the deceased patient, who was in a highly anxious state and totally incomprehensible. She was clearly reacting badly to her husband's death. I reckoned that Keith must have got to the house by then and decided to telephone him and see what was happening.

I called the house and a very distressed lady answered. "Could I possibly speak to the undertaker?" I asked. There was a silence at the end of the phone, then Keith's assistant must have grabbed the phone. He explained to me in a trembling voice that Keith had himself expired while they were taking the deceased's coffin down the stairs.

I had liked and known Keith for many years. He, together with our optician and pharmacist, had contributed as sponsors to a medical information booklet that I had written and which we had given to all patients in the practice. Indeed, the first day that we distributed it in the waiting room, a young man read our advice on testicular self-examination and saw one of us doctors with a cancer of the testis, which was later cured. So I was grateful to Keith and he was invariably and infectiously cheerful. Someone I was always pleased to meet though, given his profession, it was often on sad occasions.

Anyway, there was no time to grieve over Keith. I now had

two bodies to manage – the man in the coffin and Keith. I also had no undertaker and a waiting room full of complaining patients because I was now running well over an hour late. I had to think fast. I told Keith's assistant to hang on in the house, while I tried to contact another GP partner to certify Keith. At the same time, I was trying to trace Keith's wife to tell her the news and see if we could find an alternative undertaker. Keith's wife did not answer the phone. Meanwhile, in-between patients, I was phoned by the nursing home to say that an elderly lady there had just died and could I send an undertaker. I tried to phone Keith's wife again but there was no answer.

It was time to take stock of the situation. I was now running almost two hours late, I had three bodies, no undertaker, an increasingly hostile waiting room and a new widow that needed to be told the sad news. Eventually, I grabbed my coat and went out into the waiting room saying, in a voice with some desperation, that I had to go out on an emergency. Then I raced out into the dark cold winter evening to try and find the new widow. I banged on her door but there was no reply, but then saw her coming down the street returning home from shopping. It was only as she put her key in the lock that she noticed me, outside in the dark. She ushered me in and seemed hardly to react to the news. "I kept telling him that he wasn't well and that he should slow up," she said mournfully in her soft southern Irish accent, "but I couldn't get him to listen and he insisted that it was just his usual chest." She made some tea, shared some reminiscences and wiped away a tear or two. Then quite abruptly she stood up and said, "Well, we can't be wasting our time now, can we then?" With that, in good Dunkirk spirit, she suspended her grief for Keith, who we had all loved, and set about organising an undertaker from another town to come and sort things out.

Returning to the surgery, the telephone was ringing. It was the nursing home asking why the undertaker hadn't arrived. Meanwhile, not a patient had moved – each had been waiting for well over two hours.

◳ ◳ ◳

When I entered medicine, I thought the purpose of being a doctor was to save lives. Sometimes we do, but equally crucial are the life-threatening situations that we have prevented. Especially today, when so much of what we do as doctors is around prevention and early diagnosis before things become serious. It is important and effective work but rather dull compared to the death-defying heroics of those early days, when medicine was much more about firefighting than fire prevention.

Consequently, failing to stop someone dying – especially if you felt that you might have been able to, was cause for much self-examination and misery. That was particularly so early on in my career when a young man who had been working in the Foreign Office came to see me complaining of nausea and extreme fatigue. He was the son of our babysitter and I especially wanted to do my best for him. My blood tests suggested that he had a serious liver infection and, sure enough, he gradually became yellower and yellower and sicker and sicker. There was no effective treatment in those days and liver transplants were just beginning. Nevertheless, I telephoned the local hospital, as he became really quite ill, to ask if they might take him in. I answered their questions. Their unhelpful reply was, "There is no point in us taking him in while he is able to take fluids and his blood tests were only X, Y and Z. Call us back if things get worse." They did get worse, and relentlessly so. When the bloods did show X, Y and Z he was finally accepted by the hospital and died three days later. It had been like a train crash in slow motion. Made so much worse

by him being such a young, intelligent and likable young man, who had shown courage and resignation in equal measure. With today's technology, I am sure he would still be alive, but watching a young man die in front of your eyes and to be able to do very little and to have so very little support left me in total misery for many weeks afterwards.

Being so well-acquainted with death as a doctor does not make it any easier to react normally when there is a death in your own family. When my father and two elder brothers died, I suspended grief as part of my 'coping' mechanism and partly because, as the doctor in the family, I was the one person that was expected to know what to do.

The hardest was the first; my brother Andrew. He was only forty-eight and, always the outsider, he returned home from South Africa to die. As a wine expert he had bought me a special bottle of red wine. For my part, I had organsed a three-day fishing holiday for us both but he was, by then, too ill for us to go. As I helped the undertaker put his rigid yellow body in the coffin, I could only think of all the ways that I had failed him. With pressures of work and a young family, I felt, as doctors eternally do, that I should have done more and spent more time with him. I kept the bottle of wine as long as I could, as part of him, until sharing it with Penny and my brother-in-law Mike several years later.

Patrick, my eldest brother came next aged fifty-five. He had been a generous and protective eldest brother and in spite of many challenges, he never seemed to take life too seriously. Typically, he died of a heart attack on 1 April – April Fool's Day. For some months previously we had been as close as we had ever been. With the demise of his sales company he had taken up farming and then finally decided to run a taxi business. It was a time when I was having to speak at medical conferences all over

the country and Patrick would drive me to them. An older brother being taxi driver for a younger one might have seemed odd to the outside world but Patrick carried no resentment for where life had taken him and we were able to talk about everything that really mattered to us. When our conversation dried up he would put on his only cassette at full volume – the Triumphal March from Aida. The same music, again at full volume, accompanied his coffin into his local church. He looked peaceful in death and his passing was made more bearable because he had such strong fatalistic and religious beliefs.

My father, by contrast, literally fizzled out. The stress and anger of his early drinking years had given way to a very genial cheerful old man who loved his grandchildren and was always the peacemaker in any situation. On our last holiday, he wore shoes saying, "Don't worry, be happy." That is how he died.

One death that affected me profoundly – possibly because it was so premature and he was such a decent man – was not a patient nor a member of my family, but a colleague. He had a fearsome intellect and later became a professor. He and I had co-authored two books – the one of which I am the proudest was titled *The Human Effect* and is about how doctors can maximise their healing effect beyond pills and potions. Kieran had been exposed to asbestos while walking in the underground corridors of his medical school and developed a form of cancer that was incurable and from which he knew he was dying. Nevertheless, he continued his work with a new intensity.

He was teaching young GPs on a leadership course in London and asked me if I would come for an afternoon to tell my story and be questioned by the students. I was flattered that Kieran should have chosen me, but he did warn me that he had done it once or twice before and it would be a challenging experience. I set off to London armed with advice on how to recruit staff,

writing and making speeches and all sorts of anecdotes, which I thought would be helpful to young leaders. No sooner had I finished what I thought was 'my story' than Kieran, as perceptive as ever, began to pick out bits that I hadn't noticed or even realised that I had said. His interest was in the 'why' questions. "Why did I want to be a leader – for what purpose?" I thought that I had given all sorts of reasonable explanations. Cross examination followed by questions from his students gave me an entirely different but truer story. I had a chip on my shoulder from having not achieved at school (apart from academically) and an even worse one because I had not felt myself to be the intellectual equal of many of my colleagues at Oxford. I was simply a little man trying to prove himself. After my session 'in the psychiatrist's chair' I asked Kieran as he escorted me to the lift whether his other victims also had so little self-knowledge. He smiled and said that it was often the case, which is why he had warned me to be in for a surprise. It was the last time that I saw him alive. His passing served as a gentle reminder of how little time we have to justify our presence on this earth.

◻ ◻ ◻

We were now settling into our house by the river. It had no foundations and no damp course. All our savings went into a constant battle to stop it from falling down. When the children complained that we never went on holiday we replied, "Yes, but you live here."

It was a medieval house which had housed the visiting Abbot from Glastonbury when he came to view his lands in this part of Devon. It was beautiful but impossible. It had a parlour, buttery, tiny hall, leaking cellar and a kitchen. The latter was separated from the house by a small corridor because, traditionally in medieval times, kitchens were constantly burning down.

We had been in this idyllic place for three years when something terrible happened. I can remember the events in slow motion. Joanna had complained of being tired but fatigue was a constant during our early years in general practice. It was Finn's fifth birthday and May's third – their birthdays falling a week apart.

We had hired Uncle Maurice. He did children's parties with a very professional Punch and Judy show and had excellent rapport with the children, though it was obvious to any adult watching that he found children extremely irritating. Halfway through the party a deer leapt into our garden and was racing around the window outside, distracting the children and Uncle Maurice. After the party Joanna seemed more exhausted than ever and then going upstairs the sunlight through the landing window caught her eyes. They were turning yellow. Memories of the clatter and our babysitter's son all rushed through my mind. Joanna had jaundice. Worst still, she had painless jaundice and most causes are serious – many fatal.

During the next few days she developed vomiting and diarrhoea and seemed to be disappearing in front of our eyes. Our excellent GP sent a specialist. "She will have to come into hospital," he said. By this time she was so dehydrated that it was almost impossible to get a line into her veins to give her intravenous fluids. The house physician made three attempts, then I grabbed the needle much to his distress. Having worked on the special care baby unit, I was confident of getting needles into any adult veins. I too failed three times before the house physician eventually saved the day. In spite of intravenous fluids and various medications, Joanna was getting visibly worse. By that time we knew that she had hepatitis A, which almost invariably has a good outcome. But things weren't going to plan. On her third day, our consultant – ever smiling and positive – let

slip that he was in contact with the liver unit at King's hospital. "Does that mean a transplant?" I asked.

"Possibly," he said. Then correcting himself he added, "Extremely unlikely. It's just that she doesn't seem to be responding and we need to be safe."

By this point, Joanna was feeling so ill that she didn't care if she lived or died. As I held her hand, I contemplated the worst. Why hadn't I picked it all up earlier? Why hadn't I taken her complaints about feeling ill and tired more seriously?

Then slowly, day by day, she began to improve. The grave faces of her doctors became smiles and the vomiting stopped. Then at last she no longer needed intravenous fluids and started taking fluids and began to smile again.

Back at our house, she took great comfort from seeing the garden and hearing the birds sing from our bedroom window. The hospital had cured her, but being in her own bed and seeing the children now healed her. Peace was restored to our family and home.

BIRTH

My mother groaned, my father wept,
into the dangerous world I leapt.

William Blake

Three years after recovering from hepatitis, Joanna was once again being sick and losing weight. A positive pregnancy test told us why. She was forty and had become what was called 'an elderly primip'. We were dispatched to Oxford for chorionic villous sampling to check that the baby did not have any chromosomal abnormality. These were the pioneering days of such procedures, and we were not to know that they would soon be stopped at Oxford because of safety issues. We had a non-alcoholic lunch at 'The Trout' near Oxford and then proceeded to the Professor's lab. The Professor was professional and sympathetic as he kept us informed on what he was doing with his needle. "I am now going through your bladder and now you can see the water surrounding the baby….". We peered at the screen watching something that looked like a butterbean bouncing up and down. We began to wonder whether we should have subjected our baby to all of this. It was too late.

◘ ◘ ◘

There were many nights when I would visit one patient who was dying and then, during the same night, would be helping a baby to come into this world. I would then drive home weary but fulfilled watching deer grazing in the fields and badgers scuttling along the roads as dawn broke.

Birth is, of course, a joyful occasion but obstetrics always filled me with fear because I had seen too many things go wrong during my hospital years. Consequently, I approached every birth expecting the worst.

Today, it would be inconceivable to practice at such risk and sometimes beyond our skills. That was the culture. Furthermore, medical papers were suggesting that a birth at home or in our cottage hospital was at least as safe as in a district hospital. You would have been regarded as rather wet behind the ears if you had sent all your expectant mothers to the main hospital and anyway, when you were on call you could still be asked to see mothers and babies of other GP partners. These were very different times, when you had to take more risks because the options that we have today did not exist. Indeed, one of the perceived greatest virtues of a general practitioner at the time was to 'tolerate uncertainty'. That meant being able to cope with doubts without constantly asking colleagues or sending patients to hospital.

I'd had plenty of experience of that during my 'elective', in my last years as a medical student in East Africa. At one point, I had been deposited in a missionary hospital in the middle of the bush, run by catholic nuns and with no doctor. It was a hillside station with muddy impassable roads and flies everywhere by day that gave way to squadrons of mosquitoes at night.

For a young medical student it was exciting and very much learning 'on the hoof'. It was equally terrifying whether treating tropical diseases, like typhoid, which I had never encountered before, or operating using the missionary doctor's surgical manual as the lights went on and off depending upon the prevailing mood of the hospital's faulty generator. One of the nuns would hold the flying doctor's operating manual in front of me as I chopped away. It had an irritating habit of mentioning

things rather too late. As you turned the page and had moved on to the next stage of the procedure, the text would read 'Did you remember to count the swabs before stitching up?', 'Before proceeding make sure that you have ligated the x artery...'.

There were plenty of difficult deliveries and I was presented with impossible situations and decisions. One of these was a frightened and tearful mother brought in by the police with a dead baby, crawling with maggots, and being asked to judge if it had died naturally or not. There were very strict penalties if she had been responsible for the baby's death. I concluded that it was impossible to tell one way or the other. This was true but mainly because I had neither the skills nor experience necessary to make a decision and, anyway, I didn't want to be the cause of further unhappiness for this unfortunate woman. The nuns and I were frequently well out of our depth and we had to develop nerves of steel which prepared me well for my life as a country doctor in Devon.

I had also been well taught in obstetrics during my junior doctor rotation at the Royal Sussex and County Hospital in Brighton. This required me to work a 'one in two' (one night in two, one weekend in two and five days a week...) with another doctor, Jonathan. Jonathan had a wrinkled and permanently worried-looking expression, which meant that midwives would normally call me when problems occurred because 'they didn't like to trouble Jonathan'. I am still not quite sure whether Jonathan was as worried as he looked.

One of my duties as the senior house officer in gynaecology was to paint the insides of each of my female patients with Gentian Violet before the morning consultant ward round. This was a blue dye, which would end up all over my gloves and the patient's bed. It was designed to prevent them from getting vaginal thrush. It would be regarded these days as a rather odd

and dubious procedure and I strongly suspect that I was the last doctor ever to perform it.

I found obstetrics to be terrifying with moments of exhilaration tempered by a permanent feeling of exhaustion. On the one in two evenings that I actually got home, our one-and-a-half year old son, Finn, would either kick me or ignore me altogether. Punishment for my absence! Joanna and I would take him for a walk in the park with his toy dog on a lead – frequently mistaken by old ladies with poor eyesight as a real dog. We were struggling financially at the time and on one occasion had to sell some silver name plates that we had inherited so that we could go out to dinner away from the hospital – albeit with baby in tow.

It was during a particularly exhausting stint on call that I found, for some unknown reason, that I only had a green biro in my pocket. I used it to fill in patients' notes and operation reports and thought no more of it. The following day a terse note was handed out to us all from 'the management' saying that 'someone' was using green ink in the notes and that this was specifically against the rules of the hospital and 'the practice should be discontinued at once'. I mentioned this to my registrar and consultant, who reacted badly – seeing this as an unprovoked attack on their senior house officer – and who then went off to buy green pens for themselves. These were then universally used by the obs and gynae team for the next few days. Disappointingly, in spite of this provocation, no further missives came from 'the management' and eventually we all reverted again to using whatever pens we had in our pockets. A few years later, as a GP in Devon, I was to further infuriate the management of that particular hospital – perhaps they had not forgiven the sins of my youth. It was around the time that doctors were being told that they shouldn't wear white coats or ties on wards because of the risk of them spreading infection.

Personally, I couldn't see the problem provided that white coats were clean and kept on the wards rather than worn out shopping or cleaning the car.

Anyway, I wrote a letter to *The Times* saying that though there might be a case for concern about ordinary ties (the ends of which could float just about anywhere – especially when doing obs and gynae examinations); there should not be a ban on bowties (which I wore) as they had been shown scientifically to carry far fewer bacteria than ordinary ones. Quite unbeknownst to me, several staff at that same hospital started wearing bowties, for which I was seen as the instigator even though I was then working at the other end of the country. I received a note from the medical director saying that my letter to the press had been 'unhelpful'.

◌ ◌ ◌

One of my fellow GPs once told me that there is no need to rush to a home or hospital delivery because if it happens before you get there then it is probably OK and if it hasn't, then you may be required. He was right. Babies, like lambs, invariably come at night. It was at the difficult deliveries where I had to spend extra time. There was the stress of helping the baby to come out and often biting my nails as to whether to enroll the help of a more experienced colleague. This would often be followed by more extensive stitching and sometimes needing to resuscitate the baby as well. After these most prolonged efforts, the mother would sometimes turn to me and say, "What's your name doctor?" and the baby would be called Michael. These Michaels had always been born under the most difficult of circumstances and I watched over the years with trepidation to see how they would grow and if they would ever pass any exams or get jobs. Fortunately, most did.

One of my medical friends was less fortunate. He was called

Nigel and after a similar experience the mother asked him his name and he told her. She simply shrugged her shoulders and said, "Well, perhaps I'll call him Trevor."

Happy mothers and rosy-faced crying babies are a delight but the constant fear of what might happen gave me many sleepless nights. My younger fellow GPs and I are fortunate that obstetrics is now a largely district hospital-based activity and, in the community, it is led by very competent midwives. I miss the close relationships between doctor and young mothers but not the stress of feeling never being fully up to the job.

At the time that I entered general practice it was becoming common for fathers to attend the birth. This was a mixed blessing. One delivery at the local cottage hospital started well with a rather confident father telling both mother and I how much he was looking forward to it all. Things did not go so well and when I told mother that I was going to need to use forceps, her husband was horrified and went a whiter shade of pale. Nevertheless, he darted about telling his wife, me and everyone else not to worry. That was before he slipped on the gore and blood lying beneath my feet, fainted and ended prone on the floor beneath me as I began to pull the baby out. While mother screamed, husband regained consciousness and we heard this whimpering voice lying on the floor beneath us continuing "Don't worry… everything is going to be all right…".

Home deliveries were a great pleasure when they went well. One that I did not look forward to was a young lady who insisted on a home water bath delivery, which was very popular at the time. I explained that I had never done one of these before but she wasn't to be put off. As luck had it, I was on holiday when the birth occurred and the Irish locum doctor that stood in for me was more than gracious about my letting him in for this. "The only problem," he said to me languidly afterwards, "Is that it

was rather difficult to find the baby in the cloudy water."

During my six months as a senior house officer on the special care baby unit, we were told to prepare for the delivery of a mother, who against all probabilities, had naturally conceived quadruplets. Inconveniently, she went into labour on a winter's night when heavy snow was preventing any movement on the roads. The senior doctors in obstetrics were unable to get into the hospital. A locum registrar (junior doctor) had to do an emergency caesarean, while I (a mere senior house officer) nervously switched on four resuscitation units for the expected premature babies. Fortunately, John, the senior pediatric consultant, lived nearby. Nevertheless, each baby as it emerged required intubation (a tube inserted directly into the lung), and we had succeeded with three of them and were just starting on our fourth as our senior registrar burst into the labour ward. Uncharacteristically, for a man with a temperate personality, he had risked the deep snow and shot through the last two sets of red traffic lights to come and help us. All was well in the end. I later had a photograph taken of myself with the four babies by the local newspaper. I keep it to this day. Recently I met all four of them – blonde, healthy and successful women now past their mid-thirties.

I felt especially fearful, when my own excellent midwife became pregnant herself and asked for a home delivery. It was a request that I could hardly refuse although she lived in a fairly isolated farmhouse many miles from the main surgery. I was happy to deal with any eventuality as far as babies were concerned and set up the incubator in her farmhouse. It was the delivery that concerned me and I watched nervously as her colleague midwife encouraged her to push. I remember poor Milly's reddened face and pain in spite of the gas and air and counting the minutes as the baby failed to appear, but all was well in the end – a pink and screaming baby and another night's work done.

My very last home delivery was a few years ago on a very hot summer night – another favour to a patient who was very keen for her last baby to be born at home. She lived close to the main street and there was a crowd gathering beneath her bedroom window to hear the outcome. As I arrived, there was a hush as most of the street were waiting expectantly beneath where the baby was to be born. Fortunately, all went well with a bonny screaming baby. I had actually had very little to do for mother or baby but was feted as central to the whole scene. Once the birth had occurred there was a cheer in the street as mother appeared at the window with her baby – just like the *Lion King* – to smiling faces and clapping hands in the street below. They then demanded encores from father, midwife and finally myself. It was an unforgettable scene of joy marred only by the parents separating just a few years later. It further encouraged me to keep a fatherly eye on the product of that night, who is now a young schoolteacher.

Delivering babies, attending the sick and dying and being responsible for emergencies creates an intimacy with individuals and the community which is long-lasting and good for both clinician and patient. Today's doctors have more time with their own families – necessarily so, as the era of the full-time working GP and GP's wife at home is just about over – but the connection and mutual respect and affection between doctor, patient and community is weaker than it was. This may have everything to do with doctors finding their work less satisfying and some patients finding their doctors less caring or available, while litigation bills soar.

❑❑❑

Following the biopsy at Oxford, Joanna's pregnancy went well until its later stages. She became increasingly exhausted and

uncomfortable and the baby seemed to be moving less. We were getting concerned. Our local GP obstetrician saw Joanna and decided that she should have a caesarean in the local cottage hospital on the following day – 13 November. Our third child was delivered safely by the GP obstetrician and GP anesthetist – the last caesarean at our cottage hospital. It may have been just in time as the afterbirth showed signs of damage – possibly an effect of the biopsy in Oxford.

We were going to call her Melissa but the Berlin Wall had just come down and therefore 'Liberty' seemed more appropriate.

Looking after the remaining two children, while Joanna was in hospital with Liberty, made me aware of my own shortcomings as a father. I took Finn and May out for a meal at the café in Cullompton and on our way back we passed Batten's shoe shop. In front of the window we saw some patent red leather children's shoes with gold stars. May insisted that we went into the shop so that she could try them on. They could not have fitted her better than if she was Cinderella. "Are you sure that they will let you wear these at school?" I asked my six-year-old daughter.

"Oh yes, Daddy," she replied. "We can wear any shoes that we want."

We bought them. Mr Batten was elated.

When I arrived at the hospital that evening, I told Joanna rather proudly how I had bought May some new shoes for school. "You haven't bought those red shoes in Battens?" she asked. "May tried to get me to buy them for her last week. They are only allowed to wear blue or black shoes in school. Didn't she tell you?"

Chapter 7

MADE MAD

They make noises, and think they are talking to each other:
they make faces, and think they understand each other.
And I am sure they don't.

T.S. Elliott, *The Cocktail Party*

Georgi Markov, a Bulgarian dissident, was assassinated in 1978. He was killed by a pellet fired from an umbrella by someone associated with the Bulgarian secret service. Around a month later my mother was planting wallflowers at the front of our Devon family home. I was in my last year of studies at Guy's Hospital. Her gardening was interrupted by a police car with blue lights flashing and sirens blaring. It raced past her to the front door of the house whereupon two policemen sprung out and entered before she had had time to put down her trowel. An hour later an ambulance, once again with lights and bells raced towards our house. Shortly afterwards they left with my younger brother David, then aged twenty-four, on their way to the local psychiatric hospital. The police had appropriately responded to his telephone call. He told them that he had been assaulted by the woman who ran our local pub. She had fired a pellet at him from an umbrella – in exactly the same way that Georgi Markov had met his death. It wasn't long before the police had worked out what was going on. It was quite a relief for David when the ambulance came to take him away, safe from any other would-be assassins.

Until that day, David had always been his own person. It was in his early twenties that reality and imagination finally parted

company and a diagnosis of paranoid schizophrenia was made. Where had it come from? Who or what was responsible for it? As his closest sibling (I was fifth and he was sixth) I naturally questioned my own role in his illness. David doesn't seem to. He was even gracious, when he was put in jail one night as a student for setting light to a pneumatic drill. It had been causing considerable noise by day and the workmen had left it outside that night. It was 3am when the police telephoned me. I asked them, "Is he drunk?"

"Yes," they said.

"Then please let him out and I will vouch for him, but perhaps you should wait until he is sober," I suggested.

The latter remark was apparently relayed to David but he never seemed to have held any grudge. He was best man at my wedding and later appointed me his guardian. To this day, he continues to live independently largely thanks to my elderly mother, sister and brother-in-law, a woman friend, the lady that runs the post office and café and his kind next door neighbours.

It is very easy to judge mental health patients particularly when they are difficult, angry or dangerous. David has given me a very personal perspective on psychosis. He rarely needs to go to hospital now and is happy for me to speak to his psychiatric nurses and doctors.

His stories about 'life on the ward' are as hilarious as they are pitiful. A few years ago, the health service ran out of his rather outdated medication but changing to a more modern prescription proved disastrous. He had to be admitted to hospital in a highly distressed state. I visited him on the ward with Joanna only to find him in a state of despair. He had only just been made Prime Minister and was trying his best to run the country. The ward staff weren't helping because they were refusing to let him speak by telephone to various world leaders

and he was particularly keen to talk to the current President of France. He had all the responsibilities of the world upon his shoulders and no one was helping him to carry them out. He introduced me to the other patients on the ward. They told me that I should treat him with great respect. I asked why. They informed me that only the previous day he had thought that he was a dog. His barking had so upset staff and some of the other patients that he had to be locked in a solitary padded cell for twenty-four hours. This had earnt him a badge of honour and much admiration from fellow patients.

When Joanna and I visited the hospital, they had at last managed to get hold of his original tablets. They didn't seem to be helping much yet. Joanna's chocolate cake, which he demolished in front of us in one go, seemed to have a calming effect. As we left, he whispered to me "I don't have to run the whole country, do I, Michael?" Things appeared to be improving.

Like most schizophrenics, David's interesting stories, unrepeatable jokes and unpredictable behaviour are punctuated with constant worry. His daily activities are continually relayed by radio to the whole of Europe. He has to keep a constant guard. Uncertain as to who might be listening in on his telephone, he rarely answers it, which makes it all the more difficult for those involved in his care. He is happiest with those that make the least demands. My children Finn, May and Liberty are very fond of him and his eccentricities. I see shadows of his former self when he is laughing with them. He is no longer a mental health patient and simply becomes 'Uncle David'.

◻ ◻ ◻

When I was young, we children were allowed to read the *Daily Sketch* – a popular tabloid at the time. I was an avid reader and one day I came across an advertisement for a book, *Improve your*

Memory. It was quite an expensive book and I had to use up all my pocket money to buy a postal order and send off for it. When it arrived I read it carefully page by page and was amazed that it worked. Like many books of its kind, it taught you to develop a pyramid of associations and probably contributed to my being able to develop a virtually photographic memory in my twenties- so necessary for taking in the reams of largely useless facts that I was later required to learn at medical school.

At university, my interest in the mind wandered beyond the rat experiments which dominated teaching in psychology at the time. I was reading Freud and Jung and enjoyed psycho-analysing my friends and interpreting their dreams. This had a variable effect on potential girlfriends but may have helped me to start confronting some of my own demons. At one point I thought of becoming a psychoanalyst, but a wise psychoanalyst father of a friend of mine advised me to do a medical degree first otherwise I would always be at the beck and call of the medical profession. It was good advice and anyway, by that time, I had decided that the certainties of psychoanalysis were no more firmly based than so many other 'received truths'.

At medical school, I loved psychiatry and the wise Professor of Psychiatry at the time would allot each of us a psychiatric patient with whom we would be in contact with for several weeks. Mine was a young man who had cut off his penis and quite literally thrown it away (down a rubbish chute). The divide between the educated, well-spoken and cheerful medical student and the suffering of a Bermondsey boy with little hope seemed literally impenetrable. Gradually I began to understand why he had done this terrible act and he taught me the truths of deep psychological suffering and the inexplicable actions that can arise from it. I also began to learn the complexities and ambiguities of the therapeutic relationship. I became emotionally involved

and things that had seemed otherwise important in my own life no longer seemed to be so. My patient's actions seem so much more a failure of society than the actions of a free man. When I discussed progress and new revelations with the Professor, the patient was very much the patient. When I was with him, I was with a friend.

About this time, I became fascinated by the celebrated psychiatrist, R.D. Laing, who had surprised the world by opening the doors of the locked wards of the Glasgow Psychiatric Hospital and found that nothing terrible had happened – in fact many patients had begun to improve. His theory, described in *The Divided Self*, was that psychiatric diagnosis was often political – a way of the sane and successful being able to separate themselves from their brethren who did not behave quite like them. He was to influence my attitude to schizophrenics but also to all my patients, when I entered general practice. He wrote:

> One has to be able to orientate oneself as a person in the other's scheme of things rather than only to see the other as an object in one's own world, i.e. within a total system of one's own reference. One must be able to affect this reorientation without prejudging who is right and who is wrong. The ability to do this is an absolute and obvious prerequisite in working with psychotics.

He was ahead of his time and his message was relevant to every interaction between a doctor and their patient.

I was so fascinated by his work that I invited him to our debating society at Guy's Hospital and dinner afterwards with the professors. He was clearly bored at the dinner and halfway through he stood up and announced in his strong Glaswegian accent, "I can no be doing wi all of this," and then looked across

the table to me and said, "Are ye comin wi me?" I was presented with a dilemma. Should I be seen to side with our ungracious guest and leave the professors round the table halfway through the dinner and possibly jeopardise my future clinical career? Alternatively, should I side with the medical icon, risk everything and embark on an adventure into the unknown? I got up from the table, apologising ineffectively to those at the table, and that was the beginning of an unforgettable evening. We visited a pub and then visited his home, where I met his family. This was followed by a tour of several other local pubs, which stayed open for their VIP visitor. He had a very high media profile at the time. We talked about the tragic death of his daughter from leukemia which had hit him very hard. He had ten children by four mothers. He was brilliant and witty but vulnerable and died relatively young – aged sixty-one. Needless to say, that misspent evening taught me more about psychiatry and how medicine needed to change than any lecture that I could ever have attended on the subject.

◻◻◻

Before entering general practice, I had done six months in psychiatry as a senior house officer just after our first child, Finn, was born. The patients lived on a different and sometimes more interesting planet. There was a Devon farmer called Ken. He was short, quietly spoken and immaculately dressed in a tweed suit. He told me that he had had to build the Cathedral in Exeter entirely on his own. In fact he had to do so twice because apparently there had been a fire and he had been asked to rebuild it. Recently things had got out of hand because monkeys were taking over his farm. They were interfering with his work and driving off in his tractors.

Graham was a troubled man and an excellent carpenter.

His delusions had led him to conclude that he must kill his much-loved father, who was dying of a brain tumor. One lady, seemingly normal in all other respects, had been told by the devil to throw herself down the stairs. Another patient was a rather dishevelled man, past his prime, who spoke in tongues. He was convinced that the key to restoring his sanity would be to have oral sex with his rather matronly and respectable wife, Betty. The latter was a sensibly-dressed lady with thick tortoiseshell spectacles, which gave her an owlish look. Mediating between them on this issue of oral sex took me well beyond any medical school training. There were voices everywhere. People trying to control us. For most there was almost constant fear.

The nurses on the psychiatric ward seemed to divide into two categories. The first, I called 'The Jailers', who completely detached themselves from the patients and saw their role simply to contain inappropriate behaviour and violence. They regarded the patients as just incurably mad. The others were 'The Angels', equally as confused as everyone else but empathising and comforting even when they could not help. My boss, the consultant psychiatrist, seeing my frustration at not being able to help said to me one day, "Michael, the best thing to do when you can't understand what is going on and you don't know what to do, is simply to be kind." Ever since, I have tried to follow this simple but profound advice.

One of my duties was to lead the morning group therapy sessions. With their long silences, unconnected sentences and sudden cackles of laughter or unexplained tears, they would not have been out of place in any Harold Pinter play. I am not sure if they did anyone any good but they did seem, at least, to have some bonding effect. At the end of one session a patient remarked that if I was to know all about them, then surely they should know a bit about me? Consequently, when Joanna and

I had our first baby Finn, they insisted that we should bring our newborn baby to the Christmas party.

The party was held on the ward and, unbelievably for these days, there was plenty of alcohol. Joanna looked horrified as our tiny son was cuddled by patient after patient, fearing for what the mix of psychiatric drugs and alcohol might do. Our fears grew worse as the music started and patients took it in turns to waltz with our precious new baby. Perhaps we shouldn't have been so concerned. Our grandchildren still play today with the wonderful presents that the patients gave our son that evening.

I enjoyed my days in the psychiatric hospital and gained invaluable experience. But too many patients seemed to be incurably broken. I wanted to see if it was possible to be effective at an earlier stage and that was one of my reasons for entering general practice.

When I started as a young GP, I found that all these experiences had normalised my view of psychiatrically ill people. I was reticent about using drugs or recommending ECT (electroconvulsive therapy), or any of the other current treatments provided by the medical profession. In hospital, I had particularly hated having to apply the ECT electrodes to the temples of each patient on Tuesday mornings, while the anaesthetist injected the terrified victim. I realised then what it must have been like to have been an executioner. These primitive treatments seemed no more than an apology for having nothing really effective to offer.

When I subsequently entered general practice, I probably empathised with my psychiatric patients too much for their or my own good. When I saw patients, who felt that they were changing sex or hearing voices, I would happily analyse and understand them but without giving them any useful treatment.

One of my first lessons in general practice was to realise that there actually were mad people. It wasn't judgmental to think in this way but it was unkind not to treat them with the, albeit inadequate, available drugs and procedures. This dented my confidence and I even began to question my own sanity.

A few months after I had started in general practice, I received a call during afternoon surgery from a very distraught young lady. "Doctor, you must do something. These fumes are getting up my nose, my head and my chest and I think I am going to die."

"What fumes?" I asked.

"The fumes coming from the greenhouses next door (there were several local market gardens) and I can hardly breathe."

The most difficult decisions, in medicine and elsewhere, are those where there is no right decision. The least wrong decision on this occasion seemed to be to take the patient at her word and leave yet another full surgery to investigate. What I found was a frightened young lady with a wealth of delusions ('fumes' are actually quite common) and convinced that 'they' were about to get her. Having satisfied myself that there was no physical problem, I was then able to hand her over to our then very effective psychiatric team. She continued, however, with her delusions but much happier and in a slightly detached manner.

She told me quite cheerfully one day that the voices had now told her that she would have to kill me and that she was keeping a special knife in her handbag, with which she was going to murder me one day but only when the time was right. She would often take it out casually during our consultations, show it to me and then stroke it gently, while explaining her problems and asking my advice.

Fortunately, she lived in a housing estate with a strong sense of community, whose residents tolerated her knocking on their

doors at odd times of the day and night to tell them about the all-pervasive fumes. The community would keep me informed if things were getting out of hand. To my own discredit, I had diagnosed her incurable cancer at rather a late stage. Helping her was made all the more difficult by her rejecting both the diagnosis and proposed treatment and declaring that 'they' were now controlling me. It wasn't going to be curable anyway and I was allowed to visit even though I had gone over to the enemy. This likeable woman died gracefully in her forties. She had a nice smile and there was never any intended maliciousness even when she told me, quite matter of factly, that one day she would have to kill me.

Malignant neighbours spying, drilling and trying to make the sufferer's life as uncomfortable as possible are almost as common as delusions of fumes. The accusations are, of course, sometimes real but mostly not. For some time, Vera, who was aged one hundred and one years, had told me that the people next door were listening through the wall day and night, talking about her and plotting to kill her. I knew her neighbours well and judged this as extremely unlikely. Over many years, reassurance and a night-time sedative seemed to have kept the problem in hand. Then she started calling the police at odd times of the night saying that the neighbours were planning to murder her. A police sergeant rang from the station asking what I was going to do to stop this. I went round to see Vera with no particular plan in mind. I decided to put it as it was. "Vera, I know that you have these fears. They are not real and if you carry on ringing up the police then I am going to have to treat you and you will end up going into an old people's home." Remarkably it worked. During subsequent visits, she would tell me how awful things were but she had decided that being murdered in her bed was far preferable to going into an old peoples' home.

June, who lived in another village, found herself being controlled by the electricity pylon outside her house. Her controllers were clever people because they only started their work by turning the controls on at 2am and then turned them off before anyone came to see her in the morning. Her neighbours came to see me to say that I must do something as they were being disturbed at all hours because of her fears about the electricity. Subsequently one of her friends, whose judgement I did not altogether trust, was persuaded to stay overnight. She declared that June was absolutely right and that there were sparks and crackles in the middle of the night. Electricians called and found nothing. Then, fortunately, 'they' decided to control her through electricity during one of my afternoon home visits. "Listen, there they go." June sounded jubilant and watched me carefully for a reaction. I had to tell her that I could not hear or see anything and it must be 'all in her mind'. She never accepted my judgement and, as is often the case, tablets didn't help. I reverted to the advice that I had given Vera: "If you carry on troubling your neighbours and ringing electricians then they will want you to go into a home." It worked.

Old ladies with delusions are rarely dangerous, but one patient that brought me much closer to meeting my maker was a local farmer, who was holding his wife at gun point on a Saturday afternoon. I knew them well. One of their friends had phoned me saying that she was afraid that he was going to kill his wife. I arrived at the farm and nothing seemed out of place. I was eyed suspiciously by the two stray cats in the hayloft and welcomed with friendly licks from their ageing sheepdog before I got to the kitchen door at the back of the house. Inside there was the familiar smell of cow dung, but as I entered their sitting room it was clear that something was very wrong. Percy was sitting

in one armchair with a fully loaded shotgun pointed at Ida, his wife, sitting in the armchair opposite. "I am going to kill her doc – you can't stop me," he said.

"Why are you going to do that?" I asked.

"I just can't take it any more – it's all too much."

I looked at Ida. She shrugged her shoulders and told me that she had no idea what was going on. Everything had been perfectly alright only an hour before.

I decided that it was time to use my 'sapiential authority' as a doctor to get the situation under control. "Percy – put down your gun at once! If you shoot Ida you will go to prison and anyway she hasn't done anything!" Percy looked at me and then slowly rotated the gun that had previously been pointing at Ida to aim it at me.

"Doc – if you stop me shooting Ida then I am going to have to shoot you too," he replied.

Using my authority had not worked. We sat in silence just staring at each other. Being on the brink of non-existence was slowing down my ability to produce a new plan. Fortunately, it wasn't required. Quite suddenly he burst into tears and as the gun moved away from my chest, I was able to take it and unload it. Percy and Ida died many years ago and apart from removing his gun and ensuring that he never had a gun in the house again, I didn't do anything more. Percy seemed equally perplexed as to what had happened and life returned to normal. I have no idea, to this day, what it was all about.

It's not only patients that wave guns about. There was a single-handed practice neighbouring our own, which was run by a very caring, respected and competent GP. Overwork and a succession of very sick and dying patients had stretched him to his limits. One evening he was sitting in the kitchen beside his wife, who was topping and tailing gooseberries. The telephone

rang. Single-handed doctors were permanently on call 24/7. "Don't answer it," he said. He left the kitchen and reappeared just as the telephone started ringing again. This time he was holding a shotgun. "Don't answer it," he commanded again. "If you do I'll shoot you and then I'm going to shoot myself," he said. He then abruptly left the kitchen and went out into the garden in the dark. A few minutes later his wife heard a gunshot. Assuming the worst, she went out into the garden and found him intact but shaking. Fortunately, he had simply aimed the gun at the sky. His quick-thinking wife then telephoned the three senior partners in my own GP practice, who came immediately and offered to take over his patients and practice from then on, much to the relief of the exhausted doctor and his wife.

Later, in old age, the same doctor became a patient of mine and his wisdom, expertise and ability to self-diagnose vastly exceeded my own skills. He called me early one morning. I knew it must be serious. He had contracted pneumonia. "You will have to go to hospital," I said.

"There is no point, I am going to die anyway," he replied.

"Hopefully not," I replied lamely.

He was right. After his death, his son found a note in his desk describing the qualities of an ideal GP:

Generosity he has, such as is possible to those who practice an art, never to those who drive a trade; discretion, tested by a hundred secrets: tact, tried in a thousand embarrassments and what are even more important, Heraclean cheerfulness and courage. So it is that he brings air and cheer into the sick room, and often enough, though not so often as he wishes, brings healing.

His wife, the one who had been topping and tailing gooseberries

at the time of his crisis, went in similar fashion a few years later. Though frail, there did not seem to be anything acutely wrong, when she told me with a smile on her face that she was dying, which she promptly did during the following night. I have learnt that when people say they are going to die they almost invariably are. The opposite does not apply. I can think of too many patients, who have said something like "I'm hardly going to die", and then did.

One of the problems in a world of delusion and sometimes violence is that you can get it wrong. One summer Sunday evening, on call, I was telephoned by a young man in a local village. He said, "Doctor, I need you to come quickly. The President of the Congo has sent his men and is trying to kill me. I have locked myself in the upstairs bedroom of my cottage. Please call the CID (Criminal Investigation Department) and ask them to come with you as soon as you can." It was clear that we had a disturbed man on our hands, but it was very convenient that he had asked me to bring the police. In those days, if you wanted to 'section' a patient (enforce admission to a psychiatric hospital) you had to get a signature from the local social worker and a doctor with specialist qualifications in psychiatry. Both would generally live many miles away and it could take many hours waiting for them, with the added stress of being unable to attend to other patients with urgent requests. The alternative to the normal section is known as 'Section 136'. This allowed a policeman alone to section a patient if he or she was in a public place. Then the patient could be transferred to hospital right away and without delay. But only if he or she could be tempted onto the street.

It seemed certain that this patient would need admission. My plan was to use Sergeant Cragg to lure him on to the road outside his cottage and then we could section him and send him to hospital. Things did not go exactly according to that

plan. Sergeant Cragg and I proceeded in an orderly direction to the village. Finally, we came to a row of pretty red brick cottages covered in pink roses. It was easy to detect the one in which our victim lived by the shouting coming from an open upstairs window. As he saw myself and Sergeant Cragg in police uniform he shouted "Who is that with you – I told you to bring the CID." Pointing at the Sergeant he said, "Are you the CID?"

Sergeant Cragg yelled a somewhat disappointing but unforgettable reply: "Sort of."

"Well that's no good," said the patient, "I need the proper CID!" With that he slammed the window shut and we heard him bolting all the doors. We had no good reason to make a forced entry so Sergeant Cragg and I retreated, accepting defeat.

The following Monday morning, I explained to one of my GP partners, who was his doctor, how we had found it impossible to forcibly admit his patient to hospital. "It's just as well you didn't," he said. "The President of the Congo is trying to kill him. He was a mercenary there many years ago and he came to Devon hoping to start a new life."

Nor is it always the patient that is mad. The O'Looneys (their real names), Sid and Cynthia, lived in a two up two down terraced house in New Street. They were good humour personified and Sid always greeted me with 'O'Looney by name and O'Looney by nature'. Cynthia's memory was going a bit and Sid asked me to visit as she was no longer very mobile. I entered the house to the booming sound of opera music (Sid was very deaf). "Thanks for coming," he said in his usual cheery voice. "Call her Jeannie."

"You want me to call her Jeannie?" I shouted as the music reached a crescendo. I was confused now.

"Yes, yes, Jeannie" he replied. "Please come through doctor."

Sid was a well built and very down to earth man. I assumed that he had his reasons. Cynthia was as frail as he was solid. Throughout the consultation and my subsequent memory tests I called Cynthia 'Jeannie' just as I had been told. She seemed a bit perplexed but I assumed that was because of my long and confusing memory tests. It was only as I left that I realised that it had been my own hearing that was at fault. As the music continued to blare, Sid smiled and said, "PUCCINI, wonderful music isn't it, Doc." He had never said "Call her Jeannie".

My deafness on that occasion had a similar negative effect to that on another occasion, when I had been very late home without warning Joanna of my delay.

"Where have you been?" she asked.

"Very well thank you," I replied to what I had heard as 'How have you been?'.

"You are deaf as well as stupid," she said tersely.

Young Finn was playing with his toys in the corner. He looked up, concerned by this parental altercation, and remarked "E's not deaf."

There are the very mad and the partly mad. Dorothy was definitely a member of the completely mad. We'd had to section her when she had been found on the main street of the village trying to direct the traffic wearing no clothes at all. She was unusually and fortunately one of a rare breed of those, who are potty but happy and no danger to themselves or others. She was protected by a very capable only daughter, Ann, until she died of old age. Ann was as sane as her mother was mad, until a day or two after the birth of her first baby. It was then that the voices started. At first it was just her husband, and then myself and then all of us became a grand conspiracy around her. Postpartum psychosis is sudden, frightening and very dangerous. Fortunately, our local psychiatric hospital had recently introduced a mother

and baby unit and Ann was quickly healed. She and her growing child have thrived ever since.

Quite often it can be difficult to decide if a person has a mental or a physical problem. Patients sometimes recognise our dilemma. During one consultation, a young man explained to me: "You doctors weren't sure what I'd got. Dr X thought it was my kidneys because I had pain in my side but Dr Y said that it was all in my mind. Clearly Dr Y was right because the next day, can you believe it, I was rushed to hospital with a suspected nervous breakdown."

The phrase 'nervous breakdown' is commonly used and everyone understands what it means. Surprisingly, it is not part of the medical lexicon, which would translate this into 'acute anxiety' or 'acute stress' or 'psychosis'. I have witnessed many unexpected nervous breakdowns in my time. Headteachers and policemen, in particular, and on one occasion a vicar just before Christmas midnight mass. His wife phoned me in a state of some agitation herself. He had announced he wasn't going to do that evening's church service and was planning to leave the area that night. Leaving my own wife and family late on Christmas Eve to see him was not how I had chosen to spend the evening. Fortunately, Joanna is the daughter of a vicar herself and she understood why I had to go.

☐ ☐ ☐

Though I enjoy the challenge of seeing patients with psychological problems like my brother David, I am not always as sympathetic as I should be with patients that have alcohol or drug problems. My father and elder brother were alcoholics. I loved them dearly, but I hated what the alcohol did to them. During my teens, our whole family was invited to a rather posh party at an airshow hosted by my older brother Patrick's father-

in-law. I was watching the air display but halfway through the show, my mother rushed in, angry and tearful, telling us that we all had to go home. The reason was apparent, when we reached the room where drinks were being served. There were two men lying on the floor, flailing on their backs like beetles. The first was my father, who my mother pulled to his feet before ushering her embarrassed family to our car. The other 'beetle', who my father had challenged to a fight was George Brown, then Foreign Secretary. I was to meet him many years later as Lord George Brown. I had invited him to our Guy's debating society. He was witty, sensitive and generous – like so many, who are too fond of the bottle.

My sympathy for alcoholics was tested during an afternoon surgery with a woman several years later. The patient, once again drunk, was making a fuss about some seemingly trivial symptom but, on this occasion, managed to walk herself to surgery and sit down in the waiting room. By this time, however, the effects of her afternoon binge were escalating as she started upsetting and insulting everyone in the waiting room, vomited all over the floor and wet herself in the chair. There were a number of young mothers with their children who watched the spectacle with great interest. Some patients started complaining to the receptionist. She banged on my door, interrupting a consultation with a patient, and asked what I was going to do. What on earth was I going to do?

The patient concerned lived on her own, had no money, no friends to transport her and was no longer able to walk out of the surgery. The ambulance service told me that it wasn't their problem and the police said it wasn't their's either. By seven o'clock in the evening, there was just myself, the receptionist and a very drunk and now immobile patient sitting in a pool of urine that was now dripping onto the floor. I called the police again.

I used all my powers of persuasion to get them to come and at least have a look. "We will come but I don't think we are in a position to do anything," was the depressing reply.

The policeman arrived. He nodded his head as if to say, "I am afraid you are on your own doctor." At that moment, the patient opened her eyes. The policeman leaned down beside her. "Are you alright dear?" he asked in a cheery and sort of caring voice, as one might with a five-year-old.

"Am I all right, you cunt?" she exclaimed. "What sort of fucking question is that!" she continued.

The policeman glanced at me. "Insulting a policeman!" He then called a colleague, who helped him to carry her off to the police station.

Drugs present ever greater challenges. It is not just the known addict, but also the increasing number of patients with pain and symptoms that seem out of proportion to any known organic cause and who are on morphine or morphine-like drugs. This is a situation that is well out of control in the USA, where this is the most common cause of death in young men, with the UK rapidly catching up. Each day on our 'same day service' there will one or two requests for us to prescribe strong drugs because the addict has lost his drugs or they have been stolen. Sometimes a patient will say that they need more drugs because the pain is getting worse. Some requests are *bona fide* but many are not. The doctor's response often depends upon how strong he or she is feeling emotionally. Refusing these requests can seem insensitive or unkind, but too often these requests for extra drugs are because the patient is supplying them to someone else to make an income for themselves. Just about every drug is readily available on the main streets of our Devon town and in the villages. Dealers come down from Liverpool, Manchester and Birmingham. The quality of the drugs is variable and they are having an increasing effect on

our young people and in schools. We are now seeing occasional fatalities from either a rogue drug or a rare drug reaction. This is creating a malignant sub-culture for which, it appears, there is no apparent solution.

Recently, I saw a young man who had been able to kick his habit. The more I congratulated him on his achievement the more despondent he seemed to become. I asked him why. He told me that he owed his previous dealers a lot of money for his past drug taking. They were insisting that he should pay them back, in kind, by selling their drugs in the town and in local schools. Though he had not looked after himself in the past, he did appear to care about others. The dealers refused his promises that he would pay off his debts in time. A few days previously he had been attacked for failing to get sufficient sales and he was now being issued with death threats if he didn't cooperate better. There was no escape. He told me that they would find him if he went away. It seemed to both of us that the least unsafe option was for him to turn himself in to the police and accept a short jail sentence. Perhaps he could then turn his life around and look forward to a new future. Sadly, I never saw him again so do not know whether he ever managed to escape the clutches of the drug dealers. However, I have been invited to conferences in Brazil and witnessed the claustrophobic grip of the drug barons on the Favelas – housing the most deprived communities in the country. It is horrifying to see the same scenarios beginning to emerge in rural Devon.

Today we are faced with two epidemics in mental health. The first is among our young – not helped by social media and a broken society that seems bent on alienating our young people. In some surgeries today it seems that almost every fourteen to eighteen-year-old girl has visible cuts down their arm or sometimes, more worryingly, concealed cuts down their thighs.

This impression is confirmed by recent research, which shows that a quarter of fourteen to sixteen-year-olds have self-harmed in any one year. Our child and adolescent mental health services are overloaded and turn down more than 50 per cent of the children that we GPs refer to them. In my own GP surgery, we are fortunate to have a retired schoolteacher, social worker, school nurse and health visitor, who have clubbed together to offer a voluntary service for such children and families, but for many there is nothing. Even if we were able to offer something for every troubled boy and girl, we would still be failing to tackle the root causes of their distress.

Some would say it is outside the remit of general practice to try and create communities that are friendlier to our young people or to reduce the number of broken families. I disagree because this problem is becoming so widespread. The number of young people calling or coming into surgery suffering from stress, anxiety and saying that life is not worth living has increased exponentially year on year. I believe that local communities – family doctors, schoolteachers, local councillors, youth groups, voluntary and volunteer organisations and many others – need to work together if we are to give our young people a proper chance. Particularly those who have been pushed to the bottom of the pile. For the time being, I find myself as an elderly family GP acting in the role of an apologist for an unkind world – trying to understand and restore the self-confidence and self-esteem of children, who have lost hope. It is a very privileged role but what on earth can a few minutes with me achieve?

The second epidemic is dementia – often known as Alzheimer's disease. That epidemic is partly the result of an increasing number of elderly people, who have to get something as they age. Their registered numbers were boosted by a strange governmental proclamation a few years ago that we GPs would henceforth

be paid an extra £50 for every diagnosis of dementia that we made. Every patient became a potential scalp. Overnight, it became financially penalising and politically incorrect to dismiss forgetful elderly patients as simply having memory problems. Every vested interest encouraged us to diagnose patients with dementia whatever the wishes, needs or good of the patient and relatives. Many GP practices significantly increased their percentage of patients with dementia. GP practices are, after all, small businesses and though most GPs are caring and altruistic, their practice managers are paid to watch the financial bottom line. Especially when it is a struggle to pay and recruit nurses, pharmacists and those taking blood, who are an essential part of every modern general practice.

Anyway, I felt uncomfortable as did very many GPs. My own father had died just a few years before and we described him as having a 'failing memory'. Many of my patients' relatives with 'memory problems' wanted 'poor memory' to continue to be the diagnosis as they felt that 'dementia' made their relative into a disease rather than a person. When I mentioned this to psychiatrically-wise colleagues, I was told authoritatively that any reticence on behalf of myself or my patients or their relatives to diagnose dementia was only extending society's preconceptions and prejudices about the diagnosis of dementia. I was simply behind the times. Was I to sacrifice the wishes of an individual patient and their relatives to what was perceived to be the better good of society? On the whole, I didn't, and sacrificed a £50 payment on several occasions. Unless an effective treatment becomes available, I hope that no one will give me the diagnosis of dementia until it is completely obvious to everyone around and only then – when the diagnosis enables me to obtain help that I might not otherwise get.

Jerry was a patient who had recognised that his memory

was going for some time and who had read up all about it. He asked me to refer him to see if he had dementia. He accepted a positive diagnosis with grace. Jerry's abiding ambition, which he had confided to me over many years, was to go to Brazil. Though Devon born and bred, he had always wanted to join the carnival and be part of the dancing and flamboyant procession in Rio De Janeiro and had told me once – *sotto voce* – that he was rather interested in the sexual freedoms that he had heard about. As dementia and dogged old age intervened, his dreams and ambitions, in this respect, only got stronger.

He would come into surgery telling me how he had checked out flights and the date of the next festival and how Beattie, his wife, was still refusing to come. He repeated this fantasy again and again over many years and as he began to realise that everything was all but lost, he then surprised me one day by coming in and asking me for Viagra.

"Viagra?" I asked.

"Well, I am not sure I am ever going to get to Brazil now... so I thought..."

"Does Beattie know?" I asked.

"No, I wouldn't tell her but hopefully..."

"Perhaps you should?"

"OK, I'll discuss it with her."

I was relieved. Fortunately he must have forgotten our discussion as things ended there. I wasn't looking forward to a call from Beattie: "Why the hell did you give Jerry that bloody Viagra!"

The privilege of having been a doctor for most patients over many years means that, for me, they have a known past. That can be helpful in understanding and treating the issues of the present. One day I recorded a conversation with a patient, Jack Fenton-Jones, who until recently had been a highly respected

member of the local Council and previously a horse trainer for many wealthy and well-known people. Jack had dementia but was particularly confused the day that I visited him. It happened to coincide with a New Zealand rugby tour.

As frequently was the case, his story seemed – initially at first – quite credible. "Of course that large New Zealand rugby chappy was here a few days ago."

"Here? Are you sure?" I asked.

"Of course I'm sure, he came here specially."

"Why?" I had to ask.

"Because everywhere he went they gave him cups of tea and things to eat but no one gave him what he really wanted."

"What was that?" I asked again.

"What was that? A seat of course – a proper sized seat. He had heard that we've got a yellow one in the basement. You see none of the ones they gave him were big enough to sit on! Quite extraordinary isn't it? They gave him cups of tea and things to eat but no one thought of giving him what he really wanted. You see I have got a wife in Totnes." His wife had actually died locally several years previously and, as far as I know, his only contact with Totnes was that his brother had once lived there. "We hardly ever meet because I've got to have my leg dressed in the mornings. Of course, I've got nothing against the district nurses. They have got to get the money to have their holidays – only there is never enough time to get to Totnes and back. Anyway, a young man with brains like you should be able to sort it all out?" In a way I was. By simply listening, doing very little and certainly not prescribing any more drugs. All I had to do was to ask his home help (who like many in those days lived next door) to drop in a little more regularly and wait for his ulcer to improve, which lessened his confusion. There is now firm research showing that if a doctor knows his patient well

then he is less likely to prescribe a medicine, the patient is more likely to be happy with the outcome of the consultation and his recovery is likely to be quicker. In short, as I described previously – relationships are everything.

The number of patients with dementia is rapidly increasingly, as are demands on general practice. Yesterday, for instance, I was presented with three problems interrupting morning surgery. The first was a softly spoken grandmother in her eighties with early dementia and unpredictable behaviour. Her son and daughter-in-law had been unable to cope with her anymore. Consequently, she went to live with her granddaughter. The latter had three children and three bedrooms in her house. Her grandmother had been taken into hospital earlier that morning with acute confusion and the hospital wanted to send her back to her highly stressed granddaughter. How could I help? How could the hospital realise that this remarkable woman was having to cope with a grandmother with delusions in one bedroom and her three children, who were now having to share the same third bedroom. Did anyone in our medical system have any idea of the stresses that she was facing and did anyone really care?

The second call was from the wife of a retired senior serviceman, who had had a serious brain injury. He was beginning to attack his wife, who was now in danger, despite various medications. He had refused the idea of going in to an 'old people's home' and his wife did not want him medically sectioned to do so. The third call was from the daughter of a rather obsessional elderly gentleman with dementia. He was sending his wife mad with his obsessional and eccentric behaviour. He would say to her repeatedly, "I have got a watch on this hand – why isn't there anything on this other hand?" His endless dilemmas and worries were bad enough. He would not let her leave the house and constantly worried about where she was. What could I do? The

GP is the first and final port of call for so many of these issues. Most of the time there is no satisfactory answer. For GPs and patients there seems to be so little effective support or kindness for these patients with dementia, or their relatives.

Most medical services and societies treat their patients with dementia badly. It all falls back on the relatives. We can do better and with a national epidemic it is important that we do so. That will mean a paradigm change in attitude on behalf of society and our medical services. As now happens in some towns, we must in future enable patients with dementia to become VIPs within 'Dementia Friendly Communities'. Perhaps, then, we will stop leaving patients with dementia and their relatives so inextricably on their own.

Chapter 8

RELATIONSHIPS

Long after people have forgotten what you said or did,
they will remember how you made them feel.

Maya Angelou

When my elder brother Patrick bankrupted the family firm and we lost all our money, none of us held it against him – not for long at least. For myself, as a young medical student at the time, it was a positive life-changing event. It taught me the value of money and human relationships. We were, as previously mentioned, a close family, supportive and forgiving of each other's shortcomings and vices. I am immensely proud of my parents and all my siblings and I feel sure that this caring, if slightly crazy, family did more than much of my formal academic training to prepare me for a life in the caring profession and all the complex and fascinating relationships it has provided – and continues to provide. All kinds of relationships are exposed in front of the family GP and particularly in country practice, relationships between individual GP partners are almost as intimate as family relationships. Relationships with the patients can be equally important to the doctor in preserving his or her sanity as they are for the patient. Science is beginning to prove what we knew all along – namely that having good relationships is healthy and prolongs your life and even makes it more likely that you will survive a heart attack. Indeed, it is now estimated that having a good personal relationship with someone conveys the same health benefit as giving up smoking. That of course

goes for all relationships but particularly for the relationship between patient and doctor.

I did some published research with fellow GPs a number of years ago exploring what made a good relationship between doctor and patient into a healing relationship. A relationship where doctor and patient liked each other was clearly important, but what surprised us most was that it was less important to patients whether they liked the doctor than whether they thought that the doctor liked them. Many of our patients have lost their self-confidence. Their demoralised state and the reactions of people around them may lead to them conclude that they are unlikeable. Our research suggests that 'self-validation' – telling them that they are OK – is an important part of the healing relationship and a means of improving self-esteem and feelings of self-worth.

'The drug doctor' was a concept proposed over fifty years ago by the psychiatrist, Michael Balint, who described how doctors and the relationships with patients could be equally and sometimes more powerful than the drugs that they gave. Relationships require time and need nurturing. Delivering babies, spending nights with terminally ill relatives, and attending emergencies all created an intimacy with patients and the local population, which is much more difficult today. Especially so with the constant fear of complaints and litigation and the emphasis on getting things technically right rather than necessarily right for the patient. I tell my younger partners that I see our relationships with patients as a bit like a bank account. The more contacts, kindnesses and successes, the stronger the account and the more likely a patient is to believe what you say, accept reassurance where appropriate and accept challenges when given and mistakes when made. When you see a patient for the first time or one that you do not know, there is no bank

account upon which one can borrow the trust and goodwill of a long-term relationship.

Thus, it became clear to me that the essential element of any healing relationship was to take time to get know each patient and to learn to like them. Pretending to like them just doesn't work – patients can see through that a mile off. It meant overcoming my projections and prejudices and trying to better understand why people were as they were.

□ □ □

In my early days as a GP, many villages had their 'local squire'. He would often live in the big house and be regarded as the local VIP. Often, in return, he would make contributions with money or in kind to the community. I had issues with one local squire, who was a bit of a bully and thought that doctors should be at his beck and call – which previously they had been.

My first GP teacher had prepared me well to know my place in such a situation. We were having a tutorial on the lawn outside his surgery on a lovely summer day. I remember him taking off his sunglasses and observing me closely. He told me half seriously, "Michael – your social position as a country GP will be this. The local squire will ask you for drinks after church but you won't be invited to stay on for lunch."

This particular squire had a knack of making me feel small, incompetent and ineffective. Eventually I understood that the feelings that he gave me were exactly the feelings that he had about himself. Then I began to understand and empathise with him. Especially so, when his wife became rapidly ill and died and he became embroiled in all sorts of family financial disputes, which were not really of his making. Humbled by life, he became a much more rounded, likeable and accepting person and, oddly enough, his suffering had made him happier as well.

I had similar problems in bonding with Beth and Cyril. Beth was as big and gruff as Cyril was small and smiley, and he never removed his flat cap even in surgery. They had been farm workers living in a tumble down cottage outside one of the villages. Their garden was amiably chaotic. Every implement that had passed its usefulness inside the house was then used outside for propping things up, collecting water, outside furniture or simple decoration.

The ferocious Beth was endlessly critical of my attempts to alleviate her many symptoms. She would bring in a bottle of tablets from my last consultation, bang it down on the table in front of me and announce, "Those never done me a bit of good." Her pains would forever, in her words be, "Giving me socks". She looked permanently angry and discontent with arms folded and a challenging look that seemed to say, "So what are you doing to do next?" I even managed to miss the beginning of a heart condition that had been picked up by another GP partner. Beth eventually had a heart attack and developed a rare disease, while Cyril also had a life-threatening disease. I began to know them quite well and realised that behind Beth's aggressive exterior there was a kind heart, with a strong sense of fairness and justice and there was a deep bond of love between the two. I think that she had been belittled in life and thought that, given an inch, a GP toff would only try to patronise her. They say never judge a parcel by its wrapping. Most Devonian patients are charming but many of those who seem to be bad mannered, blunt and gruff often simply lack social skills and hide hearts of gold.

As I progressed through my career I couldn't understand why some patients particularly wanted to see me, when for many years I had failed to help them in any substantial way. In part, it may have been 'The devil you know…' but sometimes, apparently, patients are looking for a therapy that is not about

pills or seeing specialists, or even being made happier. Sometimes it is something to do with telling the story, making things real and establishing some kind of control.

I learnt this from Denis, a large and cheery dustman. He had a sunny personality and I never remember him complaining about anything. He once described a distant GP predecessor of mine saying, "He could be a bit rude and frightened us children. Of course, I was much younger then and he was an awfully good doctor but he did shout a lot." As a dustman, he had strained his abdomen and developed a hernia. I referred him to Dr X at the local hospital but unfortunately the hernia recurred shortly after he got back to work. I then referred him back to Dr X. Dr X felt that it was too early to operate again. Denis reported back to me, "Dr X says that he won't be sending for me for another three months until this scar (the previous operation) has healed. He says that he always likes to operate on a virgin groin."

This cycle of hernias coming undone, after being repaired, repeated itself three times. Eventually, I suggested to Denis that we should try one of the younger surgeons, who had a better record of hernia repairs, which did not fall apart! He was disarmingly polite and firm. Even though the surgeon concerned had managed to botch up three hernia operations this had not left a tinge of bitterness in the dustman's mind. "Oh no we can't do that," he said, "Dr X always does my hernias." He stuck to his guns, even though the reason that Dr X always needed to do his hernias was precisely because they always came undone!

Later still, in early retirement, which was partly due to Dr X's succession of unsuccessful hernia operations, Denis developed heart failure. He saw a local consultant, who had clearly been less than polite or helpful. Forever positive and grinning cheerfully,

Denis told me, "The specialist didn't seem to care very much but the nurse at the hospital was very nice. She made me a lovely cup of tea. It really was a lovely cup of tea."

▫▫▫

Home visits, when the GP invades the patient's territory, are in many ways a more intimate form of relating. In tragic times, it is often the GP, uniquely, who can walk into the house and be welcomed as if only we have the skills to know what to do and say in these most difficult situations. Patients are also invariably welcoming. Gwen frequently asked me to visit her husband Lawrence because he had dementia, prostate problems and was in general decline. Whenever I visited their small bungalow, I was met by the delicious smell of home baking. She would have fresh Welsh cakes on the table (she knew they were my favourite) and we would share them over a cup of tea before going in to see Lawrence. There was very little, medically, that could be done for Lawrence. In retrospect, supporting Gwen over Welsh cakes was probably the most important part of my visit. We had more time in those days to share ourselves with patients and their relatives.

One night, I was called out on a visit at 3am. As can often happen with a blurred mind just waking from sleep, I remembered the street that the patient was in but not the exact number of the house. Fortunately for me, there was only one light on in the street. I pressed the bell and opened the door, which was unlocked, and went upstairs. I entered the bedroom and a young couple slightly flushed and embarrassed turned on the light. "So who is the patient?" I asked. Their blank faces told me everything. I had got the wrong house. Instead of dispatching their unwelcome intruder, they asked me who I had been asked to see and then gave me instructions as to how to find their

house. Then, unforgettably, the wife added, "Doctor, you do look frightfully tired, can I get you a cup of tea before you go?"

Not all patients, however, were polite on home visits. Bernadette was a well-known drunk, who specialised in rather scarlet language. She asked one of my GP partners to visit her at 2am in the morning, saying that her tummy was about to burst. He arrived, knocked on the door and rang the bell but nothing happened. So he then bent down and peered through the letterbox. The lavatory door was open and a slightly inebriated but otherwise well looking Bernadette was now sitting on the throne. Her abdominal problems had apparently sorted themselves out. In a cheery voice he shouted through the letterbox, "Hello Bernadette, are you all right?"

"Fuck off!" were her only words as she slammed the door shut.

On another visit, I was asked to see the patient of a GP partner, who was bleeding from the back end. It was one of those days, where there were more visits than time to do them. I assumed the diagnosis was going to be piles. The patient welcomed me at the door and forgetting to introduce myself I led her into the sitting room and asked her to lie on the sofa on her left side. I then hitched up her dress and pulled down her pants. It was only as I exposed her behind and introduced the proctoscope that she exclaimed "Oh, so you must be the doctor – I was expecting someone to come and mend the television."

☐ ☐ ☐

Absolute trust is the essence of a therapeutic relationship, and the gradual disconnection between doctors and patients is not helped by an often hostile press which is threatening that trust. I noticed during the Shipman case that when I went to visit patients who were vomiting and offered the usual injection or suppositories, a much larger percentage of patients would opt

for the suppositories. Where there has been insufficient time to build up a relationship of trust, consultations can sometimes become quite combative. I have experienced this, when seeing patients of younger partners, when they are on holiday.

A rather stunning young Eastern European woman, who I had not met before, was the patient of one of those younger GP partners. She was the last patient after an exhausting evening surgery. "I want to have my breasts enlarged." I was tired and a bit puzzled.

"But your breasts seem to be very normal in size."

"No they are not. They are far too small! You look and see."

It was a hazardous situation and not helped by the fact that surgery had been locked up and everyone had gone home. She removed her bra and revealed two entirely normal breasts and I asked her to dress again. It was important to get the right adjective and words like 'perfect' and 'shapely' or even 'beautiful' were not going to work. "You have what we in the medical profession call clinically normal breasts." She was not to be appeased.

"I don't care about your clinically normal," she hissed. "I want them bigger and it is my right to have the operation on the NHS."

I tried to explain that it wasn't. She told me angrily that she was going to write to her MP. I recognised someone who had had a hard life and therefore learnt that she had to fight every inch of the way. I surprised her by saying that I thought this was an extremely good idea and exactly what she should do – enabling me to end a rather tense consultation on peaceful terms.

For some patients, I have come to the conclusion that a talk and a relationship is all they want, as they already realise there is not much that the doctor can do. This was particularly the case with Sam. Nothing ever seemed to go right in his life. He had had cancer of the leg as a young man requiring amputation and

an artificial left leg. This together with him being overweight, having diabetes and a permanent back problem had led to early retirement from the local slaughterhouse. He had married early but his wife had left him for another man leaving Sam alone at home with their young son Darren. Sam doted on the young boy and Darren responded by becoming a very effective home nurse as Sam got older with an ever longer list of medical problems.

Each consultation with Sam would start with, "So how are things now?" The inevitable reply was, "Terrible". This might be followed with, "Things were bad enough last time that I saw you, doc, but now they are even worse…" If it wasn't burglars or aggressive neighbours then it was his car packing up, being apprehended mistakenly by the police, his benefits being withdrawn or concerns about Darren (concerns that Darren did not appear to have for himself). These constant woes, recounted cheerfully and with a smile, sat alongside a vast array of physical symptoms none of which seemed either diagnosable or treatable apart from giving sympathy and painkillers.

Everything but everything seemed to go wrong in poor Sam's life but he continued smiling and was a good citizen to those around him. As Sam's back pain got worse along with his knees, piles, indigestion and chest – it seemed that life itself had reached rock bottom. He came in one day. "So how are things Sam?" I asked. He gave me a grave look. "Well at least things can't be as bad as when I last saw you?" I asked hopefully.

"They are," he said triumphantly with a smile. "Worse than you can possibly imagine." He paused. "I died last night."

What on earth could I say to that? "But you are still here."

"Only because Darren jumped on my chest and shook me."

Any decent doctor would have organised cardiograms or hospital admission, but I knew Sam well enough to know that hospital would not have been appropriate. You might well ask

what use a GP is for people like Sam in such situations. Maybe the relationship helps to get people like Sam to their various medical checks and hospital appointments that they really do require. It also avoids them being carted off to hospital with symptoms, which in any other patient might seem potentially fatal. Above all, it prevents an endless trail of consultant referrals for changing and un-diagnosable symptoms.

Maurice was another patient for whom everything always went wrong. Unlike Sam's cheery face, Maurice always looked miserable and suspicious. He glanced sideways and behind him as he spoke, often ducking as if someone was about to hit him. On one occasion, he had offered to help two blind people manage a market stall in a neighbouring village. Business hadn't been very good so he left them to have lunch. When he returned, he was surprised to see that everything had disappeared from the stall. "You have done well," he exclaimed.

"We haven't sold anything," they told him.

Maurice had been through all the ordinary antidepressants and treatments. Cognitive Behavioral Therapy was the rage at the time – no good. Nothing worked. Considering he was near retirement age, we settled for three monthly consultations, when he would collect his certificate and explain how awful he felt and how bad things were. He was impeccably polite, immensely grateful and would never see another doctor. I was never going to be able to re-script him to someone who could conquer his afflictions because his internal anger would not allow it, but at least we managed to avoid using specialist and other NHS services.

I was equally ineffective with another family that lived on a local council estate. The head of the family, Sid Partridge, was pale, thin and did all the family chores on his bicycle. His wife Bessie was as fat as he was thin. She never got out of bed because of her nervous condition and balancing disorders. They had

proved to be immune to every treatment that I offered her. Her condition had spread, at an early age, to one of her daughters Chelsea, whose anxiety, dizziness and trembling rendered her unable to work as well. Another sister, Danielle, had a profound learning disorder and the third, Rachel, was slightly more capable than the others but had a very bad temper. One of the more effective members of the family was Minnie, their Jack Russell. She was also an excellent diagnostician. As I arrived, she would jump over which ever member of the family happened to be ill on that day.

The house smelt permanently of school cabbage and whatever time of day I called, it seemed, the family would be having their lunch in the sitting room – all vastly overweight apart from the lean Sid. They lived frugally, supported only by benefits and were neither lazy nor malevolent – just unable. Nor were they always unable – Chelsea was one of the voluntary helpers, who was able to help keep Doris at home (Chapter 4) in her later years. They would come to see me with all their crises and catastrophes, totally trusting my opinion, and each would send me a homemade Christmas card, which normally arrived well before the end of November. They did what they could for each other and used the medical services infrequently. They also went through an endless cycle of well-meaning people, encouraging each to take up employment but eventually coming to the same conclusion that they were all unemployable.

They were the very opposite of the 'benefits scrounger'. The house was a tip and their expectations were low and I saw my role as trying to guide one of their brothers and an unexpected son of one of the daughters towards more productive lives. This inevitably required them to live independently of the main family set up. It is so easy for people to judge such families. To say that they are simply not trying. Some people are simply not

able to function as effectively as others. Part of my job was to minimise the extent to which the Partridges called upon my other partners or the local hospital and to encourage, as best I could, any behaviour that increased their self-dependence. In an ever-harsher environment for the less well-off and without a personal doctor – will they sink or will they swim?

The Chicks were a family with far more than their fair share of genuine medical problems. Old man Chick had been a local gamekeeper and was what the village called 'a character'. He was also stoic and as his lungs began to pack up in his sixties, the legacy of a long-time smoker, he left the world without a fuss. This left his wife Eva, who today is almost one hundred and continues to live in the same council house, attended each day by her daughters and son. Eva has heart failure but her main problem is hearing voices and 'seeing' people walking round the house and stealing her things. The problem has been partially solved by an evening sedative and her daughter saying, "Mother, Dr Dixon says there isn't no one in the house and it's all in yer head," to which the not very convinced Eva replies with a smile, "Yes, I suppose so."

Their son Terry, ruddy faced and now in his seventies, has a very rare tumour that has grown from the lining of his nerves. It has compressed his lungs and caused them to fill up with fluid making him permanently breathless. An operation would be extremely dangerous and for several years Terry has lumbered on, as stoic as his father, with occasional visits to discuss the pros and cons of an operation, when his symptoms are particularly bad.

His son Jake is caught in the horns of a similar dilemma. Aged fourteen, he was having a snowball fight with his friends, when he was hit in his back. This seemed to cause him more pain then I would have expected and his right leg was becoming weak. It

turned out this was due to a bleed from abnormal blood vessels in his spinal cord. As with Terry, any operation would carry high risk and possibly cause total paralysis. The blood vessels continue to bleed from time to time causing further weakness in the legs and Jake was told to prepare for being in a wheelchair. Thankfully, like Terry, Jake's condition has not advanced much and he remains active, working in the local mill.

Kelly is Terry's wife and, possibly as a reaction to the phlegmatic attitude of her son and husband, she bears all the family worries. She, herself, is battling successfully against lung cancer. Many years ago, with two sons already in tow, she came to see me in surgery unexpectedly pregnant. She was tearful, wondering how she would cope with yet another child. Especially as she was now aged forty-one. I patted her tummy following my examination and tried to comfort her, "Never mind, at least it's not twins." It was. Furthermore, between the ages of five and fifteen the twin boys were to eat crisps and absolutely nothing else, defying the best efforts of our health visitor, paediatrician and local psychologist. They are now grown-up, capable young men.

I doubt that the Chicks think that I am the best doctor in the world. They do, however, know me and trust me and, more importantly, know that I know them and will do my best in the context of their lives rather than according to some medical algorithm. Our relationship is mutually satisfying – I look forward to their visits – and our relationship avoids them having to tell their story repeatedly or undergo an unnecessary string of extra investigations or procedures. Current medical theory has it that these one-to-one relationships between doctor and patient can be replaced and even improved by having families like the Chicks looked after by teams sharing a common database. Digital certainly works for the young and those with episodic

disease but more complex illness requires a more human healing relationship.

One of the greatest challenges in general practice is to enable children to achieve their potential in an environment that seems set against them being able to do so. Lizzie, Laura and Ryan had had hard lives. I first met Lizzie and her two young children shortly after her husband had walked out on her. Lizzie, with her wide face and pageboy haircut was ever smiling and positive though tears were never far away. Laura, her daughter, exuded a defeated sadness but had a lovely smile on the few occasions that she appeared happy. Her mission was to help others and particularly her brother Ryan, who never seemed to be out of trouble.

One year, when Laura and Ryan were still young, I was asked to judge the local primary school art competition. Laura's painting was instantly recognisable. It was a not particularly good likeness of a Bambi deer with tears pouring off its face. It certainly wasn't the best painting, either, but I had to give her a prize.

Lizzie found a new partner and most of her energies were then spent making sure that he did not stray, and holding down a fulltime job in the local factory. Laura became Ryan's surrogate mother and would bring him in for frequent consultations during his teens and early twenties. Ryan was not only accident prone – breaking numerous limbs – but also endlessly involved in fights and squabbles for which he always had a good explanation. Laura as she grew up, still pale, sad and vulnerable developed into a beautiful woman – ever defending the wayward Ryan.

In his early twenties Ryan had a terrible accident, while syphoning petrol from the tank of someone's car. The petrol caught light and his body was badly burnt and scarred. He required very strong painkillers, which did not help a drink and drug habit, which he was already developing. Laura

became virtually his nurse, making sure that he got to hospital appointments and that I was doing the best that I could for him. Ryan, however, was on a downward spiral becoming increasingly crestfallen with every defeat in his life. Eventually he died from a probably unintentional drug overdose. He wasn't even thirty. Shortly afterwards Lizzie developed a very malignant cancer and, as uncomplaining as ever, was dead within a few months.

That left Laura, who by this time had two children, a boy and a girl, who both reminded me of her and Ryan when they had been children. Her partner was a charming and good-looking man but with a reputation for violence. She was happy and besotted, telling me that she thought that she would be able to change him. Sometime later the sadness seemed to return. I started seeing her and her two young children more frequently for seemingly minor complaints. Then I noticed the bruises. She insisted that they had been accidents. One day, she quite suddenly burst into tears. "He only hits *me*," she pleaded. "He would never harm the children." I feared for the safety of her and her children. Fate intervened soon afterwards as it often does. Her partner had been involved in a serious fight and was given a custodial sentence of several years. She came to see me a month or two later with the children. She was a changed person. She and the children were well dressed and happy. Her vulnerability and suffering had been cast aside. She was strong and had decided on a new life. "We are going up north to stay with a friend. I am never coming back." She didn't.

◧ ◧ ◧

It is easy to become depressed as a doctor, when you hear people's endless woes and everything that you have tried has completely failed. Medics have various ways of restoring their sanity – a furious digging session in the garden or a glass of the

hard stuff normally works for me. In some cases, with patients, it is a question of try, try, try again and success eventually comes. In others, it becomes clear that acceptance of the state by patient and doctor is all that is necessary.

Occasionally, miracles do happen. I looked after a forester with back pain and absolutely nothing seemed to help him. We had tried physiotherapists, osteopaths, pain killers, anti-inflammatories, muscle relaxants and even morphine. All no good. He was miserable and so was I. Then one day he walked confidently into my surgery and said, "Don't worry, Doc, I've sorted it!"

"So what was the solution? How did you do that?" I asked.

He got a packet out of his pocket and threw it across the table. "These," he said. "I have got a friend in the Coldstream Guards. He gave me these. It's what they give them when they get shot in battle. He told me that they are the strongest pills that you can get. They worked a trick for me!" I read the writing on the bottom of the silver wrapper, 'Codeine and paracetamol'. We had tried exactly the same chemical constituents many times before with no beneficial effect. The words of the Coldstream Guard had turned them from sawdust into a magical cure.

I witnessed a similar effect in another patient of mine who had a back operation. The surgeon was not particularly hopeful of success because her scan had shown multiple problems of the spine and he was only able to operate on a small section. Nevertheless, a few weeks after the surgery, she literally skipped into surgery an entirely new woman. "It's amazing," she said. "He removed each bone (vertebra) from my back one by one and gave each of them a really good scrub. He said after that that I would feel as good as new. I do." I have no idea of what the surgeon did actually tell her but it would have been more than foolish to contradict an explanation that proved to have such a

permanent healing effect. If we want our patients to get better then we ignore the language of symbols, belief and imagination at our peril.

Modern medicine has deprived us of our magic (see Chapter 11). Its formulaic evidence-based approach means that most patients get more or less the same pills, their doctors often say more or less the same sorts of things and they receive the same information sheets. This may have led to far safer, more consistent and more predictable treatment but it may not always have led to more effective treatment. Too often it results in patients who are over-diagnosed and over-medicalised. I can think of one patient in a wheelchair, who has been diagnosed by various specialists with all sorts of Latin-sounding diseases following despairing referrals from my perplexed colleagues. Today he is permanently off sick and solidly believing that he is an invalid though 95 per cent of this, I suspect, is in the mind – aided and abetted by over-medicalisation. Just as the psychiatrist R.D. Laing saw much psychiatric diagnosis as a political act, some (though happily few) of our patients with long-term disease seem to be the result of both the patient and their doctor renouncing hope. Traditionally, it was the role of the GP to protect patients from specialists. This was a relatively easy job when I started, as GPs outnumbered specialists by three to one. Now that there are more specialists than GPs, it is becoming an ever more difficult task.

Another patient in a similar state came to see me a few years ago. He was overweight, diabetic, incapacitated and in constant pain. He had an absurdly long list of drugs. We had a lengthy discussion about how his symptoms had started following dramatic events in battle as a red beret in the 'Paras' many years before. At the end of the consultation I muttered, "You are a brave veteran and you have served your country well. We must look after you."

He burst into tears and then looked straight at my face, "No doctor has ever said that to me." From that day, he started losing weight, reduced his drugs and threw off the mantle of a victim.

□ □ □

Relationships between partners and staff are important in themselves and patients feel reassured when there is a good relationship between those that care for them. In one small village branch surgery, I worked for twenty years in one room, while Jenny, our kind and perceptive nurse, saw patients next door. If patients thought they had something serious they were often sheepish about consulting me and would smuggle themselves in to Jenny hoping that she would reassure them and tell them they didn't need to see me. Thus, she became, effectively, the village screener for serious disease. Fortunately, her intuitional and clinical skills were well up to the task. In later years, when I had to spend two or three days a week in London, she would, for example, examine patients' ears and tell me the diagnosis enabling me to prescribe the necessary treatment over the phone. The village saw Jenny and I as an inseparable and interchangeable duo. If we were both away at the same time they would assume that we had gone on holiday together. Indeed, I think several villagers imagined that Jenny and I lived like Morecambe and Wise or Bert and Ernie – tucked up in bed at night in the upstairs of the surgery with our Ovaltine and hot water bottles discussing our patients and plans for the next morning's surgery.

A few years ago, we decided it was time to close the village surgery because it was falling down, damp, poorly equipped and had no disabled access. We had also built a palace of a new Integrated Health Centre only a couple of miles away in Cullompton. We thought we should consult the village first. To

our surprise, 125 villagers turned up on the Saturday afternoon for this consultation and they were in a mean mood, as they thought that we had already decided to close the village surgery. They would have none of it. It was **their** village surgery.

The waiting room was a community meeting place. The receptionist would give patients a cup of tea if I was running more than an hour late. On one occasion a patient berated me for being on time because she hadn't had time to catch up with the village gossip. It was also a place where people came as equals and if someone looked particularly ill, then the others would make sure that they were seen first. Our receptionist, who lived in the village, acted as my medical spy. She would brief me on what she had seen in the waiting room and give me background knowledge on discussions and observations in the village hall, shop, pub or at the previous week's meat bingo.

Things that matter to the Care Quality Commission or Health and Safety Executive were of absolutely no consequence to the villagers. Even those in wheelchairs would struggle into the village surgery in spite of the much better wheelchair access at our main surgery. Small is not always beautiful. But, it is certainly very helpful when you are trying to build relationships. Will the next generation feel the same about our village surgery? I doubt that they will be given the choice.

◘◘◘

Most Devon villages still have the same sense of community. This was particularly the case in one village, where most of my patients lived. For many of them the summer holiday was always a week's bus ride on 'Pickering's Magical Mystery Tour'. Mr Pickering was the charming but understated proprietor of the village's bus company, which also ran the local school buses. If you asked any of the villagers about their summer holiday plans, they

would invariably say, "Of course, we are going on Mr Pickering's Magical Mystery Tour – as we always do". One year, I think it was 1989, there was considerable excitement as they had been asked to bring their passports. The magical mystery tour ended up going to Austria. It was the talk of the village for some time afterwards.

As Mr Pickering got older, his menu of destinations for the magical mystery tour became increasingly short. Hardly magical or a mystery! He developed a heart condition, which further reduced his repertoire. For the last four years, the magical mystery tour went each year to Chester as he knew it well and it was the only place that he could drive to and from safely. The villagers didn't seem to care. They would come in and say, "Yes, we are going on the magical mystery tour once again, but we all know that it is going to Chester." A golden era drew to a close, when Mr Pickering's sight and strength meant that he could do the tours no more.

His heart condition meant he had a tendency to produce blood clots, so, using the most up to date 'evidence-based guidance', I had to put him on warfarin in order to thin the blood. Shortly afterwards he fell in the kitchen and bumped his head resulting in a bleed into the brain, which ended a rather noble life that might well have lasted longer without the warfarin and intervention of modern evidence-based medicine. When his wife, who has always been a force to be reckoned with, required the same blood thinning tablets, she firmly and understandably refused.

Coach tours in the village were never quite the same again but Bill and Mollie were seasoned travellers. Bill looked like an elderly, unshaven version of Fred Flintstone but spoke with a cut-glass English accent inherited from his time in the Navy. Mollie had not weathered quite so well with heart failure, a pacemaker and rapid-onset dementia, which Bill either did not notice or

simply chose not to notice. Soon, Mollie was unable to move more than a step or two without becoming breathless and her memory had become so bad that she didn't seem, at times, to even know who Bill was.

Imagine my concern when Bill strode into surgery one day to tell (not ask) me that he was taking Mollie on a coach tour to Europe. "It's the least she deserves," he said.

"She won't survive a ten-day coach tour," I pleaded.

"Of course she will," he said firmly.

"But Bill, her memory is so bad now she doesn't know where or who she is and you want to take her to the middle of Europe! What about her heart? What if something happens?"

"It won't," Bill said with the voice of certainty that I had heard a little too often before.

Should I protect Mollie from Bill's seeming blindness to the condition of his dementing and dying wife? It was easier to do nothing. I did nothing even though alarm bells were ringing loudly in my ears.

To my endless surprise Bill bounced into surgery two weeks later. "You were quite wrong, Doc! Best holiday of our life. Mollie thoroughly enjoyed every minute of it." According to stories from other villagers, it was true that she had. She and Bill had sat shotgun – right at the front of the bus next to the bus driver. During ten days touring France, Switzerland and Italy, they were VIPs with Mollie glowing even though she had no idea of who and where she was. She died a month after returning home. A more cautious and proactive GP might have stopped her going. I was glad that I hadn't. Relationships had triumphed over medical correctness.

That wasn't the end of Bill's story. He was a social animal and after Mollie has died, he joined a social group that met every Monday in our surgery's café. There he met a rather quiet

widow, Flora, to whom he was soon married. His daughter took it in her stride when Flora joined him in his rather cramped bedroom in the ground floor of her house. A few weeks later I was called early one morning to catheterise Bill, when his prostate had packed up. They looked like an elderly couple that had been married for years. Flora reading a book and paying scant attention to the proceedings, while Bill, stoic as ever, had succumbed to the catheter, which was to stay with him for the rest of his life. Shortly afterwards he caught pneumonia and had to be admitted to our local nursing home where, for the first time in his life, he was alone and died shortly after.

This sense of community existed not only between the villagers but also between the professionals. The chemist, optician, undertaker and vicar were all, effectively, part of the same team. The same went for local businesses. Eventually I had to stop ordering fish and chips within the practice area because the shop owners refused to ever charge me.

The car mechanic who kindly mended my ancient and ever decrepit car was considerate and patient with frequent call-outs at short notice. He also had an enviable vocabulary. Nothing on my car was ever just checked – it was always double-checked. If anything relatively minor needed doing then he would say, "I'll get my man to do it." Both of us knew that he didn't have 'a man'. "Not as such" was an expression that he frequently used in answers to questions such as, "Is my car ready?" or "Have we found out why it won't start?" It must have been a coincidence but I did notice that when he required more than one or two 'bites of the cherry' repairing my car, members of his family would also come in with all sorts of un-diagnosable symptoms – as if to say that diagnosing cars was just as difficult as diagnosing patients.

My first conscious recollection of vicars was in a tiny country

church, where I was brought up. It had a candle in the pulpit, which would flicker precariously close to the sleeve of visiting vicars, who were unaware of its dangers. Then one day, to the delight of my seven-year-old self – it happened. I remember it vividly – even sixty years later. He was the Reverend Saddler and for reasons I never understood, he called all children 'Honeybunch'. That day he was in a passionate mood, waving his hands up and down – talking about goodness knows what (my ears were closed as my eyes were glued to the candle). With one flourish of his sleeve, his surplice caught the flame and up he went. The whole congregation rushed to his rescue and though shaken he was physically undamaged.

Vicars became part of my integrated approach to medicine combining mind, body and spirit. I convened all the vicars of local churches to form a rota to offer spiritual counselling in our GP surgery on Friday afternoons. This was very popular with the patients and I was surprised to see some, who had no religious beliefs, making regular visits to individual vicars on the rota. Our Roman Catholic Father was never sober but particularly popular. I think the patients identified with this fallen angel. He provided a sympathetic and unthreatening listening ear, and screams of laughter would brighten up my Friday afternoons as I was in the consulting room next door. In the village where most of my patients lived, I had a close working relationship with the Reverend Andrew Scott-Evans. He was a true man of God, carrying out his pastoral duties to support the meek and less able. They were often to be seen in the back of his battered Morris Oxford either taking them shopping or going on social and educational outings.

As local doctors, we had a specially privileged position within this network of local relationships. A GP partner of mine was very upset one day because some valued possessions had been

stolen from the boot of his car, while he was doing consultations in the surgery. Billie, a young man with cropped hair, few teeth, covered in tattoos but with a heart of gold, was enraged when he found out about this. He also happened to know everyone in the village. The following day, all the stolen objects had been mysteriously returned.

Chapter 9

EMERGENCY

*It is by presence of mind in untried emergencies that
the native metal of man is tested.*

James Russell Lowell

What more could any man ask for than a young family, house and garden, and to breathe God's air fresh from the Atlantic every day? Those years following Liberty's birth were our halcyon years. We had been joined by Joanna's mother who was recovering from cancer. She lived in a small annexe that we had built by the house. She too was a keen gardener and became an intrinsic part of our happy, extended family.

Our days off were spent walking or catching small creatures with nets in the river, bicycling to pick apples, blackberries, rosehips and elderberries to make hedgerow jelly and occasional visits to the sea. Some summer evenings I found time to fish by the river and just occasionally I was able to catch an edible trout. When this happened, I would joyfully walk back through the vegetable garden and pick some new potatoes, spinach and peas on my way to the house. By that time, Joanna would have finished washing her brushes after an evening in the studio and we would then cook a meal that had been in the river and garden only minutes before. What more could life offer?

Of course it wasn't all perfect. Our beautiful house by the river continued to drain all our income. When the river rose, the old well in the kitchen would flood the floor downstairs. In winter we froze and it would take us twenty-five years before our plumbing allowed us a full hot bath. If we ever stayed at a hotel I

would have a bath when I arrived, a bath before I went to bed and another when I got up in the morning enjoying the exhilaration of hot water. However, in spite of not being able to afford new cars, upmarket restaurants or expensive holidays, coupled with family time together being still very limited by my having to work 'all hours', we had everything. Concepts like 'quality of life' had not yet been invented but it was an unequalled period of peace and calm. That was until the events of 18 November 1998.

❏❏❏

When I started in general practice, the GP was first on hand for all emergencies. In one village that wasn't always true. It was a standing joke that the vicar (Andrew of the last chapter) often arrived before me. In those days, however, there were no paramedics, no helicopters, and an ambulance could take up to forty minutes to arrive. So, when it was a difficult birth at the cottage hospital, a heart attack or a car crash, we were called first and had to do the 'immediately necessary'. Particularly stressful was when you had to decide between an emergency in one place (e.g. a delivery going badly at the cottage hospital) in the west of the practice or a heart attack 20 miles away in the east of the practice. Mike, our senior partner, told me reassuringly when I started, that "You can't be in two places at once – it is not your fault when this happens." Few of us had training in major trauma: it was simply a question of doing your best and holding your nerve.

My first personal ordeal was a lorry crash late at night. Nowadays there are sophisticated lighting systems so that you can see what is going on at the crash site. In those days, it was torches, and I remember crawling through the cab in a lorry over a dead body in order to pull out the survivor. Rather like delivering babies in the cottage hospitals, it was simply assumed

that one did so – especially as there was no one else to call on.

On another occasion, I was called to a young man in a crumpled Mini Minor. The police and fire crew had arrived just before me. The young man had hit his head badly and was having an epileptic fit. Rigid as a pole and covered in blood – it was impossible to remove him from the tangled wreckage. Petrol and oil were all over the road and the firemen told me that there was a real danger of the car igniting. I crossed my fingers, injected a substantial dose of diazepam (a tranquiliser, which can stop fits) and his body went limp, which enabled the firemen to get him out of the broken driver's window, into an ambulance and off to hospital. Shortly afterwards the car burst into flames.

I rang the hospital a few hours later to see how he was getting on. "He is going to be fine," the junior doctor said. "My boss wants to have a word with you."

The consultant came on the telephone, "What in the hell did you think you were doing? You could have killed him with that injection of diazepam – haven't you heard of respiratory depression? He was completely out of it when he got here!"

I started trying to explain to him that the boy would never have got to hospital alive if I hadn't given him an injection, but it was no use. As far as the specialist was concerned, it was yet another case of an ignorant GP making a hash of it and almost killing the patient. Sadly, that attitude still persists in hospitals, whether it is in teaching or sometimes (but much less nowadays) on occasions when trying to admit a patient to hospital. This perceived differentiation between GP and specialist still exists also with patients and the media. A charming couple that I had looked after for many years thought that they were heaping me with praise one day when they said, "Dr Dixon, we have decided that you are so good that they should make you a specialist."

One winter's evening, Joanna and I were already late

for supper with friends, when we came across an accident between a car and motorbike which had left the motorcyclist sprawling and badly injured in the middle of the road. They were surrounded by a number of people who were trying to help. Grabbing my medical bag, I waded through them finally getting to the patient and ushering away a well-meaning man with a head torch saying, "I am a doctor – I'll take over now." It was dark and it was only as I started to assess the situation with my own torch that I realised that the discarded bystander was one of my own GP partners, Tim. He already had things already well under control.

These events were just preparation for a later emergency, when a minivan bringing patients back from the supermarket crashed into the wall next to one of our branch surgeries. I came out of the surgery and found a lot of traumatised people, some were trapped in the minivan, while others had been able to get out and were wandering around in a daze. Most of the patients were elderly, some had to go direct to hospital and others were triaged in our main surgery – most were patients of our practice. From memory, I don't believe anyone died though the driver, as it turned out, had an early incurable brain tumour, which had been the cause of the accident.

These early days, when we were on our own, contrasted with one of the last accidents I attended. Two boys had careered off the motorway and landed in a field. One of them was clearly dead, while the other was in a very bad state, but I was able to call the air ambulance within half an hour and fly with him and the paramedic to the hospital. He survived but would not have done so only a few years previously.

Car accidents apart, there were all sorts of other gruesome events, from fatal tractor accidents to limbs being severed by a combine harvester and another patient becoming attached

to the mains electricity and literally cooking his legs. One particularly rainy day, a pole had fallen on a worker, who lay prone underneath it at the bottom of a deep ditch. For reasons I don't remember, I was wearing a rather smart suit that day, which together with everything else that I was wearing became unrecognisable in the mud, but with the aid of strong men and intravenous painkillers, he survived despite the fractured limbs and broken ribs. On each occasion, it was an entirely new clinical situation and we just had to manage.

The local police were invariably supportive and there was a good channel of communication between the GP surgery and police station. When I say invariably, I should have said almost invariably. One night I was called from my bed three times and on the third call out – totally exhausted – my driving through the local village must have been erratic. Two rather officious policemen, who normally guarded the motorway, had pitched themselves in the village for some reason and stopped me. They were convinced they had a drunk on their hands. "Excuse me officer," I said, "I am on my way to a patient, who's probably had a heart attack. I really need to get there as soon as possible."

"So you think you are a doctor do you?" said the first policeman.

"Well, I am," I replied.

They laughed. They knew they had a confabulating drunk. They bundled me out of the car and looked very disappointed when the breathalyzer didn't register any alcohol at all. They looked at me blankly then one of them caught site of the stethoscope on my passenger seat.

"So you are a doctor?" the second policeman said.

"Yes, and you are preventing me getting to a heart attack," I said impatiently.

Both of the policemen went a whiter shade of pale. "You will

need an escort to make sure you get there as quickly as possible," said the first policeman – thinking on his feet.

"Yes, please," I said. Following a police car at speed with siren and lights provided added drama to my arrival at the patient's home. That was before the inevitable anticlimax – not a heart attack but wind from a rather overindulgent meal the night before.

Worst of all were the fatal accidents involving young people. One young boy was run over, while crossing the road in one the villages. There is now a pedestrian crossing, where it happened, but I still see his shadow every time I drive through the village. I am also haunted by an image of his perfect form in intensive care at the local hospital as we had to make the collective decision to turn his ventilator off. Shortly afterwards, as commonly happens, his parents separated.

There are others, where I hadn't attended the original trauma but they were patients of mine and I had to pick up the consequences. Two wonderful young men come to mind. One was killed trying to mend a machine at the paper mill. His father had fairly recently died of cancer and his widowed mother came to see me saying that she thought she was losing her memory. She was an intelligent woman but the disease progressed rapidly and mercilessly. She was soon reduced from being the pillar of the community to an old lady with no past or future – repeating herself and playing with her faeces. The death of her son at the paper mill seemed to be yet another terrible injustice for that family.

Another young man was the solider in the Rifles, who I mentioned earlier. He was killed in Afghanistan. The town gave the soldier a magnificent funeral, which helped just a little to lessen the awful pain of his family who were all registered with me. There were also the violent suicides, where we were

the first professionals on scene, and these were particularly harrowing. Witnessing the remains of a patient who has hung, suffocated or shot himself is nothing as compared to sharing the sudden unbearable agony of the relative, who was invariably first on the scene.

Trauma apart, all sudden deaths leave the relatives equally shocked and bewildered. One evening, I visited a family that had sat down to a dinner of chilli con carne before the relatively young husband had a heart attack and died. I still remember seeing half empty plates and a half drunk glass of wine with a sense, as I entered the house, that no one knew what to do. That is when everyone looks at the GP and expects him or her to know, to give instructions and to manage things – whether it be about whether to call the undertaker right away, what to do with the body still sitting on the sofa or discuss details about registering the death or organising the funeral. However long you stay in such situations, it never seems long enough – especially when there is only one relative in the house and a dead body. Never perhaps more so than with cot deaths, which are rare nowadays but, thirty years ago, were an occasional and probably the worst out of hours call.

Not all emergencies, thankfully, were fatal. Shortly after I came to the practice – in 1986 – we decided that the duty doctor should have an emergency defibrillator in his/her car. These provide an electric shock to the heart, which can restore normal electrical activity and save a patient's life. Nowadays, a death from a heart attack for a patient under sixty-five is relatively rare. At that time over fifteen patients under sixty-five in our practice of around 10,000 patients, died of a heart attack each year. In the first few years that we used defibrillators, we were able to revive a third of those whose heart had stopped shortly before we arrived. This seemed to be an extraordinary high success

rate compared to hospital crash calls but possibly because these occurred in previously well patients.

I had to make one call of this sort to a patient, who happily lived in my own village and who had collapsed during the classic England/Germany world cup match, when England lost the final on a penalty. It was proof, if it was ever needed, that over-excitement, disappointment or a broken heart can literally kill. To my great surprise, the defibrillator worked second time and he was back home ten days later. We don't use defibrillators as much today because we now have far better systems for prevention and early detection, and most heart problems go directly to hospital rather than us trying to treat them at home.

The same goes for childhood asthma. On foggy nights in the 1980s, we would be called to two or three children with acute asthma each night and reverse this using our new high tech nebulisers. Like the defibrillators, they were lifesaving. Sometimes, however, they were not effective. I remember driving as fast as I could to Exeter with a mother and very sick asthmatic child looking paler and paler and gasping weaker and weaker until the breathing stopped. I stopped the car, horrified. I was just about to pull the pale motionless body out of the car and treat him for a respiratory arrest, when quite miraculously he gasped and then started breathing almost normally. We were lucky. Sometimes, as I later learnt, when the body stops altogether during an asthmatic arrest, the lungs relax and the patient begins to start breathing spontaneously, provided the heart hasn't already stopped.

I wasn't so lucky with a farmer's wife, who I had to treat just as I was coming off on call one morning. It was an important morning because I had promised to take Joanna for a small operation at the local hospital at 9am. "For heaven's sake don't be late," she said as I set off at 7am for what seemed like

a normal asthmatic attack. As we were equidistant from the surgery, I persuaded the patient's husband to meet me there and was dismayed to find a very sick and breathless patient waiting outside the surgery door. I led her into our small operating room and gave her a maximum dose on our nebuliser, but neither this nor injections of steroids and substances to open the lungs seemed to have any effect. She went from breathless to blue to white and then a few gasps and stopped breathing altogether. On this occasion the patient didn't start breathing again. I started mouth to mouth and cardiac resuscitation and by a stroke of luck one of our receptionists arrived at the surgery early and continued compressing her chest, while I gave her adrenaline.

Miraculously, she came around. Still very wheezy and breathless when the ambulance arrived, it was clear that her life was still in danger and she wasn't safe to go to hospital on her own. I had to telephone Joanna to say that I was not going to be able to take her to hospital as there was no one else to accompany this critically ill patient to hospital. There was silence at the other end of the phone. I knew what it meant. It is a scene that is played out so many times in a doctor's life, when he deeply disappoints those around him. It happened more often in those days, when in an emergency, we were quite literally the only person that lay between life and death. Joanna is the most supportive and understanding wife that anyone could possibly be, yet both of us still remember that brutal morning when, effectively, I deserted her.

Another medical emergency was a call to a farmer who said that his guests had fallen ill during a dinner party. "What did you give them?" I asked.

"We started with some lovely mushrooms. I picked them myself this morning. I know my mushrooms – it couldn't have been them."

"What did you have next?"

It was around nine in the evening. "We haven't had our second course yet."

One of the guests looked so ill that I wasn't even sure that she was going to make it to hospital. As ambulance response times were slower then, we were used to putting up drips and giving intravenous fluids before sending patients to hospital. That particular guest survived and all the guests recovered. The farmer was so sure that all his mushrooms had been safe that, ever since, I have never trusted my own judgement in picking mushrooms.

□ □ □

Apart from the serious and life-threatening emergencies, there were plenty of minor casualties from insect bites to moving metallic fragments from eyes.

One such minor casualty, or so I thought, arrived at the end of Saturday morning surgery as I was about to go out on an urgent visit. It was a middle-aged man, not a patient of mine, who had knocked on the door just after I had locked up a patient's notes and was about to leave the surgery. "Do you mind looking at my thumb, Doc?" he asked. He had shut it in a car door. It was predictably red and swollen and I judged – wrongly as it turned out – that it wasn't fractured. I dressed it and gave the usual advice about applying ice and elevating it and said he should come back and see his own doctor if it wasn't better in a week or two. It didn't improve and a few weeks later he saw his own doctor who organised an x-ray and discovered a fracture, which later required an operation.

I was shaken to receive a solicitor's letter some time later. My defence union decided that the case was indefensible and decided to settle out of court. They normally do to the irritation of many

doctors. Apparently, I had a poor case because I had written insufficient notes and thumb fractures are quite common when people trap them in car doors – something I didn't know at the time. The patient received a handsome out of court settlement. It dented my confidence. It was my first and fortunately my only case or complaint to date.

Honest mistakes were acceptable when I started general practice and patients would never think of sueing their doctors, who had acted in good faith. Hungry patients and eager lawyers have changed things utterly. Storm clouds are gathering on the relationship between patient, doctor and the health service. If mistakes are punished then logically one way of avoiding mistakes is simply to do less and so reduce the risk of anything going wrong – not to put your neck on the block when it can be avoided. If past medicine was about care, compassion and sacrifice then future medicine may command just a little less sacrifice. Next time someone taps on the door when I have finished surgery, I may simply direct them to the nearest casualty department.

Today (2020) the health service faces a £90 billion negligence bill – far more than half its annual cost of around £134 billion. Last year the NHS paid out more than £2 billion in negligence claims. The very concept of a health service free at the point of delivery is under threat from this alone. My younger colleagues are in constant fear and so terrified of getting things wrong that this can often deter them for following what they may feel instinctively to be the right course of action.

One of my happier memories is of a Saturday afternoon when a man had been fishing with his ten-year-old son. He brought him into surgery with a large fishhook stuck in the very top of his head. My youngest daughter, Libby, then aged ten, was helping me with my rounds that day and being about the same age as the

boy, was fascinated by the whole situation. We went into the tiny operating theatre in one of our branch surgeries. The boy lay down, hook in head, father on one side and Libby on the other. I told her to hold his hand and keep talking as I injected the local anesthetic and started with my scalpel to remove the hook. The scene of the two of them holding hands is imprinted in my mind forever – the boy didn't move or complain. He suffered in silence as Libby and his father comforted him and I removed the offending hook.

◻◻◻

In rural practice, many patients present with 'zoonoses', which are diseases that come from animals or insects. The commonest of these, historically, was brucellosis which was responsible for sizeable rates of depression and suicide in vets but was becoming thankfully much less common when I entered general practice. In those early days, sheep farmers would commonly present with orf, which I misdiagnosed in my first patient as a tumorous growth on the finger. Lambing sheep would also present the threat of enzootic abortion and it was important that pregnant women avoided being in contact with infected animals. Lyme disease has always existed but appears to be on the increase, especially as the parasite is now being found in both the nymph and larval forms as well as the adult tick. Consequently, we are now seeing it in patients who were never aware of having been bitten by a tick, and this is further complicated by 20–30 per cent of patients with Lyme disease never developing the easily diagnosable rash – erythema migrans. Often the first signs can be arthritis of a limb or paralysis of one of the eye muscles.

I encountered many other diseases that I had never seen in the city such as mycoplasma (which would cause a fierce headache, fever and pneumonia), Q fever and on two occasions,

psittacosis, which made each of the patients gravely ill. The puzzle with both was that psittacosis is commonly caught from parrots and though the diagnosis was confirmed in each by our excellent microbiology department, neither had had any contact with parrots! Leptospirosis, caught from rats and particularly from contact with their urine, presents from time to time. It is a particularly malevolent condition that starts with a more or less flu like illness from which the patient seems to get better before succumbing to the full weight of this awful disease, which can then progress to blood in the urine and occasionally (though happily not in my experience) proves fatal. Every now and again a patient can still present with something that is beyond even the most seasoned GP's experience.

A farmer rang me one morning when I was on duty. He was in some distress. "There is a giant bug coming out my nose. Can I come and see you?"

As perplexed as the patient, I said, "Of course, come right away."

Seeing the patient fifteen minutes later it was clear that a giant bug was actually coming out of his left nostril or to be precise, had just emerged as he entered the consulting room. It looked like a giant maggot – about an inch and a half long and almost an inch wide. Furthermore, it was alive and wriggling. The farmer seemed highly relieved after delivering the bug as a mother might following childbirth. I sent the wriggling specimen off to the laboratory, where it was diagnosed as a 'Bot Fly'. It is a bug that normally inhabits the noses of sheep and goats in North Africa. The patient had been lying on a beach in Tunisia six months previously and had suffered since from sneezing and sinus problems, which had then proved to be due to this bug growing in his nose – now safely in a laboratory pot.

Tropical diseases could be particularly mystifying, as could

the expert advice on what to expect and how to overcome them. One patient explained to me with total resignation "I ate a malaria eating mosquito ten years ago. The tropical people told me that when it's hot I won't be able to sweat but when it's cold I will." This seemed entirely reasonable to the patient who felt that this had become the case but inexplicable to his GP, who had to work out whether the patient or the tropical experts had gone entirely mad.

Gone today are those moments of intimacy, when you are removing a lump from the head, a piece of wood or metal from an eye, an early skin cancer from the leg or even a ball bearing from the nose. General practice is no longer paid or trusted to do these things, which go to accident and emergency departments in hospital instead. Meanwhile, GPs are blamed for an increasing number of people going to A&E. The outcome is more expensive though I am not sure it is either clinically better or, indeed, good for GPs themselves, who are left with consultation after consultation seeing patients with a number of complex symptoms and diseases and have to carry the full weight of human misery. Gone too are the relatively simple problems requiring quick solutions that made up many consultations in the past. No longer do we perform minor operations along with the idle chat that accompanied them and the important revelations that such chat produced.

Not so long ago, a fourteen-year-old girl and her mother came to see me because the girl had quite an unsightly but clearly a non-cancerous blemish on her nose. They had been told to see a plastic surgeon but couldn't afford it. Another GP partner had told her that I might be able to help. I couldn't be sure that my intervention would make things better. Wounds can heal unpredictably and if the patient was to form a keloid scar, then the result would have been far worse than her original blemish.

Nevertheless, they implored me and against every medico legal flashing light in my brain, I did operate but with considerable anxiety. The result was a success but I am not sure that I should have done it. The whole ratio between doctor/patient trust, fear of complaints and litigation and acceptable risk has now changed so much that I would almost certainly never do it again.

Vera was an eighty-six-year-old retired school nurse who also presented me with a difficult decision. I had removed a number of large lumps from her head (sebaceous cysts) in the past, but not so long ago she came in with one that was not only very large and visible but also making it difficult for her to brush her hair. As always, she came in with Graham, her son aged sixty-four, who has a learning disability.

Graham is utterly charming and has a lovely smile when he is in company that he trusts. It is a standing joke between us that once I have examined him or Vera, he will prepare the examination couch for the next patient by removing the old paper from under the sheet and replacing it with a new one. He previously had sheltered employment at the local slaughterhouse. Vera and I had had to intervene when he was being teased by other staff, who should have known better. As a doctor, you always know where you are with Graham. He will say quite definitively if a treatment does or does not work.

Anyway, following 'new rules' I had to tell Vera that I was no longer able to operate on her lump. Our GP practice was no longer funded to do such operations. I was also now supposed to do annual training if I wanted to do so in spite of having operated on my patients for lumps and bumps for over thirty years. My only option was to refer her privately to a local plastic surgeon. She returned a week or two later looking despondent. On the basis of the photograph that I had sent, it would cost her £700 to have the cyst removed – well beyond the pension of a

retired school nurse looking after a vulnerable son. Ten minutes later we were sitting in the otherwise unused operating theatre of our new Integrated Centre for Health. Graham holding Vera's hand. The procedure took no more than fifteen minutes. I carefully hid all the used instruments. Working in a system that has lost its kindness and which underrates and undermines the importance of kindness provided by its staff adds yet another pressure to those of being a modern family doctor.

Even more recently, when I was doctor on call, a mother rang me saying that her epileptic daughter had crushed her ear during a fit the previous evening and the earring had become embedded in the earlobe and was not retrievable. Everything in our current system told me that I should send her to the local accident and emergency department but she refused to go there. She said she was fed up with hospitals. I asked her to come to the surgery and holding the hand of her boyfriend, I was able to find the stud of her earring quickly using a local anaesthetic and a scalpel. She was immensely grateful not to have to go to hospital yet again.

I feel ashamed to practice in a system that may do technical things so much better than ever before but which has also had to become expert at protecting itself against the greedy, the vindictive and the embittered. Too often it means that we now fail those who are none of these. Many of them – particularly the elderly and the vulnerable – just want a reasonably good service. They are not bothered if it is not technically the best. More than that, they want a service that is easy to get to, compassionate and which is provided by people that they know and trust.

□ □ □

On 18 November 1998, I had to drive that afternoon to London to chair a two-day medical conference. I knew that Joanna didn't

want me to leave. Things weren't going well. Finn was having problems at school, her car had broken down and we were recovering from the effects of a recent flood. I knew she was unhappy but I had to go.

An hour later I was filling up my car with petrol at a service station off the M5, when she called. She spoke calmly but I could detect panic in her voice. "The house has blown up. You must come back right away." I started asking questions but she continued, "I can't talk. Everything is happening here. We are all right but you must come back **now**."

◘ ◘ ◘

An hour later, I witnessed a scene of devastation. The village's firework factory, just upriver of us, had exploded. Its roof had gone into the sky and landed in a field several hundred yards away. Fortunately the children were in school and no one was harmed. The sonic boom had directly hit our house and then been trapped by its L-shaped medieval design. Consequently, half the house's windows had shattered into the house and half had shattered out into the garden. The main beam in the sitting room had collapsed through the plaster ceiling showing its fractured edge. That part of the house had cracks all over it. Inside the house, Joanna and two close friends from another village were busy cutting bits of hardboard and turning them into makeshift window panes. Was this the end of our dream and of all that hard work and money spent?

The next few months were months of hope and desperation. Hope, when our insurance company's structural engineer arrived and put props all over the house to hold things up. Hope also, when he told us that the insurance company would pay for the broken main beam. Despair a few weeks later, when he told us that they would indeed pay £350 to replace the broken beam

but that was all. "What about all the building that we need to make good all the disastrous consequences of that broken main beam?"

"I am afraid that's not covered," he replied.

Apparently he had discovered that the beam and that part of the house had been unsafe for some time due to the faulty workmanship of Tudor builders some 450years before. The beam that had broken had itself been repaired and there was even a date – 1555 – at the junction of that repair. Furthermore, these Tudor wide boys had replaced the windows and instead of putting bricks, where the old windows had been, they had simply filled the casement with rubble. According to our structural engineer, the house had simply been waiting to fall down for over 400 years.

We were in no position to question his opinion but pointed out that before the explosion the house had been standing and now it no longer was. We were desperate. We couldn't afford the repairs and neither would we be able to sell a house that was almost entirely uninhabitable. Our nerves were frayed and we did not sleep. Finally, in answer to our protests, the insurance company sent a new surveyor to arbitrate. I remember the day well. Joanna, myself and the new structural engineer were standing on a few floorboards that were the remains of our bedroom, which was now open to the sky. Joanna was in tears and, unusually for me, I was angry. The anger of a desperate man. Then the conversation changed. The new surveyor confided that he did not agree with the previous judgement and that the costs of the rebuild should be paid in full. Shortly after that, we heard the firework company's own insurers had agreed to pay for any damage caused locally.

The stress was over, but it was a further six months before we were able to move back into the house. During that time the

three children lived with my mother-in-law in her tiny annexe, while Joanna and I spent those months in a small attic room at the other end of the house, which had been relatively untouched by the blast.

I shall never forget that Christmas of 1998. Trying to get answers from surveyors, structural engineers, insurers and builders, while they answered their telephones during Christmas parties and never knowing if we would still have a house or not. As with many disasters in life it had taught me lessons. I had experienced those same feelings of helplessness which are so often the cause or consequence of illness in my patients along with the fear, desperation and anger that result from them. I had been at the receiving end of a superficial offer of help from one surveyor who only went by the book, followed by a much more human and helpful answer from the second who had taken our whole situation in to account. Meanwhile, life as a country GP continued. A collapsed house might have seemed like an emergency to us but, as far as the practice and patients were concerned, business continued as usual.

Chapter 10

A WALK ON THE WILD SIDE

Natural forces within us are the true healers of disease.

Hippocrates

I had been a GP in Cullompton for ten years. I was driving to work one rainy Monday morning and experienced a deep sinking feeling. I was dreading another whole day of seeing patients who would be as frustrated (as I was) with how little I had to offer. I began to realise the huge limitations in what I could do for my patients. In too many areas of medicine there seemed to be 'evidence gaps' with conventional medicine having no answers. Patients come to see me with a vast array of symptoms such as chronic tiredness, back and neck pain, headaches, eczema, irritable bowel syndrome, fibromyalgia, premenstrual tension, stress and depression. Too often the medical model failed to explain their symptoms or provide a helpful answer. Too often, also, my treatment for such conditions was at best partially effective and sometimes not effective at all. I was depressed and on the road to burn out.

It was around this time that Gill, the wife of a local judge, asked to see me. By this time we had moved away from the health centre with its leaky roof to a new surgery that we had built ourselves.

Gill was a Christian healer and she said she would like to treat patients at my NHS GP surgery. Initially I was reticent, to say the least, wondering what patients, my GP partners or the Family Practitioner Committee (our ruling body) would think if a surgery offered the services of a healer. Gill was a

force to be reckoned with and 'no' was not part of her lexicon. We compromised, initially, with her seeing some of my patients outside the surgery and my observing what happened to them.

I was quite surprised by the very positive feedback that they gave me. I remember, in particular, a patient who was dying of widespread cancer and had been terrified throughout her ordeal. Having seen Gill, she far outlived her predicted time and died with an aura of happiness and calm. So I buried my reservations and with the support of extremely open-minded but rightly sceptical GP partners, invited her to come and do clinics within our GP practice. It soon became clear that she was offering immense benefit to patients, and I was particularly fascinated because she didn't have any of our conventional gimmicks such as pills or injections or even those of other complementary practitioners such as needles and medications. Consequently, I started to study what was going on and the results of my research were eventually published in the *Journal of the Royal Society of Medicine*. The editor of that journal (who had previously been the editor of *The Lancet*) said in his leader of the issue which published my paper, that the healer had undoubtedly helped my patients but he raised the question as to whether this might simply have been a 'placebo'. This has been a debate that has raged ever since and involved many other areas of complementary medicine.

As far as I was concerned, my patients had been helped and were both healthier and happier than previously. Surely that was all that mattered? As far as the scientists were concerned, this was not legitimate if it had simply been a 'placebo effect'. It seems a little odd that until a hundred years ago medicine almost entirely relied upon placebo and yet today it is regarded as fake, illegitimate and something that messes up good scientific experiments. I challenged this view in my book

The Human Effect, written with the late Dr Kieran Sweeney and feel today that medicine is missing a trick by ignoring the huge healing power of the doctor/patient relationship.

I was mesmerised by Gill's ability to make people better using absolutely nothing (apart from herself). To find out more, Joanna and I signed up to her Wednesday evening sessions where we learnt about a different complementary method each week. I remember leaving surgery hot and sweaty, one Wednesday evening, when the session was to be on reflexology. Just something to do with reflexes, I assumed – so no need to change my clothes before going out. It was a decision that I was to later regret as I worriedly removed my socks to be a 'demonstration patient' for a therapy that turned out to have everything to do with feet.

From then on, I made a conscious decision to get out of my medical groove. I did a week's course on manipulation (for necks and backs) and then a day's course on herbal medicine. The latter was the beginning of a fascination with herbal medicines and how herbs growing in our own garden could be used for a wide variety of conditions.

Shortly after the course, a patient phoned me early on a summer morning with abdominal pain. She had a history of irritable bowel and said that the pains were worse than ever. I had a good idea that it wasn't serious but as she had no medication in the house, I asked her to go out into the garden and gave her instructions on how to make mint tea. As I sank back into precious sleep, I reckoned that it would take at least an hour for her to pick and prepare the tea and wait for any effect.

Later I woke in a sweat. What on earth had I done! I started rehearsing my would-be defence at a hearing of the General Medical Council. Then I phoned the patient. Ten rings and no answer. She must be dead. Then at last she answered. "That was

a great suggestion, doctor, it worked a treat and the pain has all gone. I was asleep when you called."

I felt a similar feeling of panic a few years later when we had moved into our wonderful new 'Integrated Centre for Health'. In the car park we have an organic fruit and vegetable garden and also a herb garden with a box hedge in the shape of a man, with all the various herbs growing according to the parts of the body that they are useful in treating. Bob, who kept the garden was keen to know the uses of the various plants and would walk round asking me to tell him each plant's use: "Lemon balm – that's very good for helping people to sleep, red sage helps ladies through the menopause, dill is excellent if you are getting stomach pain, rosemary is helpful with memory… etc… etc…".

Thinking no more of it, I wondered a few weeks later why there seemed to be less pressure on doctors' appointments. One day I ventured outside the front entrance and round to the herb garden, where I found that Bob had lined up rows of pots for sale at £1 each labelled with their various uses – 'Rosemary if your memory is getting bad', 'Lemon balm if you can't sleep', 'Red sage for those hot flushes' etc… Furthermore, he had taken to intercepting patients before they got to the main door of the surgery, asking them what their problem was and then giving them the requisite herb and collecting a pound in the process for our equipment fund. Once again I saw myself being hauled before the General Medical Council with newspaper headlines saying 'NHS Cuts – GPs tell patients to grow their own herbs'.

From manipulation and herbs, I graduated to acupuncture having found that it had virtually healed my own frozen shoulder. Then I got interested in diets and the 'human biome'. The gut with its trillion bugs of over a thousand different varieties clearly governs our bowels but also dictates our weight, our mood and many other things.

Around this time a patient, Karen, came to see me with what the surgeons were calling intermittent appendicitis. We used to call this a 'grumbling appendix' but the term is now frowned upon. With antibiotics and all the other medications that we had given her being unsuccessful, the surgeons had finally listed her for interval appendicectomy (removal of the appendix). With my new-found interest in diets in full flow, I gave her a dietary regimen – written in fountain pen on headed notepaper to give it authority. The pain has never recurred since and she never had her operation.

My interest in complementary medicine was not only helping several of my patients but also giving me a renewed interest as a doctor. I was beginning to fill in those evidence gaps – diseases or problems for which there was no known conventional treatment. Inevitably, the evidence was usually less robust than with conventional remedies but provided they were cheap, safe and didn't stop patients getting conventional treatment where it was effective – I couldn't see any problem. The first tenet of the Hippocratic oath is 'do no harm'.

Chronic tiredness is a case in point. TATTS (Tired all the time syndrome) is particularly frustrating for patients and doctors because there is no conventional treatment for it. A tenth of our patients come to see us complaining of chronic tiredness, but only in one fifth of them are we able to find a cause such as thyroid disease or anaemia. The medical cupboard is empty in terms of any useful treatment. Often doctors try to bulldoze patients into agreeing that they are depressed and give them an antidepressant. The research shows that though this may be true for a third of tired patients, there are a third of patients with chronic tiredness, who are not depressed and a middle third, where the patient doesn't think they are depressed, though the doctor does. A group of us did

a pilot study on a herb – St John's Wort (*Hypericum Perforatum*) – at my own surgery. This suggested that it could be useful for patients who were simply tired but (using a questionnaire about depression) were not depressed. Unfortunately, we were unable to get further funding for more definitive research on this – herbal preparations can't be patented unlike their highly profitable pharmaceutical cousins.

By this time I was beginning to pick up quite a few tips from my own patients. Some were using horse embrocation for their sore knees. Others would take cider vinegar and honey or rosehip (which has recently been found to be an effective treatment by mainstream doctors) for their arthritis. If patients had a cold they would boil an onion in vinegar. For warts they would see a wart charmer. If patients thought these things would help them – what was the harm? It nurtured a good habit of self-dependence, which has sometimes been eroded by my profession's over-medicalisation. Recent published research shows that patients of GPs with an interest in complementary medicine are 25 per cent less likely to be given antibiotics.

My next journey was into mind-bending techniques and started with self-hypnosis. For many years Joanna had noticed that I would get low and irritable in the autumn after our summer holiday, with a whole year to work before the next one. She bought a book on self-hypnosis and we read it together on the last day of a family holiday with my parents in Menorca. I had to write down and repeat all sorts of positive messages about finishing my holiday and returning to work. It worked. My GP partners, witnessing my new cheery autumn self, wondered exactly what drug I was taking. From then on I explored Thought Field Therapy, hypnosis, meditation and a whole range of mind/body treatments. They were often quick, unlike psychoanalysis, and didn't require you to go back in time but simply re-build the

future. These treatments have made an enormous difference to me and many of my patients.

One of the few evidence-based treatments currently approved by the NHS for anxiety and depression is cognitive behavioral therapy (CBT). The problem is that it is expensive and time intensive requiring a clinical psychologist and several weeks of treatment. Furthermore, waits for this treatment, in our area are usually up to a year or more. This is damaging to patients because it leaves them in therapeutic limbo for several months and carries the implicit message that they don't matter. Nor is CBT always successful. Consequently, it seems common-sense to try these much shorter and cheaper treatments even if they only obviate 50 per cent of ongoing referrals to CBT, which remains the clinical community's 'gold standard' treatment. Unfortunately, though I see them work with my own eye, they don't have an official evidence base and thus patients cannot get them on the NHS and clinicians don't recommend them – largely because they don't know enough about them or their method of working or how safe they are. Also, because in a litigious society they are loathe to risk suggesting treatments that go outside traditional evidence based medical tramlines.

My increasing satisfaction with professional life and the positive feedback from patients was in contrast to the jeers and personal, vindictive criticism that I received from fellow clinicians, when I started to write about my experiences. None of this came, I should add right away, from my open- minded GP practice partners, who were and remain always supportive or at least tolerant (even though some are sceptical) and often referred and still refer patients to me, when all else has failed.

There is no sin worse than challenging the totemic foundations of your own tribe. The physician, John Snow, found this when he proposed his germ theory of cholera. London's leading

Medical Officer at the time labelled his theory 'peculiar' until he controversially closed the Broad Street pump, the cholera epidemic ended and he had proved his point. Cicely Saunders, who founded the hospice movement, received similar opposition from the conventional medical establishment. Complementary medicine faces the same challenges. Having trained for many years in conventional medicine, many medical colleagues see complementary medicine as an insult to them and their profession. How could complementary therapists possibly provide useful answers as well?

One of the challenges was that complementary medicine was unsafe. Undoubtedly it can be in the wrong hands – as with any treatment. But it seemed a bit rich to attack complementary medicine on this score when conventional medicine could be so much more dangerous. What about the 2,000 deaths a year due to bleeding from the stomach, when patients take anti-inflammatory agents for arthritis/other pains? An unbelievable one in eleven of our patients today are medicated with sleeping tablets, tranquillisers, antidepressants or strong pain killers. We have created a drug dependent, over-medicalised army of patients – often with no clear diagnosis (the official term is 'medically undiagnosed symptoms'). Having given them often addictive and frequently harmful medicines, we as the medical fraternity then have the cheek to say that complementary medicine is unsafe! Biomedically trained complementary therapists, such as osteopaths, on the contrary contribute in a very positive way to patient safety. Concerns raised by an osteopath in my own surgery over just one year led to the prompt diagnosis of a malignant melanoma (potentially fatal skin cancer), cancer of the spine and temporal arteritis (a condition that can cause blindness if not treated rapidly). All these were patients who I might not otherwise have seen until it was too late.

Furthermore, some of the safety concerns for complementary medicine are a direct result of the attitudes of conventional medics themselves. Studies suggest that 50 per cent of patients taking complementary medicine or seeing a complementary practitioner do not feel that they can tell their usual doctors. Often this is because they say they are fearful of the negative reactions of many conventional doctors.

If there are flaws in the safety argument, the same applies to the other major criticism of complementary medicine – its lack of evidence. In my early years as a GP, I have to admit that evidence did not really interest me very much. What worked for my patients and what worked for myself was good enough evidence – evidence of my own eyes. Bad science perhaps but possibly good, or at least, reasonable medicine – when it came to my own patients. As the NHS becomes increasingly concerned about an evidence base and the need for double blind placebo randomised controlled research trials, complementary medicine is bound to lose out. It was on to a losing wicket from the start because the NHS is not open minded enough to fund the necessary research to prove it. In recent years none of the NHS research budget has been spent on investigating complementary medicine. When clinical trials were funded, they too often asked and answered the wrong questions, which may have been of interest to researchers but not to clinicians. For instance, researchers have looked at 'Is conventional acupuncture more effective than sham acupuncture?' or 'Is homeopathy a placebo?' More often than not the research has failed to be conclusive.

Instead, the research that practicing doctors require is much simpler and more down to earth. It is along the lines of 'If a patient comes to see a doctor with a headache/back pain or a sore knee which better treats their symptoms or gives them a better quality of life – a current conventional treatment or an

alternative complementary one? If a patient is depressed or stressed how does an antidepressant or tranquilliser compare in terms of long-term cost effectiveness with a visit to a homeopath?' Without this sort of practical evidence it is difficult for clinicians to make an opinion. The scientist wants to isolate the treatment from the individual patient or practitioner. The clinician wants to compare the whole bang lot (practitioner, patient and treatment) with an alternative. That is because in the real world, the clinician and the patient and their perspective and beliefs and motivation are all relevant. Evidence-based population research gives us information on the 'normal' or 'average' patient but I have yet to encounter a normal or an average patient. Different treatments suit different patients and guidelines necessarily rule out these individual subtleties.

The pity of all this is that complementary medicine surely does have a place in medicine and could undoubtedly save the NHS a substantial amount of money – particularly as complementary therapists are far cheaper than conventional ones. We now need to stop asking the question 'Complementary medicine – bad or good?' And replace it with one that asks 'What is the place of complementary medicine in a modern health service?' Instead of this commonsense point of view, the NHS has firmly placed itself as anti-complementary. The National Institute for Health & Care Excellence Clinical Guidelines have dropped complementary therapy from their palliative care and back pain guidance. NHS England has banned the use of herbal/homeopathic drugs. The cost of these were around £100,000 a year – one thousandth of the one hundred million pounds that we spend unnecessarily on medication for constipation, which could be sorted in many cases with proper lifestyle advice and natural remedies. As the prevailing wind of intolerance blows ever harder, the Council of the Royal College of General Practitioners recently told GPs

that they should no longer be offering homeopathy to patients in their consultations. Is such intolerance appropriate in our pluralist society?

Homeopathy is seen as one of the weakest links in complementary medicine as it defies current medical theory and yet, paradoxically, many patients claim to be helped by it. A few years ago there was a study on aromatherapy and the researchers concluded that it did not work on the basis that though it did help those with a positive attitude towards it, it didn't work for those that did not. Good science should surely have concluded that it did work but only for those with a positive attitude. Here lies the rub. The patient is not a black box to which we subject treatments with a population research-based x per cent chance of success. Patients are complex, self-organising and self-healing beings with a vast array of internal drugs. These include natural painkillers, steroids and hormones, which are the agents of healing in self-limiting conditions and can play a major complementary role in those treated for serious disease with conventional medicine. Thus the success of any treatment depends very much on patient perspective, the peculiarities of their mind, body, genes and biome. It is well documented that if a patient thinks a treatment will work, then 'ergo' there is a much greater chance of it working.

Research and evidence have taken centre stage although sometimes we may have forgotten how often scientists have prevaricated and even changed their mind on issues such as hormone replacement therapy, drugs for heart disease and even aspirin during the last ten years. Surely in future, it should be patients that take centre stage advised by clinicians, who are able to balance the idiosyncrasies of each individual patient with the current population-based evidence. What is to be lost, provided that whatever treatment a patient chooses is safe and his beliefs

do not exclude him from having a conventional treatment that might be potentially lifesaving? Unfortunately, in this vitriolic debate, the ordinary patient hardly gets a look in. It is a debate that is too often dominated by the vested interests of conventional medicine and its Royal Colleges and by sundry commentators, who may have never experienced serious illness or ever been treated by a complementary therapist. On the other side of this debate, admittedly, there are some complementary therapists who choose to defy what is well proven in conventional science and confuse their patients by having a negative view of doctors – as some doctors do of them.

In 2010, I founded the College of Medicine. This was in part to create a college that could be a disinterested umpire in this whole debate and create a level playing field where a patient could, in the words of HRH The Prince of Wales, access 'The best of both worlds' – the best of conventional and complementary medicine. Complementary medicine is still largely despised by many medics, who may have felt their blood boil as they read this chapter. I can only reply that I felt that way once. I now recognise that it wasn't the doctor or the scientist in me speaking but someone with a closed mind, who was fearful that some answers might lie outside everything that I had been taught or previously learnt.

My next venture into the unknown was what is today called 'Social Prescription'. It had become increasingly obvious to me that my patients were being helped by a whole range of interventions that often had nothing to do with pills or medical procedures. One of our first initiatives was to introduce an 'exercise on prescription scheme' in the local gym run by the local council. Patients prescribed exercise could join the gym at a vastly reduced expense. Extraordinarily, the scheme paid for itself because sufficient patients stayed on after their initial

induction and they consequently paid the full rate to support further sets of patients, who were tempted to take up these cheap introductory sessions. From there we introduced 'walk and talks' – where patients lead walks of varying length and direction depending upon their members' physical abilities. Mother and toddler walking groups were added to the list – enabling mothers to get outside and also to exchange tips and frustrations.

Later we introduced 'question time evenings' at our new Integrated Centre, where a GP, pharmacist and complementary practitioner would answer questions on a particular disease topic. These were normally fully attended and often ended with patients ignoring the speakers and exchanging their own tips. Frequently they would then form patient groups to support each other in whatever disease area was being discussed that evening. Loneliness and isolation was another major problem and a 'Knit and Natter group' arose and, we also started memory cafés for patients with dementia. Bit by bit we have added other items such as benefits, housing, employment advice and solving difficult family relationships through to gardening and singing groups, yoga, Tai Chi, meditation and sitting exercises. It soon became clear that there was an army of local volunteers and voluntary organisations that had an enormous potential to improve the health and care of our patients.

Early on, we realised that the patients who most needed these things were often the least likely to use them. Often they lacked self-esteem/self-confidence or were nervous and fearful, possibly felt alienated or unmotivated for a whole host of reasons. So, we approached Ruth, who had set up the local exercise prescription scheme and she came to our new Integrated Health Centre as our 'health advisor'. She would receive referrals from us doctors (the social prescription) and then see each patient for half an hour to share his/her views, beliefs, challenges, wants

and needs and then provide a personalised menu of non-medical interventions that might help them to become stronger, more self-reliant and less dependent on NHS resources. We did some formal research (symbolically supported by *Dial a Flight* rather than any NHS research body) which showed that a third of diabetics or those at risk of diabetes after seeing Ruth, our health advisor, were no longer either diabetic or at risk of diabetes. A cost effectiveness review of our results concluded that there had been NHS savings in the first year quite apart from the long-term savings from patients no longer being diabetic or at risk. Increasingly, evidence from Rotherham, Gloucestershire, West London, Croydon and Frome was showing that social prescription substantially reduced the need for GP consultations and hospital admissions and though the evidence was by no means conclusive, unlike the situation with complementary medicine, there was very little opposition to these ideas from the conventional community.

Perhaps the NHS and its professional bodies were beginning to learn a little humility. After all, in spite of our best efforts, the rate of obesity, diabetes, stress, depression and cancer are all continuing to rise rapidly. Furthermore, expenses continue to exceed health service income and NHS financial sustainability is becoming a real question. Anything that might reduce NHS costs should be very welcome.

Social prescription is, in some ways, back to the future. Ruth, our health advisor, is offering the sort or personalised care that we doctors were previously able to offer, when the pressures were not as great as they are today. She has time to discover their hopes, fears, challenges and abilities. Time, that is, to understand each patient in a way that is so much more difficult for the GP in the current environment. Time matters but health advisors like Ruth are also unthreatening – having been part of

the local community for years – and with motivational training she is able to inspire and activate each of her patients to become their own agents of healing and living healthier lives.

Social prescription does two other very important things. It moves medicine and general practice from a very biomedical model that previously only provided tablets or procedures to a more psychosocial model of care that makes better use of the patient's physical and social environment. It is about de-medicalising care and avoiding patients becoming dependent on doctors or drugs and seeing themselves as their own agents of healing and health. That has to be the future path of medicine and social prescription is offering our most vulnerable patients a new direction. It is proving to save GPs' time and connecting general practice to the community, which is itself now providing many of the answers for their patients often through volunteer and voluntary organisations.

Social prescription is also a Trojan horse for developing health creating communities. Too often patients come to our surgery because they live within alienated communities that make them ill. Social prescription provides general practice with the means of reducing factors that lead to patients coming to see GPs in the first place and interventions that might help to improve their lives after each consultation. Where social prescription is successful, it is increasing the number of offers available from the volunteer and voluntary sector and creating an ever-wider range of potential community interventions. This adds to local social capital and will increasingly have a major influence in improving local health.

Sir Tim Schmidt, founder of the Eden Project, recently described social prescription as restoring hope to medicine. We now realise that it is not enough to hector our patients with messages such as eating healthier or exercising more. They

need to be in the right frame of mind to do so. That means, at first base, feeling that your life has meaning and significance. Without these things, we can never heal ourselves and health is unimportant.

Today, social prescription has become part of national policy. It has developed with extraordinary speed. Only a few years ago a small group of us decided to make it into a national movement. Today NHS England is funding the universal rollout of social prescription so that, in future, it will be available for every GP and every patient. Other countries are now following suit. It has liberated the concept of non-biomedical approaches being relevant in treatment and health. It has also legitimised the use of such approaches outside a traditional therapeutic armamentarium that was historically confined to drugs and medical procedures. Previously my fellow GPs called me 'the vicar' for proposing these ideas. It has been gratifying to find them become mainstream within a very few years but challenging for likeminded colleagues and myself to find that we are now part of the current orthodoxy!

What have I learnt from my walk on the wild side? That every medical premise can be challenged, that vested interests reign supreme and that accepted wisdom is often merely prejudice. That everyone is different – patients, doctors and their interactions. That modern medicine, guidelines, computers and formularies have made medicine far safer and more effective in the areas that they are able to be effective. But this has also homogenised medicine. The science of medicine has superceded its art. The doctor as technician, applying evidence-based medicine, has replaced the doctor as healer. The most dangerous thing that a doctor can do these days (in terms of his/her career) is to deviate from clinical guidelines.

If a doctor has failed to help or comfort the patient. If he

does not see it as part of his role to inspire, to encourage or to provide his patients with hope, then these are issues of no interest either to the General Medical Council or any overseeing or remunerating body. Being up to date with current evidence, following guidelines and prescribing according to the official formulary are all that matter. Population-based medicine uses evidence from whole population statistics to provide medicine that fulfils the dictum of 'The greatest good of the greatest number'. It has achieved immense good, especially in specialist medicine, but it cannot, on all occasions, decide what is best for any individual patient. Especially when the patient has many symptoms and several diseases. The underlying reasons why they are not well and why they cannot easily be healed may go far deeper still. The strength of primary care and general practice is that it reaches beyond each system and disease. Much of what happens between a doctor and the patient is unspoken. Our most important work cannot be entered on a spreadsheet.

It has been estimated that 25 per cent of what we do as GPs has no evidence base. Is this the remaining 25 per cent of general practice that must be eliminated? Or does it represent the final citadel of personal medicine?

Chapter 11

MAGIC AND MYSTERY

*The intuitive mind is a sacred gift and the rational
mind is a faithful servant. We have created a society that
honours the servant and has forgotten the gift!*

Albert Einstein

When our house blew up, an odd thing happened. The fractured beam in the sitting room had torn open the plaster. A bundle of letters that must have previously been between the floorboards of our bedroom and the ceiling of the sitting room floated down to the sitting room floor. Each had a thick black border. They were letters of condolence to a man called Swetenham Bishopp following the death of his wife Hilda, who had died in our house following childbirth a hundred years previously.

I knew Hilda's story well, having researched previous owners of the house. She had died from an infection (most probably a post puerperal streptococcal infection) shortly after having a baby. Post puerperal streptococcal infections were common in those days and, before the age of antibiotics, frequently fatal. After she died, her husband had taken to drink and seems to have been rescued by his housekeeper. At a later date, the owner and the housekeeper and the now young child left the area altogether. Hilda has a rather poignant grave in our local churchyard. It is a double grave and she occupies half of it. The other side remains empty.

Until the time of the fireworks blast, Joanna and I would frequently wake up at night and smell a very distinctive perfume,

which had a strong scent of roses. It was intense and quite different from any perfume or aftershave that either of us ever used. It was some years before we discussed this and found that we were both waking up with the same experience. After the blast, the smell inexplicably disappeared forever. Was it something to do with the explosion or the rebuild? Or was it Hilda at peace at last?

◻◻◻

Sylvia is a witch. To be precise, she is a hedge witch. Hedge witches, Sylvia tells me, are good witches. They are also quite sociable souls and meet in a local pub on Thursdays.

Sylvia has a pet chicken. She brings it into surgery to the delight of any children in the waiting room. She also brings me six eggs, whenever she comes for an appointment. She has a number of long-term diseases and problems – some dating back to a difficult and troubled childhood. For these, she has a repeat prescription list that includes quite a few conventional medications for her different conditions. She treats herself for most problems and, if she asks my advice she is normally keen to try a complementary option first if it is appropriate. She is the magician and I am simply her pedestrian advisor. Investigations and hospital visits are anathema to her. If all patients were like her then this would probably halve the cost to the NHS.

Sylvia tells me that there are also white witches. Apparently, they are also good but represent a more conventional wing of the witch community and are not quite as sociable. One grateful patient told me about her visit to a white witch. "Everything was going wrong. If I touched anything it exploded. If I planted anything in the garden it died. Then I went to see a white witch. She said I was definitely under a curse and she removed it. She offered to give me back my £50 if it didn't work".

Magic and mystery are a big part of healing for many patients.

Some like Sylvia produce their own magic, whether it be traditional remedies handed down through the family or a friend who is a wart charmer or a healer. Some magic was traditionally dispensed by us doctors – the Horny Goat Weed that I gave my patients with impotence probably falls into that category.

It is when things are at their worst that we take to prayer and seek magical solutions. It might be the patient, who has just been told that he is going to die and that nothing can be done medically. Perhaps the man who has made a series of wrong decisions and ended up estranged from his family with no job and no friends. Possibly the elderly person with a whole range of aches and pains that are an inevitable part of ageing. In their heart of hearts they know that little can be done, but they need hope and something to alleviate their suffering. These patients don't want their doctor to be ordinary – the man in the pub – they want him or her to have special abilities and powers and to exert 'sapiential authority'. Research shows, for instance, that patients have more confidence in a well-dressed doctor than one who is less so. They don't need to be on a pedestal but they do need to be credible and have the patient's best interests in mind and, preferably, special powers of healing.

A number of studies are showing that doctors, when asked what makes a good doctor, talk about technical expertise, postgraduate training and a well-organised practice – all left-brain type qualities. Patients conversely assume their doctors know more or less what they are talking about and rate them according to much more right-brain attributes – are they friendly and welcoming, concerned, compassionate and are they good listeners, who can provide them with hope? They want a healing ability that goes beyond medical knowledge or simply being a sympathetic listener. It may explain why some doctors take up complementary medicine.

I am not advocating that family doctors should become mystics, but merely saying that our consultations are infinitely more complex than the simple medical model of 'symptom ➠ diagnosis ➠ prescription'.

It may be surprising to some that many of our patients are far from clear as to why they are coming to see us in the first place. Yes, a headache, neck ache, stress or inability to sleep – but there are things that lie behind these symptoms that may matter much more and which require something more profound than just literal answers. A few years ago, I started keeping all the lists that patients brought with them to my consultations. On average there were about five items and I estimated that in about half of the cases the real problems (e.g. impotence, a cantankerous mother-in-law, inability to get over a death or general sadness) were not listed at all. Consequently, explicit symptoms may often be simply metaphors for what is actually going on. The danger is that if we doctors don't recognise this then we treat our patients literally, fail to solve the underlying problem and the patient continues to suffer and overuse precious health resources. We all have left (cognitive) brains and right (emotional) brains. The modern medical consultation encourages the patient to come with a left-brain problem, when quite frequently it is the right brain that is really suffering. Some patients do recognise this and come in saying, "I don't know what's going on but I just don't feel right." That is probably the most irritating thing that any patient can say to a doctor firmly entrenched in the left-brain medical model.

As if all this wasn't complicated enough, similar considerations apply to the treatments that we do offer. They often have huge symbolic and cultural significance – witness the forester helped by painkillers that were given to the Coldstream Guards in battle. Placebo theorists have shown that the average placebo effect of a tablet is around 30 per cent–35 per cent (though this

can vary according to colour and size). The placebo effect of an injection rises to around 50 per cent and an operation to a staggering 80 per cent! The last seems unbelievable but prior to my studying medicine – in the 1950s and 60s – patients with angina (heart pain) were subjected to an operation which involved tying off an artery that goes behind the breastbone – an operation called internal mammary ligation. It wasn't until a surgeon, who couldn't see the logic of the operation, started simply making a skin incision without performing the operation and produced similar success, that the operation was generally abandoned. USA researchers have shown similar results in patients given limited knee operations. Tonsillectomy is another case in point. Once common, it is now relatively rare. For most patients, it seems, it was the doctor and patient as healer – not the operation – that worked in the past.

The success of any given treatment is thus only partially a factor of the doctor getting the right diagnosis and treatment and has much to do with the patient, the doctor, their relationship and their perceptions of each other. If some successful treatment is 'all in the mind', then far from regarding it as illegitimate, perhaps we should see it as far safer and more sustainable than some of the procedures and strong medicines that we currently give.

Our immune system is central to disease, health and healing. Its role is obvious in infections, cancer, arthritis, eczema, allergies and a number of other disorders. Recently it has also been shown to be relevant in areas such as depression, which academics (e.g. the Academy of Medical Sciences) are now seeing as being, in part, an inflammatory response. Conversely, some components of our immune system (e.g. the natural killer cells) are themselves altered by emotions explaining why, when we are stressed, we are more vulnerable to upper respiratory tract infections, cold sores

and thrush. Individual considerations apart, it is equally clear that our culture determines, to some extent, what heals us – e.g. acupuncture if we are Chinese and suppositories if we are French.

Does this suggest that doctors should be deceivers in order to elicit the placebo response and that we should return to the days of the pink and blue pills? Clearly not. They may have been appropriate in their time, but knowingly giving a placebo is no longer acceptable.

Given that doctors can no longer give placebos, how can we retain our magic ability to heal when all we have is a mercilessly dull menu of between forty and fifty different sorts of tablet that have been approved as effective by the National Institute for Health & Care Excellence and as affordable by the Government? Sceptics might say that complementary medicine is too easy a way out of this dilemma. That is because supporters of complementary medicine are likely to believe in their treatments (doctors, therapists and patients), while more conventional scientists might say that they are just placebo. The latter would say that the delusions of those supporting complementary medicine unfairly allow them to refute the accusation that they are knowingly giving placebos. Whatever the truth, it is clear that the magic and mystery of healing goes far beyond suggesting medicines (active or placebo).

Take touch, for instance. Hippocrates refers to 'its ability to heal'. Bernie Spiegel, an American breast surgeon, refers to elderly people, who are rarely touched/cuddled and get 'skin starvation'. Sometimes just touching a patient – taking blood pressure or giving acupressure – may have a healing effect in itself. Witness the healing power of my daughter Libby when she simply held the hand of the boy with the fish hook in his head.

Much research is beginning to show the power of relationships. These lessen the likelihood of you getting Alzheimer's disease and you are 50 per cent less likely to die following a heart attack

if you have good social relationships than if you don't. Indeed, it has been estimated that the health impact of having close relationships is the same as giving up smoking. Love, intuition, belief and inspiration all have a role in healing but are not part of the modern medical lexicon. For the sceptics, belief is simply superstition, when it cannot be substantiated by evidence. Yet how much of our lives is guided by belief? Is it not legitimate for a doctor to use, reinforce or initiate beliefs in the name of healing? Especially when this amplifies nature's natural healing processes and is likely to be safer and produce more homeostatic effects than the 'medical method' which often seeks to reverse the processes of nature.

I have this debate quite frequently with a very skilled GP colleague, who has plenty of compassion but is very conventional in his medical approach. I argue that if someone has a cold that will probably get better in three days, then it is quite legitimate to say that they will be fine and back to work in three days. My colleague would say that this is dishonest because I don't know. I reply that he is only partially right because though I cannot be entirely sure that the cold will be better in three days, all the evidence shows that if I say this will happen then it is even more likely to do so. In a similar vein, if a patient is likely to have between three to six months to live, a bit of realistic optimism can be helpful. If we say that he could have six months, then he is likely to live beyond the three months. If we say that he has three months then he might not even live that long. Is it not reasonable to factor belief into our healing method? Surely good science should include belief and objective evidence?

When a patient is ill or worried, he or she wants some control or certainty. Ideally, we are able to put them in control but in a fearful patient, one who is sucked of all energy or in extreme pain, they may want to know that someone else (e.g. the doctor)

can offer some level of control over the situation that they are unable to exert by themselves. The conventional view of a sick patient is that they are their ordinary selves plus the disease or the problem. In reality, science shows us that we are changed by our diseases and problems and this alters both our mindsets and our needs. That is what leads all of us – even the rationalists, who may normally despise these things – to become people that require hope even in relatively hopeless situations. If providing hope, inspiration, suggestion, empathy, touching our patients, reassuring them or a whole list of other things can restore some normality and balance – even if it is only in the mind – then surely this is an effect that is worth having?

That said, the concept of the 'doctor as healer' can be taken too far. Especially if the doctor develops a personal delusion of being a 'medical superhero'. It would be a backward step if future doctors were to follow the path of Indian gurus or US preachers. This would be bad for the doctor, who needs to be more self-aware and for the patient, who needs to become more self-dependent and less reliant on any potential medical superhero. There is also a danger that like *The Wizard of Oz*, the patient will peer behind the curtain and see that the Emperor has no clothes! This is because the doctor as healer is no more than a catalyst for the patient's own self-healing powers, which create multiplier or cascade effects within a patient's own immunological, hormone and nervous system.

Once the doctor healer has set the scene then the ideal is that the patient can then continue to create his/her own magic in exactly the way that Sylvia does. This may not be possible for patients who are right at the bottom of the well and who require the doctor to be a supportive and protective healer in the first place. Nevertheless, wherever possible, surely it is best that the doctor can hand the healing magic to the patient and then take

Chapter 12

ANCIENT AND MODERN

The good physician treats the disease, the great physician treats the patient who has the disease.

William Osler

Several years ago, I had a call – in afternoon surgery – from a well-known, middle-aged heavy drinker saying that she thought that she had broken her ankle. Normally, in such circumstances, it is possible to persuade a patient to either hire a taxi or find a friend and come into surgery. She checkmated all these suggestions. She'd had too much to drink to drive a car, all her friends were out, she hadn't got any money and, what's more, she thought this was a very serious injury indeed and that I should come and see her right away. I didn't go immediately but an hour or so later, I interrupted afternoon surgery and drove out to the village to see her.

She walked, not even hobbled, to meet me at the door. Rather than immediately dismissing her fears and returning to surgery, I have learnt that you need to listen carefully, do a proper examination and only then, if appropriate, tell a patient that they are wasting your time. I asked her to take off her shoes, socks and roll up her trousers so that I could examine the ankle but was hindered by a very yappy little dog that jumped up on me and then jumped up on her, barking all the time, preventing me from getting a good look at her ankle. My patience sorely tried,

I said that I would put the dog in the kitchen, while I continued my examination. She seemed happy with that suggestion, so I opened the kitchen door and not very gently dropped the dog onto the floor. What I had not noticed sufficiently was that there were three clothes horses close to the entrance of the kitchen all lined up and covered in wet clothes. The ejected noisy dog landed on one clothes horse that collapsed on the hapless hound and created a chain reaction as the second and third clothes horses collapsed on the first. The yapping stopped abruptly. There was a deafening silence. I was pretty sure that I had killed the dog.

"Are you all right?" my patient called from the living room.

"Yes, everything's fine." I slowly lifted the third, then the second and then the first clothes horse expecting to see a very flattened dog. To my delight, the dog was alive and well but the yapping had certainly stopped! In my relief, I changed persona from an irritated and slightly aggressive doctor to a cheery, kind and compassionate one. I am not sure that the patient noticed – she was too drunk to care. Anyway, her ankle was fine.

There is a saying that doctors end up with the patients they deserve. Doctors who nurture dependence in their patients, for instance, often end up with a disproportionate number of 'clinging vines'. I do not claim to have nurtured that lady's dependence but it would be inconceivable today to act as I did then. By analogy, it could be said that each generation ends up with the health service that it deserves. Today, we have a health service that is certainly more effective and more cost-effective than previously, but it is also less personal, caring or generous. I could never now, even if I wanted to, interrupt an afternoon surgery to attend to a drunk with a possible broken ankle. Perhaps this reflects how society itself has evolved. I have my own theories on how general practice and country medicine can adapt to this new world. In preparation for that, however,

it is important to put the stories of previous chapters in context.

First, I need to explain how general practice works. Following five years at medical school, doctors then spend two years in hospital as junior doctors (F1/F2) before deciding whether to become a GP or a specialist. Those that want to become GPs have to do a further three years, which would normally include four, six-month jobs in hospital and a year of experience in general practice. After these three years most doctors would then apply to join a GP practice. Previously, each GP practice might have a hundred or more applications from young doctors wanting to join it. Those chosen would often have worked for a year or two as a salaried doctor – paid less than the full partners – before hoping to be taken on by the GP practice as a full partner.

Today many GP practices are lucky if they get even one applicant and most offer the incoming doctor a full partnership from the first day. Ironically, most young doctors today don't want to be full partners because of the responsibility and financial risk and prefer to work simply as salaried partners. Another reason for them doing so is that, with the current shortage of GPs, they are often able to earn as much as a full partner anyway. Worse still, an increasing number of newly-qualified GPs are choosing not to join a particular GP practice as a partner or even as a salaried partner and instead opt to be 'locums' offering their services on an occasional basis to GP practices that desperately need doctors to fill in for morning or afternoon surgeries – especially when there are unfilled vacancies, partners go on holiday, maternity leave etc. They can often earn more this way and have a far more flexible working life. The most recent figures from the King's Fund paint a stark picture. Forty-eight per cent of doctors finishing their GP training intended to become salaried doctors, 44 per cent planned to work as locums and only 3 per cent said that they wanted to work as full GP partners. The current model

of general practice has been broken.

Inevitably, the less financially beneficial it is to become a full GP partner, the less doctors will want to become partners and fewer GPs will be available in any locality to provide ongoing care and continuity for their population of patients over a number of years – as in the past. Most GP practices are struggling today to attract GP partners and many are finding it difficult to get salaried partners or even locums, which, for an increasing number of GP practices, means that they are having to close down altogether.

Each GP practice will have a given number of patients registered within a geographical boundary. In country practices, the GP practice often covers the whole of the population within a given area, while in towns GP practices may overlap geographically with patients on the same street belonging to different GP practices. Until 2004 each GP practice covered its population 24/7 with a responsibility to provide services out of hours. Increasingly, in the early part of this century GP practices were working together to provide out of hours services as cooperatives so that each individual GP partner did not have to do 'on call' as often as before. With the 2004 GP contract, out of hours GP services became entirely independent of GP practices and are now the responsibility of separate GP 'out of hours providers'.

Our system of payment may come as a surprise. Until relatively recently, GP practices were paid a sum by the government, which depended upon the number of patients registered (with some allowance for age and rurality) plus refunding of rental for their premises and a partial refund for some of the staff employed by the practice. It was a relatively loose arrangement, where the government effectively gave each GP practice an overall sum and anything left over after paying staff and running

costs of buildings etc. was kept by the GP partners and divided as their take home pay. Consequently, if you only wanted to maximise your income you would register as many patients as you could and do as little for them as possible using a minimum of resources and as few staff as you could. Inevitably there were some GP practices that did exploit the system but, to the credit of most, the majority provided a good service in spite of GPs having to face the dilemma between being a caring doctor and a successful small businessman.

In the last ten years or so, it was decided, quite reasonably it seemed then, that the system was not sufficiently accountable and that government should have a stronger hold on what it got for its money. As a result, some of our income became effectively 'performance-related pay'. Around a fifth of our income came to depend upon whether we had achieved various targets, such as controlling the blood pressure, sugars and cholesterol of our diabetics, checking patients with long-term disease, reviewing their medicines etc. Then there were added payments for doing extra things such as preparing care plans for the frail elderly and increasing the number of patients diagnosed as having Alzheimer's disease (see Chapter 7).

Increasingly, however, these new targets and specifications were beginning to bring about unintended consequences. GPs inevitably wanted to meet them – partly because many of them were good medicine, partly because they were paid for them and partly because they were important in meeting the quality standards required by the Care Quality Commission and other inspecting bodies. Today, when the patient enters the modern consulting room, there are red lights all over the computer screen telling the doctor about all the checks that need to be done on that individual patient (e.g. blood pressure, weight, blood tests, enquire about smoking status, checking repeat prescriptions,

asking about alcohol intake) – all issues that may have very little to do with why the patient is coming to see the doctor in the first place. The doctor's performance will be judged within the system by how well he performs in ticking all these boxes – whether he actually attends successfully to the patient's problem is of no interest to the powers that be.

A typical day's work today is quite different from thirty-five years ago. Then, I would start surgery about 9am, often after an early morning visit or night on call. I then had ten-minute appointments until around 12pm. After signing repeat prescriptions, I would then do between five and six visits on average (rather more than today) but often still had time for a quick lunch at home before early afternoon surgery, which might be an antenatal clinic, followed by later afternoon surgery and then getting home around 6:30pm. Surgery appointments were interspersed with minor operations (e.g. skin biopsies and 'lumps and bumps') or sometimes there would be a late visit on the way home, and not infrequently the day would be interrupted by having to suddenly leave surgery for emergencies such as accidents, heart attacks and delivering babies. I was on call one in five nights, weekends and bank holidays.

Today the average day is much less varied. There is far more paperwork and I need to get in before 7:30am to read letters, check results and answer various patient requests and review their medicines. Surgery begins at 8:30am with the first few appointments being for a quarter of an hour and ends around 12pm, in theory. Each patient is far more complex. More straightforward patients (e.g. ear, nose and throat and other childhood infections) are today seen by our nurse practitioner. Instead of the sixty-year-old with one or two problems (such as angina or a chest infection), today's patients are mostly over seventy-five and they often have a long list of problems. These

may include heart or chest disease (probably with a previous stent inserted or surgery), often a history of one or two previous cancers, depression/anxiety or loneliness, a failing memory, concern in the family as to whether they should be driving or still at home, and as often as not with the hearing aid left behind. Consequently, morning surgery always ends late; around 12:30pm or 1pm, just allowing time for our reduced number of visits (around two on average) to patients with more complex problems than previously and whose average age is generally over ninety. Afternoon and evening surgery is the same, without the same mix of surgery consultations and operations (which we hardly ever do now) or other interventions such as minor casualties (for which we are no longer paid). When the last patient leaves the surgery between 6pm and 7pm there is usually still an hour's work to be done dictating letters, catching up with correspondence, reviewing results and answering enquiries that have come through during the day. With many GP partners being part-time, there is the added task of completing the paperwork for partners that are not in surgery that day.

With increasing pressure to provide adequate access, each GP partner (in my practice at least) is also spending half the day providing a same-day facility for patients that need to talk on the telephone, be seen or have visits that day. Attending to the needs of the fifty to one hundred patients, morning and afternoon, who require this service means that all the paperwork and communications involved in having a personal list are then concertinaed into a half day rather than a whole working day. In spite of all this increased pressure, patients are today more demanding and less understanding when the doctor has a 'bad day' than in days when they knew that we had been working throughout the previous night as well.

□ □ □

These developments are reflected in the history of my own GP practice in Cullompton. It seems such a short time ago that I was the new, keen young partner in the practice to whom all the other doctors deferred for technical advice on modern medical guidelines. Today, as the oldest and most senior partner – beyond pensionable age – I am probably beginning to frustrate my younger medical colleagues by not always being up-to-date and sometimes failing to comply with guidelines, formularies, practice policies and all the other paraphernalia of modern general practice. Decline is just around the corner! I remember a guide in Egypt once telling a group of us that there had been three Egyptian Empires – the ancient empire, the middle empire and the modern empire. One rather rude member of the tour remarked, "So where's the modern empire?" My own GP practice is far from imperial but it has, similarly, spanned three separate eras.

The first of these was our first few years in the health centre that I described at the beginning of this book. We were five full-time male doctors and one part-time female doctor (who was married to the senior partner). The Health Centre, with its leaky flat roof and peeling paint, was one of the last vestiges of a great sixties ideological movement in general practice. Instead of seeing patients in the back room of a doctor's house or an adapted building, the Government offered groups of GPs these sparkling purpose-built buildings which were to offer patients the best of modern medicine. The aspiration behind calling them 'health centres' was that they would be as much about improving the health of local people through prevention as treating patients, when prevention had failed. These aspirations were never really met.

Our health centre was a happy though very overcrowded

and sometimes disorganised place. Living and working cheek by jowl created a closeness between doctors, nurses, secretaries, receptionist staff and others that has never been quite the same since.

The medicine that we practiced is described in the earlier chapters of this book. Initially, doctors did not have fixed personal lists but patients, who wanted to see a doctor regularly, could do so. Others would tend to 'do the rounds' trying each doctor in turn – often with the same symptom or problem. It became clear that those patients, who wandered from doctor to doctor were often among those who were the least organised and often had difficulty in forming relationships. They frequently had what we would call today 'medically unexplained symptoms'. Others had issues that lent themselves to haphazard consulting patterns – such as drugs or alcohol. These patients needed to relate to a particular doctor, who could then be responsible for their welfare and enable them to take greater control of their lives, providing them with consistent messages and support. Early on, we moved to personal lists, somewhat at my insistence, and the constant flow of patients going from doctor to doctor looking for yet another answer to deep-rooted problems became a little less.

Our health centre was responsible for around 10,000 patients, day and night, covering an area of 150 square miles. Sending patients to hospital was regarded as somewhat of a failure and we tried to do as much as we could in the community – minor casualties and operations, delivering babies and even most heart attacks, which we looked after at home in those days. We had absolute respect for the autonomy of each GP partner. If a partner gave a treatment that conflicted with the modern evidence, then it would have been out of the question to criticise him/her unless they had asked for your advice. Conversely, we were very supportive of each other as we had to contend with so

many unknowns among the suffering and deaths of our patients. Much more of our work was what would be called today 'unscheduled care' – attending patients with acute asthma, chest pain, accidents and infections – all of which we see much less of today because of much better proactive and preventative treatment. We had to be more flexible in our working day – often doing morning visits before surgery and dropping in on patients on the way home if they had 'gone off'. That flexibility was possible because we were, all but one, full-time partners living within the practice area and mostly with spouses at home, who could cover for the unpredictability of our working lives.

Within five years of my arrival it was clear that the health centre was getting too small. Even putting our practice manager in a Portakabin failed to sort the problem. Furthermore, health centres were then falling on hard times with the authorities running short of funds for their upkeep. The flat roof leaked more and more, repairs took an unbearably long time and with lack of paint and love, our building was beginning to look increasingly shabby.

Consequently, we gave up on our rented health centre and built our own new GP surgery taking out a £500,000 loan from the bank. Moving to a place where things worked and the roof didn't leak was an enormous relief for both doctors and most patients. Nevertheless, in our less-cramped quarters, staff complained that we didn't meet up as often and some patients felt intimidated by the splendour of our new waiting room. I remember well our very first day there with my gleaming black desk, comfortable swivel chair and specially chosen green carpet. The last patient of the day was a child, who had been sick. Prepared as I was with vomit bowls arranged all around my new consulting room, the inevitable happened. The yellow mark in my new carpet was soon to be joined by the aftermaths of lanced abscesses, bleeding

limbs and farmers in muddy gumboots.

Meanwhile, the number of patients in our GP practice was increasing rapidly, with new housing estates springing up all over the town. We needed new GP partners – the first two were full-time male partners as before but after that, increasingly, we were taking on part-time female partners – somewhat to the relief of our one previous female partner, who had become the preferred point of contact for many gynecological problems. Then came the third person in the consulting room – the computer – always breaking down in those early days and initially causing much more work than it saved. Today, it is indispensable. IT has led to far safer medicine but it is a beast that needs to be fed and, for those with limited typing ability, adds significant time to the working day.

We called our new surgery 'College Surgery' because it had been the site of a 'college', where monks from Buckfast Abbey had congregated on their way to Bristol. With our new name and new premises, our practice developed something of a swagger. We had previously been regarded as wild medical territory by other local GPs – non-conformist with few of us being members of the Royal College of General Practitioners. We were beginning to hold our heads up high among many of the so regarded best GP practices in Devon. Attached to the main surgery we had three branch surgeries and three sub-branch surgeries, which required quite complicated timetabling and much travelling but added to the colour of our working lives. I particularly enjoyed doing a sub-branch surgery in one of the villages, which was in the spacious living room of a rather grand patient. It resembled the theatrical set of a Somerset Maugham play, while the lady of the house provided me with endless quantities of coffee, cake and cucumber sandwiches. In another village, we would leave all the medications for the

villagers in an unlocked box. Inconceivable today but there were never any mishaps.

Within fifteen years we had begun to outgrow what we still regarded as our new surgery. Realising that we would need to move yet again, we developed aspirations to restore the ideals of the original health centres. We wanted to create a building where the primary care team was reintegrated with doctors, district nurses, health visitors, school nurses, occupational therapists, physiotherapists, and the whole team worked in one building. We also wanted to include others such as complementary therapists and create a place with aspirations to improve health as well as treating illness.

In 2006 our third era began with a move to our third premises – 'The Culm Valley Integrated Centre for Health', which is where we are today. On the ground floor are all the usual GP services plus café, complementary practitioners, patient group room and a health education suite, while upstairs are all the community services including district nurses, health visitors, school nurses, social workers and the ambulance service. We have learnt that everyone working in the same building doesn't necessarily mean that we are properly integrated, but it has enabled an ethos of a community team and increasing involvement of the patients themselves in the running of the surgery and our health projects. The patient gardening club looks after our vegetable and herb garden and the gardeners are frequently interrupted by other patients, who want to know how to grow the plants, how to cook them and their medical use.

Recently we have added an 'Anton Chekhov Garden', which is a reproduction of the Russian doctor and author's garden south of Moscow. Shortly we will begin work on a community garden that will provide occupational experience for future gardeners, green exercise, healthy food and education particularly for

children in the neighbouring primary school.

Creating our Integrated Centre has been something of a financial nightmare with rental and costs proving to be far more than we had expected, and austerity has also limited our ability to keep patients away from the hospital with the withdrawal of funding for our minor casualty work, many minor operations and funded emergency beds in the local nursing home. It is a story that I have had to repeat many times in this book of general practice, having almost unlimited potential but being constantly constrained by lack of imagination and inflexibility from our paymasters.

In the days of our health centre and our later move to the first College Surgery, we were supported and even protected by the Family Practitioner Committee, which then became the Family Health Services Authority. In recent years, the Family Health Services Authority has given way to the Primary Care Trust and thence to NHS England. We no longer feel as protected or supported. Our paymasters are much less 'hands on' and seem mostly concerned with whether we are fulfilling national targets and keeping within our contract. There is no one seemingly either willing or able to come and understand or support our ambitions for the local population.

◘◘◘

Just as doctors and their premises have changed – so has medicine. The improvements have been immeasurable. Last week a very overweight man of forty-eight, who I have known for many years, came to see me with his wife because he was getting breathless. He thought this was due to his anti-inflammatory medication worsening his asthma. He claimed that stopping this had improved his breathing. His wife was not so sure. In the old days, I would have done a cardiogram, possibly ordered a

chest x-ray and then possibly left things at that, assuming that his being very overweight was causing his shortness of breath. There was the very small possibility that he might have a clot on the lung (though there was no reason for this to have happened, apart from his weight). Today it is very easy to rule this out with a blood test that can be done in surgery. Surprisingly, the blood test did suggest a clot and he was transferred to hospital, where a potentially fatal thrombosis in the artery going to the lung was discovered and treated.

When I started in Cullompton, we were very much less aware of the frequency of patients getting spontaneous clots on their lungs, and we did not have any blood test to suggest or prove it. The only way to confirm the diagnosis would have been to admit a patient to hospital for complex investigations for which each hospital had only limited capacity. As a result, in 'the old days' this patient would almost certainly have died of a sudden pulmonary embolus (clot), as one clot is often a precursor of a much larger and more fatal one. His would have added to the list of many deaths in relatively young people at that time. Greater medical awareness, better diagnostic facilities and a much lower threshold for risk have completely changed the safety and effectiveness of medicine that the country doctor offers today. Asthma, chronic lung disease, heart disease and cancer are all treated so much better. Mental health may be the only exception. The pity of it is that though we are so much better at patching these things up and better at preventing those who are at risk of getting them, we still seem completely unable to change those reversible lifestyle factors that often lead to these problems in the first place – e.g. poor diet, inactivity and social isolation.

Alongside these changes in doctors and medical practice, patients have changed as well. Mavis and Reg illustrate this.

Mavis is in her nineties and lives in a council house in one of the villages. For many years she has had to be on steroids to control a disease (Giant Cell Arteritis), which might otherwise make her blind. We tried stopping the steroids a few years ago but the headaches returned and have had therefore to continue the steroids ever since. Partly because of them, Mavis has also developed diabetes and needs tablets to control her sugar and cholesterol, as well as other tablets to stop the steroids thinning her bones. At the forefront of her mind, however, is her itchy back that doesn't seem to respond to anything and her reduced mobility because of a chronic back and arthritic hip. It is too late in the day to consider an operation. Carers go in the morning and evening to get her up and put her back to bed. Her son, who has just retired, looks in most days but mainly sits with her and reads the newspaper. Her daughter, who is a retired nurse, is her advocate and protector and keeps me informed of developments, making sure that I visit Mavis whenever necessary. Together we have kept Mavis out of hospital.

I have known Mavis for thirty-five years. She and Reg were a devoted couple. In better years Reg would produce a fine display of dahlias outside his front door with a neatly trimmed lawn. Today it is a wasteland, which their son strims twice a year. Reg, like Mavis, was always smiling and positive though completely stone deaf in spite of his hearing aids. His prostatic problems and leakages caused the house to smell of urine. It still does a bit, long after he has gone, and there is now also a smell of wet mould with the trinkets on their mantelpiece increasingly covered by cobwebs. It was Reg's declining heart and memory that eventually meant that he could no longer stay at home and had to be admitted for permanent nursing care. Memories of their life together are recorded in photographs all over the living room. I have never seen Mavis cry, but I

remember speaking to her a few days after Reg went away and the only concession that she gave to personal emotion was to flick a tear from her eye with her right hand as she discussed the practicalities of future life on her own. She has got used to things without Reg, but it is not the same.

One day she handed me a box of unused medication to give to our local chemist. Inside it I found a small metal medal, which Reg had won in a competition at the local flower show. She was quite unaware of losing it and surprised when I told her that I had kept it having found it in the box. On repeated visits I forgot to give it back to her but eventually remembered to put it in the front pocket of my car and did return it to her. It was important to me that I remembered and important to her that I did so. She and Reg lived in an age of absolute trust in the doctor even if he did sometimes make mistakes or seemed a bit hurried. That trust means that I cannot fail her, even if it means doing things that are not expected of modern doctors or ignoring strictures that sometimes seem more important to the system than the patient. I haven't done a TEP (resuscitation) form for Mavis even though I probably should. I haven't done a dementia assessment even though her memory is not quite as it was. Our relationship and, by proxy through her son and daughter, is entirely based upon long term-trust and affection. These will never enter any system for appraising the worth of a doctor.

Our service over the past four decades has changed in line with the wishes of patients and the demands of government. In the early days we provided personal care for those that wanted it. In those middle years, it was personal care for all patients and an almost enforced relationship with a personal doctor for those patients, who might otherwise have preferred to consult each in turn. Today is exactly the opposite. We are no longer able to provide the personal care that we did previously or that we would

want to now. The concept of 'my doctor' is fast disappearing.

Successive governments have, understandably, focused on rapid access – often within 48 hours. For the doctor with a registered list, trying to offer instant access and planned access for his 2,000 patients this has become an undoable job. Especially with an increasing number of GPs, who are mostly part-time and who often need to get their children to school before clocking into surgery and also need to get back to rescue them from the nursery or childminder at a given time in the evening. There is no flexibility for early morning or late evening visits.

Adjusting to the new world, we have had to divide our team into some doctors and nurses providing 'same day access' for patients with urgent problems, while other patients can book to see their own doctor but often with a wait that has extended from five days a few years ago to over two or three weeks today. The long waits for each patient to see their own doctor have led to an increasing number of patients requesting same day access with any doctor or nurse. As the numbers of these same day access patients have increased from around sixty a day to over two hundred a day in winter, we have had to increase the number of our GP partners manning the same day access service – now three each morning and afternoon on Mondays, where there was just one doctor only four or five years ago. As more GPs in the practice are required to offer same day access, fewer are available for booked ahead appointments and thus the waiting list for booked ahead appointments gets longer and longer. As that waiting list gets longer, then an increasing number of patients quite reasonably opt for the same day impersonal service. This is happening all over the UK. The result of this house of cards effect is a loss of personal doctoring and loss of the personal relationship between each patient and their doctor.

In only five years, the personal service in my own practice

and in most of the UK has gone into sharp decline. Previously, each patient in my practice was seen well over 80 per cent of the time by their own doctor and each doctor saw his/her patients well over 80 per cent of the time. Five years later that figure is around 50 per cent and dropping. Even in rural practice, possibly the last bastion of personal medicine, the idea of patients having their own personal family doctor is rapidly facing extinction.

Does that matter? Especially, as I have said, when we are treating heart attack, asthma and cancer so much better than ever? It does. That is because we are also using hospitals more than ever. Because we are failing to attack the causes of increasing obesity, heart disease and cancer, which are now beginning to reduce our life expectancy as a population. Because we are also ignoring evidence from the World Health Organisation, which shows that if you invest more in general practice and primary care then population health is improved, patients are less likely to die and the health service is more cost-effective. The same research shows that if, by default, money continues to flow into secondary care then the opposite applies.

British general practice is unique and has been described as the 'jewel in the crown' of the NHS. It is envied by the outside world and it is the reason why the NHS is the most cost-effective system in the West. It offers free care for every patient registered with a GP practice at a cost that is less than 10 per cent of the NHS budget and with a diminishing share of that budget over the past ten years. Nearly all the time this care is entirely provided by a GP. Those 10 per cent of patients requiring hospital specialist care are filtered and referred by GPs ensuring, generally but not always, that the right people are treated in hospital. It means that precious health resources are not wasted on unnecessary hospital treatment. But no credit is given to a system of general practice that has survived and

delivered in spite of years of central neglect. And now, sadly, the cracks are beginning to show.

Chapter 13

TIME TO REFLECT

A man's reach should extend his grasp or what's a heaven for?
Robert Browning.

I am now approaching the end of my career as a country doctor. The fears of my younger days that I might never achieve anything memorable have given way to the comforting inevitability that I now never will. Meanwhile the children have grown up. Two of them are now GPs with their own families. Our youngest is a scientist, currently working in the civil service, firmly rooted in London. Soon it will be time to hang up my stethoscope. We will then have to move from our house on the river.

My thirty-five years in general practice has given me plenty of experiences on which to reflect and I am pleased that, in that time, country medicine has moved on and mostly for the good. In spite of the warmth, humanity and close relationships of my earlier years as a country doctor, I have to admit that things are generally better now. Birth has become far safer and is largely led by midwives in the community, with a far diminished role for GPs. Emergencies are dealt with faster and more professionally than they were previously. Sick people are treated more promptly and safely in an age of computers, mobile telephones, better diagnostics and paramedics. Hospital waits for routine appointments and operations may still seem long but are much

shorter than previously. The safety of modern technical care is incomparable to thirty-five years ago. The same goes for our ability to prevent diseases of the past such as strokes, heart attacks and asthma. Instead of firefighting as we did so often in the past, we are now preventing those emergencies happening.

In future, we won't be delivering babies at all hours, racing to every local accident and disaster or be the first point of reference for just about everything that goes on in the community. A new army of paramedics, nurse practitioners, community matrons, pharmacists and social prescribing advisors are taking on a number of our traditional roles. That is how things should be because as community care expands, a new workforce with new skills will be required to take on many of our traditional roles.

The life of a country doctor in future will be less romantic and less dramatic. But we can and should keep the good things from the past. We can and should also adapt and evolve the role of the family doctor so that it is even more valuable and fulfilling than before. So that doctors want to become family doctors rather than, as now, leaving in droves. They are leaving, I suspect, because the work has become so *relentless*. Our work today is far more intensive and far less variable than previously. The number of patients that I look after on my list is roughly the same as it was thirty-five years ago, yet the number of elderly, those with long-term disease and those with health problems such as obesity, depression and stress have vastly increased. So too have the demands on general practice with a broken society and patients who are fueled by a consumerism that makes them more demanding themselves. One consequence of this is that the average patient sees his GP more than twice as often as when I started. This has created a toxic mix of increasing demand that can never be met by limited supply. The GP is left as 'piggy in the middle'. An apologist for never having sufficient time.

This problem is compounded, as described in the last chapter, by newly graduated doctors not wanting to become GPs. When I applied to become a GP in Cullompton there were around 180 applicants. Today, we are lucky if we get one application and that often means poaching a GP from another GP practice. When junior doctors do train to become GPs there is a haemorrhage of newly qualified GPs deciding to work outside the UK, or choosing another career altogether, or devoting their time to bringing up their family. Meanwhile at the other end of their career, doctors are retiring early in their late fifties or early sixties – too often exhausted and burnt out – and partly because of a pension system, which though admittedly generous, does not encourage them to work until late in life.

The result of this is that the number of GPs (whole time equivalent) in the UK has actually gone down over the past few years, at a time when everyone recognises that there needs to be more. In some desperation, in order to meet its target of increasing the number of GPs by five thousand, the government has tried to recruit overseas doctors. These efforts have not been successful nor are they going to always be the right solution.

Meanwhile, those GPs that continue to work in the NHS find themselves increasingly the whipping boys of an under-supported health system and generally negative press. When I chair medical conferences and ask GPs what troubles them most, I am surprised by their answer. Time and pressure are major issues. Yet what depresses them most is the continuing negativity of the press – too often highlighting the bad and inferring that GPs are lazy and overpaid. Most doctors want to improve the world, and being seen as the 'bad guys' has a deeply demoralising effect.

General practice, in many ways, is in the waiting room to hell. It has been undervalued, undermined and underfunded.

With insufficient GPs to man the deck, a demoralised workforce, unhappy patients and a negative press – it amounts to a betrayal of general practice and its patients. There are solutions. They can be divided into the superficial, the obvious and the fundamental. So far we have failed to progress much beyond the superficial.

One obvious priority is the need to increase the number of GPs and the length of their consultations so that the workload becomes manageable. This increase in GPs will reduce the number of patients on each GP's list so that they can properly look after those patients for whom they are responsible. European doctors see approximately twenty-five patients a day, while the average in the UK is nearer to forty. This was quite manageable in previous times but not today with the increasing complexity of each consultation. Furthermore, foreign doctors, who sit in on my consultations, tell me that today we are undertaking roles that in their country would be regarded as the responsibility of a specialist physician. We have improved skill mix as much as we possibly can with nurses, pharmacists, physiotherapists and many others taking on many of a GP's previous roles. There is no more flesh on the bone. We simply need more GPs if general practice is to survive. Extra bribes for doctors to enter general practice (payments in the form of 'golden hellos') and bribes to stop them leaving (payments in the form of 'golden handcuffs') and a host of other superficial initiatives have been tried before, and they are not working this time. For instance, recently it was announced that doctors becoming GP partners would receive a £20,000 golden handshake. This initiative is totally failing to recognise why doctors don't want to become GPs in the first place or what is required to create the necessary sustainable change that might persuade doctors to see general practice as a long-term career. Behind all of this are two fundamental problems: education and funding.

Medical education needs to change because it is currently designed to produce specialists rather than general practitioners. Money is channeled through hospitals to medical schools, and most of a young doctor's training is in the specialties. It is assumed that if you have learned all the specialties, then you will be sufficiently equipped to be a generalist. The culture and values of medical training are mainly specialty focused. I hear too often of medical students who fear for their reputation if they stand up and say they want to become GPs. In too many medical schools there is still a culture that sees GPs as the 'also rans' of the medical system. It is hardly surprising then that insufficient of those coming out of medical school want to become GPs (rather than the 50 per cent required). It is also unlikely, as things stand, that the extra places recently created in medical schools will lead to more GPs unless general practice is more valued and is given more time in the medical curriculum. If nothing changes then it may be necessary for our future GPs and future specialists to be trained in separate kinds of medical school. One day, no doubt, there will be a generation of GPs, who will regard it rather odd that GPs of the past were mainly trained in hospitals with some general practice input rather than vice versa.

During my thirty-five years, the number of GPs has remained almost static, while the number of specialists has trebled. When I started medicine in 1979, GPs outnumbered specialists by three to one, but today there are now more specialists than GPs. This reversal in the proportion of generalists and specialists is partly a result of NHS funding mechanisms. These also need to change.

Hospitals are paid by activity in England. The more they do, the more they get paid according to a tariff for each intervention. This system was introduced in order to reduce hospital waiting times. The more patients they treat, the more the hospitals get paid and the less time patients have to wait.

The vast reduction in hospital waits over the past twenty years is proof of the success of this idea. Unfortunately, there have been unintended consequences and this has left general practice as the Cinderella of the NHS. While hospitals increase activity and income, general practice is paid a flat rate for whatever each GP or GP practice does and this rate has failed to keep up with the increasing workload and complexity of general practice.

General practice faces a further funding discrepancy, which is more by mistake than by design. As the NHS is becoming increasingly challenged financially, many hospitals have run up overspends. Rather than let its hospitals go bankrupt (it never has), the NHS ends up paying for these hospital deficits as a first call on any NHS money available. Consequently, money that may have been planned for general practice and care in the community ends up being inadvertently swallowed up by overspending in hospitals. The same cannot happen in general practice because if a general practice goes into deficit then it goes bankrupt. It then has to close down and cease work without any direct extra cost to the NHS. This is the fate of an increasing number of GP practices today.

General practice suffers a third ignominy. Each year, the health service (through its commissioning groups) has to hold back 'contingency funds', which act as a cushion against any losses that it might make. These contingency funds come mainly from what is regarded as 'soft money' that would otherwise have been intended for general practice and primary care. The Commissioning Group is not allowed to go into debt, so contingency funds that should have been spent on general practice are often underspent and sent back to the Treasury. Once again, primary care loses out because it is regarded as the soft underbelly of NHS funding.

These funding flows are creating a strong bias for hospitals

as against general practice at a time when all the NHS plans are emphasizing the importance of improving health and care within our communities. The only answer must be to create a level playing field between the funding of general practice and hospitals. That has yet to happen.

Quite apart from medical teaching and NHS funding, general practice also loses out because of a deeply historical and continuing division between generalists and specialists. In 1665 the Great Plague spread across London. The physicians and the surgeons fled from town leaving the apothecaries, who came out of their shops to tend patients in their homes. When the plague ended, the physicians and the surgeons returned to London bullying the apothecaries back into their shops. That difference in status still exists today between the surgeons, the physicians and those descendants of the apothecaries – modern GPs. This unequal division between the professions is symbolised most vividly by the honours system. The leaders of the two oldest colleges, the Royal College of Physicians and the Royal College of Surgeons, change every three years as do the leaders of the much newer but much larger Royal College of GPs. Each outgoing leader of the Royal College of Physicians and the Royal College of Surgeons receives a Knighthood or Damehood, almost as of right. Yet for reasons that have to be historical, the equally-talented outgoing leaders of the Royal College of GPs are deemed as simply not worthy of such recognition. Indeed, for over more than twenty years and of the last seven Royal College of GP leaders, none has received either a Damehood or a Knighthood on leaving office. Everywhere else the medical establishment is also dominated by specialists at every level. This is so, whether it be the medical director for NHS England or the number of government advisors, professorships, peerages, other honours or awards.

Given this historical and continuing hierarchy – is it any surprise that generalists are seen – and too frequently see themselves – as bottom of the pile? If we really do value our generalists in the health system, then we will need to give them the same status, privileges and career prospects as our specialists. Of all the disciplines in medicine, general practice is by far the hardest to do well and it may be time to recognise this. It may also be time for a name change. 'Specialist in General Medicine' might sound a somewhat paradoxical title, but it may be that the title 'GP' with its implication of 'humble GP' has passed it's sell by date.

A radical overhaul in medical school teaching, NHS funding and parity of respect between generalists and specialists would help to start getting general practice back on its feet. It might not be enough to convince the 97 per cent of GPs in training, who say that they don't want to become full GP partners. We will need to do more if we want to restore general practice to being a sufficiently fulfilling and interesting career. There are two further changes that will enable general practice to achieve this full potential. The first is to restore and enable its traditional role of providing personal and continuing care. The second is to extend its purpose as a leader for improving health in the local community. We will need to achieve both if we are to reduce the burgeoning demands on our health system and attract an increasing number of doctors to want to become GPs of the future.

☐ ☐ ☐

Most doctors set out with high ideals. This is more evident than ever when you talk to today's medical students and young doctors. But instead of enabling these high ideals, we crush those young minds with knowledge rather than wisdom. Then we

send them out into a health service, which is so full of guidelines, regulations, processes and incentives that they quickly forget why they are doctors in the first place. This is not helped by the increasing lack of respect with which they are treated, by the lack of gratitude or by the merciless processes of accountability and litigation that destroy trust and individuality – reducing medicine to a transactional process of just treating individual symptoms. This can heal the broken finger or the blocked artery but not the underlying misery, the fears, the lack of confidence and self-esteem or the loss of hope that underlie many of the symptoms that patients present to their doctors and account for a significant proportion of NHS spending. We must aim, first of all, to restore a relationship of respect and commitment between the NHS and its doctors. You will never get the best out of people if you treat them badly. The disrespect shown to our young doctors means that they no longer regard the NHS with the same affection as my own generation. To reverse this trend, the NHS must cease to exploit its clinicians and nurture its staff from the very beginning. In our hospitals, we must restore the ethos of self-supporting clinical teams and heal the increasing disconnect between doctor, ward and patient. The hospital relationships that I described earlier in this book were not perfect, but those positive relationships among the staff were an important element in our being able to create healing relationships with our patients.

More specifically, we must give our young doctors space to park their cars, feeding facilities out of hours and sleeping accommodation, when they are not required on duty. A new managerialist culture in hospitals is denying them the courtesies of any normal employer. It is no wonder that they feel that they are minions working in an unsympathetic sweatshop. We must also review the whole issue of indemnity and litigation

in a free health service, which not only threatens to bankrupt it but also keeps our young doctors in constant fear of making a mistake that might bring their careers to a premature close. Fears, which may minimise risk but which are also stopping clinicians doing the right thing. A compassionate NHS should be setting an example in its relationship to its clinicians rather than drinking them dry without thanks or ever a backward glance. Neither the health service nor its clinicians can show the necessary compassion when they are overstressed, overworked, distracted and fearful. These stresses are also leading to an alarming casualty rate, with more and more burnt out doctors and an increasing number of GP practices closing altogether. The strain is visible in every general practice in the country. My own GP practice has a Care Quality Commission rating of 'excellent', but this has been at the cost of an increasing number of experienced GP partners going on the long-term sick list and one suicide.

Much to the credit of its clinicians, most still retain the core values of good clinical care that patients expect – in spite of a system that conspires all too often to demoralise rather than support them. Today, an increasing number are choosing to work abroad or leaving medicine altogether, so things are not improving. A recent survey (King's Fund 2018) illustrates this sad state of affairs. GPs in training were asked if they would choose to become a doctor if they had a chance to go back in time. Only a third said that they would do so. What have we done to them?

◻◻◻

It is also time to heal a new divide between doctors and their patients. Today's health service suffers from a surplus of blame and a deficit in trust. No win/no fee, negative press and

a consumerist interpretation of medicine have contributed to this. When the National Health Service owes in litigation costs an amount that is far more than half its annual expenditure, then something has gone badly wrong. Organising a proper system of compensation within a service that is free at the point of delivery should not be impossible. It would stop patient always being pitted against doctor whenever things go wrong.

When doctors are courageous, generous or inspiring – that is when miracles occur. Patients recognise when their doctors go the extra mile, but our current system puts no value on them doing so. It is designed to reward the lumbering box-ticker, those who keep their noses clean and those who do not think for themselves. The less you do, the less likely you are to do anything wrong and the less likely you are to go to court. This is dehumanising the doctor, the patient and their relationship.

I have learnt that good medicine, as a country doctor, is less about what we do for our patients and more about our ability to enable them to heal themselves and lead more healthy lives. It was the great medical iconoclast Ivan Illich (in *Medical Nemesis*, 1974) who wrote: 'The greatest single advance in medicine will not be some new drug or procedure but an increased ability of patients to care for themselves'. Broken families, loss of the extended family and loss of people like the 'wise women' in the village have all reduced our ability to self-care. This dependence has been aggravated by media scare stories and the message on every drug leaflet or piece of public health advice, 'If your condition persists/you are in any doubt … then see your GP'.

Medicine is now able to treat our most serious diseases such as heart attacks and cancer. It mostly does this by contradicting or reversing nature's processes with operations or the application of industrial doses of drugs. This model is not appropriate for much of what a GP sees – that is much long-term disease

and minor or self-limiting illnesses. In these cases, instead of contradicting nature's processes, we should be encouraging them and mobilizing our patients as assets in their own healing. It is the only way that we will be able to reduce the demands on the health service and retain sufficient resources for high tech interventions when patients absolutely need them.

Our indiscriminate use of the 'medical model' (e.g. for minor illnesses and psychological and social problems) has led to a nation that is over-medicalised and a generation of medicine-addicted patients. In future, we must encourage patients to find their own solutions and accept that these might be quite different from the population-based evidence that is our current gold standard of treatment. We must accept that sometimes the person best placed to judge which treatment is most likely to work is not the doctor, but the patient himself. And the only way a patient can make an informed judgement is if they have a positive and trusting relationship with their doctor. It is the splintering of the relationship between family doctor and patient that is leading to the unhappiness of both. Once that relationship is fractured, there is less give and take between doctor and patient and healing becomes all the more difficult. The tales in this book are about such relationships, but they don't need to belong to the past. I have described how the demands of easy and rapid access within a system that is strapped of resources is leading to patients seeing 'any old doc' as opposed to 'my doc'.

◻◻◻

This is becoming a source of frustration for both patients and family GPs, who can see the value of a continuing and trusting relationship between them. Patients too often tell me tales about 'the family doctor of the past', with the implication that he/she no longer exists. They complain every bit as much about not

having 'their own doctor' as they do about finding it difficult to be seen quickly. Hard economic evidence is on their side because a whole body of research over the past forty or fifty years (to which I have made a minor contribution) has shown that if patients have an identifiable family doctor, then they are less likely to go to hospital as an emergency or following routine referral, have less prescriptions, consult their GP surgery less often and are generally more healthy and more satisfied with the service. In spite of this, the family doctor providing continuing care is slipping away gently, almost unnoticeably and without any real public debate on the consequences of this disappearance. Politicians and senior NHS managers have generally failed to alert the public to the urgency of this problem. When they have, they have failed to avert it. The public and our patients should be openly informed about a situation that is rapidly going out of control and be fully involved in decision around the relevant choices and consequences.

Part of the problem is a misconception among politicians and policy makers that GPs are simply generalists – jack of all trades and master of none – each replaceable by another. They are seen as the frontline clinicians, who can help patients out with the less important stuff and filter, as appropriate, those that need more serious intervention in hospital. This thinking has, for instance, led to proposals that GPs should be employed in hospital casualty departments in order to reduce the number of people being admitted to hospital.

It is not entirely clear why politicians and senior NHS managers have generally ignored the equally important role of GPs as family doctors and healers in the community, providing personal and continuing care – particularly for those that most need it. Perhaps this is because GPs, as independent contractors, cannot be controlled and line managed in the same

way as hospitals. Maybe it is because few senior managers and politicians are among the 20 per cent of patients that see us 80 per cent of the time. David Widgery, in his book *Some Lives!* sees the neglect of the family doctor as connected to a lack of concern about growing inequalities generally. He puts his case with some force:

> Prevention for populations, service according to need, the family doctors' very idea of themselves as people who had time to grieve with their patients, to share the joy of childbirth, the crisis of illness and the time of day in the corner shop, are swept away. The New Model GP is hunched over the computer screen calculating uptake and turnover, auditing not clinical skill but fiscal returns and acting as an accountant, an architect, a travel agent, a manager: almost anything but a doctor.

Enabling family doctors to return to being family doctors will require GPs having more time with each patient and a less pressured day – GP pay is not an issue here. It will require government to keep to its promise of 5,000 extra GPs, especially as the number of GPs (whole time equivalent) has decreased year on year since this promise was made. It will also require a relaxing of central directives that distract the GP from dealing with the patient's problems and a reduction in the bureaucratic workload that takes up too much of each GPs time. The NHS should demand of its GPs a workload that is more similar to that of the average European family doctor rather than milking its victims beyond their limits. Instead of being supported in this way, whenever general practice is given any extra funding, this comes with a new set of extra 'must dos' that are out of proportion to the extra funding. Government generously offers the public improved

access to their GP but without the generosity of giving GPs the means of being able to provide such improved access. Once again, family medicine has been betrayed, and so have its patients.

In a society where depression is now more common than heart disease and where we are creating an underclass of the disaffected – the relationship between doctor and patient becomes ever more important. Some might regard this interpretation of general practice as the doctor simply becoming an apologist for an increasingly unequal society. Others might regard it as general practice becoming a crucial safety net that can also provide the seeds of local communities that are healthier and happier and eventually use health services less. Your viewpoint may depend on whether you are a glass half empty or glass half full kind of person. Personally, I sincerely believe there is a way forward: we need to develop the role of the family doctor into becoming the catalyst for a healthy and health creating community. It is happening, through social prescription and community projects in specific areas and they are slowly becoming more accepted. But they need to become the norm in *all* communities.

<p style="text-align:center">▢ ▢ ▢</p>

Forty years in my profession has taught me a great many things: I have learnt that first and foremost medicine is not about anatomy, physiology, care pathways or always finding an evidence base. It is about people. How they are, how they feel, what they believe and their hopes. It is about our common humanity. It is also about a doctor's place in a community; having the time to get to know and to understand an individual as well as understand the community in which they live. The Coronavirus pandemic provides a stark reminder of why we need to regain these lost connections and an urgent message about how we might do so.

COVID 19 AND RESTORING THE FAITH

They knew now that if there is one thing one can always yearn for, and sometimes attain, it is human love.

Albert Camus, *The Plague*

One of my predecessor GPs in Cullompton, Dr Thompson, did some remarkable research in the 1940s that was to save many lives. His work echoed John Snow and the Broad Street pump. He noticed that the people of Cullompton seemed to have a much higher rate of deaths from bowel cancer than in other areas. He then set about trying to find out the common factor that might have led to these increased deaths. Eventually, he made a map of all the households, where patients had died of bowel cancer. They formed almost a circle around the local tannery. He then interviewed the surviving relatives and came to a remarkable conclusion. In those households, where relatives had died, they were using effluent from the tannery to fertilise their gardens. This was highly effective in producing healthy looking plants but, unfortunately, an analysis of the effluent and relevant garden soil showed very high quantities of heavy metals – particularly cadmium. This was causing a high level of bowel cancer and once local people stopped using the effluent from the tannery as fertiliser, the epidemic of bowel cancer ended. It was a good example of what a close, local connection between clinician and community can achieve.

▢ ▢ ▢

I sometimes tell my GP partners that I feel that I am living 'on borrowed time' – by which I mean that my knowledge of many of my patients has derived from stitching a mother up after a delivery, or sitting on the bed of a dying relative or visiting someone during a personal disaster, but we no longer do these things in general practice and for the younger partner they don't have this borrowed time upon which they can call. For me, a close relationship between clinician and patient and clinician and community are the two main contributing factors to the success of a healing relationship. During the Covid 19 crisis, a time when physical relationships have become more difficult, nurturing our social relationships – in whatever way we can – became even more important. Having that borrowed time proved invaluable as we adapted general practice, yet again, to cope with a new, altered reality.

From March 2020, general practice had to go 'virtual', with most consultations being by phone or remote face to face, with very few home visits. What I have learnt from these virtual consultations is that they are much more useful to the patient if the doctor already knows them, their hopes and beliefs and their context and also that patients, for their part, are almost certainly better helped by a doctor who knows and understands them. So in a sense, the success of virtual consultations (by telephone or video) is predicated on the level of preceding relationship with the doctor concerned. For example, in one morning's surgery at the height of the Covid 19 pandemic, I had a telephone call consultation with a ninety-year-old retired army officer with extreme back pain. If I had been a doctor who hadn't known his case, I would have concluded that he would need to be seen or sent to hospital. But I did know him and his history and that he had a collapsed vertebral fracture, which had previously been x-rayed, so

instead of a hospital visit, I was able to prescribe something for the pain. I spoke to another patient, a thirty-five-year-old lady with panic attacks. For a variety of historical reasons, she had very low self-confidence and self-esteem which we had explored during several previous face to face consultations. Now she had got a good job and was dating online but had developed panic attacks because of an altercation at work. It had dented her confidence, and she felt that she was slipping back. She didn't need any medication; just a few encouraging words, from me, someone she knew and trusted. Virtual consultations are also good for very straightforward episodic medical problems and seem more personal than a hurried telephone consultation. They are certainly cost effective and, in this respect, Covid 19 is likely to have changed general practice forever. Indeed, virtual consultations may, counter intuitively, help future GPs to preserve the doctor/patient relationship and provide better continuity. That is because with relationships once made, virtual consultations can save time and allow more time for seeing other patients. The trick here will be for future GPs to know which of their patients either need or want to have a relationship and to enable that to happen. The introductory consultation when a patient joins a doctor's list was a very good way of initiating such a relationship and may become increasingly important in establishing a relationship that might be maintained later through the right mix of face to face and virtual consultations.

The other important factor to consider if virtual consultations are really going to be beneficial is that most precious of commodities: time. Previously, as 'on call' doctor I would have around forty telephone conversations to make, some of which would then require consultations or visits. I felt very much the 'Doc in a box' and tried to make each as brief as possible, attending only to the problem in hand so I could then attend to

the next and not get too far behind. These brief consultations were unsatisfying to me as a doctor and I suspect equally so to many patients. With Covid, I learnt to have much longer telephone consultations. This is partly because they needed to be longer as the option of seeing the patient was at a far higher threshold, and partly because the fewer patients that were telephoning had more complex issues. The longer the virtual consultation the more satisfying I found them and the happier the patient seemed to be. I have also been surprised by how much can be achieved remotely with time and patience. For example, I spoke to an old lady, during Covid, who was getting extreme pain in her hip following a fall and had already spoken to two doctors on previous days. The rule for most GPs is that if a patient calls three times, then you see them; especially with this patient where the possibility of a fractured hip was quite high. The problem was that she was a shielded patient and would need a visit on an already long list of visits by a doctor, who could not be guaranteed not to have Covid himself/herself. So, I got her to lie on the bed and went through a detailed set of movements questioning her at each stage as to whether they brought on pain or not. I was able to establish that she didn't have a fractured hip but was getting referred leg pain from her back. The experience not only taught me how much can be achieved with a sufficiently long virtual consultation, but its length and thoroughness also appears to have reassured her as well.

Apart from recognising the importance of my knowing my own patients that telephoned during this time, I have also learnt that it is equally important to direct patients that I didn't know to GPs that they did know. I received a call from a member of a family in one of the villages that was struggling to look after an old lady who had recently been discharged from hospital, having had a stroke. It was much more appropriate for me to put them

in contact with their own doctor who was able to sort out their problems on the telephone in a way that I could not have – not knowing the village, the family or the patient.

Covid has also shown us the importance of each GP, or GP practice, having a list of patients that we know well. For instance, our most vulnerable ones received letters from the government about 'shielding'. GPs were asked to check these lists and add any other patients that should be 'shielded'. This is something that we were able to do rapidly, simply by glancing at the list and adding others gleaned from our flu vaccination lists – a job that otherwise would have taken very many hours and could well have ended up being inaccurate, because it would have depended entirely upon notes rather than knowing the patients and the families concerned.

○○○

Forty years of being doctor has taught me that people are mostly kind and good. Those that aren't almost invariably have good reason not to be. John Berger and Jean Mohr in *A Fortunate Man* make this point more emphatically, 'Our present society wastes and, by the slow draining process of enforced hypocrisy, empties most of the lives that it does not destroy'. Alienated patients are a result of an alienated society. It is not sufficient for us simply to patch bits of them up once their lives have been destroyed. Future medicine must play its part in creating healthy citizens and health communities. More recently, a growing number of GPs have bemoaned their inability to make a real difference for their patients. A ten-minute consultation may patch some people up but the damage that is done both before they come to see the doctor and afterwards has historically been outside the remit of the family doctor. Again, John Berger and Jean Mohr relate it very clearly:

In individual cases he (the GP) must do all that he can to help his patients live more fully. He must recognise that what he can do, if one considers the community as a whole, is absurdly inadequate. He must admit that what needs to be done is outside his brief as a doctor and beyond his power as an individual man.

The same theme was taken up by Dr David Widgery. As a London inner city GP, he graphically describes the frustrations and limitations of a GP trying to help what he describes as 'the urban have-nots'. The doctor described in *The Fortunate Man* committed suicide and Dr Widgery died aged forty-five. Frustration and feelings of inadequacy killed doctors then as they do now.

Today, it should be possible to remedy this. National policy is recommending that people should be looked after in the community, wherever possible, and that there should be an increasing focus on self-care, personal health and improving local health. The rhetoric is fine, but the people and the resources were lacking and continue to be. Once again, Covid may have a hand in changing this as it has reinforced the importance of family relationships, as well as those with neighbours and friends for that matter, doing far more for vulnerable patients at a time when district nurses and GPs are less available to them. Many of the calls I have received have been from caring relatives asking for advice on how they can help a sick or frail family member.

Prime Minister Boris Johnson called for 250,000 volunteers to step forward to help look after the most vulnerable people in our communities during Covid: the call was answered by an amazing 750,000. In communities that had historically looked after each other and where social prescribing was already strong, Covid accelerated their progress in creating social capital, and

almost everywhere people started behaving differently towards each other. When I walked in the countryside, people kept their distance but they all smiled, waved and said a few words – the only other time this happens is when there has been a heavy fall of snow. People also became more patient and polite waiting for others to go through gates or over stiles. The sense of community strengthened and just as when it's snowing, volunteers started coming forward to deliver prescriptions and go shopping for the housebound and vulnerable. Social Prescribing link workers were, historically, often at the centre of detecting who needed extra help and with Covid their role became bigger and more important as some took on roles in enabling volunteers to do their work. They also had to coordinate between nationally recruited volunteers and the local ones, many of whom were already in place. What needs to happen now is to ensure that these cohorts of new volunteers are maintained and that we create a new army of local volunteer organisers and facilitators so that they continue their good work, even after Covid has gone.

In nearby Ilfracombe they have divided the town into eleven areas each with a voluntary facilitator, and the voluntary facilitators meet regularly and are responsible for making sure that the volunteers carry out all the necessary tasks for those that need them. This was already in place before Covid, but now it has proved itself essential in making communities more resilient and better able to face further potential events such as pandemics, climate change and natural disasters. In future, we must work to make all our communities as resilient as possible and this needs to be seen as a priority in every aspect from initial town planning to community organisation and bringing all health-related leaders together.

Future GPs and general practice should provide health leadership in this as the effective face of local public health (for

years public health has been too remote, making great plans which gather dust on shelves). Such community development reduces the call upon the NHS, supports its work and leads to a happier and healthier community generally. This will mean embedding a community role in the GP's job description and creating the relevant funding flows that will allow this to happen. If we continue, as now, with more and more of the GP's work and funding being related to providing services rather than improving local health, then the rhetoric will just remain a pipe dream.

In the countryside, at least, there is every reason why general practice and its rural GPs should and could take a leading role in bringing this about and enabling GPs and their communities to do things that *The Fortunate Man* and Dr David Widgery might only have dreamed of. Extending a GP's role in this way would not only add to his effectiveness but also provide more variability in his work and greater job satisfaction.

Social prescription may provide one of the keys to unlocking this. It now enables GPs to get direct help for the 20 per cent of patients that attend surgery with a social problem. It also enables the community (e.g. by involving the volunteer or voluntary services) to help patients with long-term disease and those with the highest health risks. It empowers general practice to go beyond pills and procedures and find non-biomedical answers within the local community for patients with a wide spectrum of problems ranging from loneliness, homelessness, unemployment and depression to diabetes and a whole range of long-term diseases. Social prescription does even more than that. It creates a new and vital link between the GP, the patient and the community. Eventually, this new non-biomedical approach to improving health and care will extend what is available locally with a much wider range of volunteer, voluntary and other services, which can further enhance the health of local people.

The local doctor of the future should not only be empowered through social prescription to help patients using local resources. He will also need to have the time to link directly to local schools, volunteer and voluntary services and the private sector (such as supermarkets), creating a local community that is much more connected health-wise. One which improves the health of its citizens rather than, as happens all too often, makes them ill. The future family doctor can be right at the centre of this and there are several examples already of this happening. There are also good examples in towns as well as the country. An Oxford GP practice has contributed to creating a 'healthy new town' giving primacy to cyclists, pedestrians and public transport as well as focusing on social inclusion, safe housing and the food environment. GP practices, in deprived areas of Glasgow, have improved health through initiatives such as walking groups, financial advice, community gardens and supporting the reforestation of used land.

This developing movement in general practice could provide the final step in the emancipation of the family doctor. Enabling him or her to move beyond treating illness and to start examining and reversing the potential causes of illness. To come out of the consulting room and step on to the street and into the community. To become a key part in the creation of a healthy local community, where its people are able to live more fulfilling lives.

This is a vision of future general practice and family doctoring, which will see GPs become local leaders of health and care in the community. It could represent the last stages of that age-old rhetoric that the NHS should be a health rather than a disease service. It would be a much more effective health service in every sense.

National policy (e.g. legislation on safety belts, smoking in public places and the sugar content of drinks) has often been immensely effective. Ultimately though, in a free society, citizens

have to make their own choices. Our current cultural 'norms' will need revision whether it is the amount of salt or the quantity of food we eat, our average weight, the exercise we take or what we expect of each other in a social sense. These cannot be dictated by central Government, the persuasion of big brother or the concern of the nanny state. They may be encouraged, but they cannot be orchestrated by local authorities and health commissioners. The new engine room of change will need to be, in future, much more local and more granular. It will enable local communities and GP practices to produce the same level of success that has already be seen in a town in Finland (Seinajoki), where rates of child obesity have been halved simply because the whole community have pulled together to achieve this. That same town now aims to eliminate childhood obesity altogether.

Once again, it will all be down to relationships. Some of these will be organisational – connecting schools, libraries, GP practices, chemists, local shops and businesses, care homes and nurseries, town planning, local farming, volunteer/ voluntary organisations and every other relevant health-related organisation or activity. Some of these will be personal and require a much closer working and social relationship between family doctor, the head teacher, the pharmacist, local volunteer/ voluntary leads, private businesses, the firemen, the policemen, the town planner, the developer and every other individual that has a potential local health role.

This may seem like a return to the days that I have described in previous chapters, when I was in daily contact with pharmacists, opticians, undertakers, school nurses and police. In a way it is but in its modern context, this concept is far more ambitious. It goes beyond creating an integrated health service. It is about having a real impact on health and those things that make us ill, and making it everyone's business to be part of it. In some

areas this is already happening with remarkable results. It does require considerable time and commitment. If we are serious about creating healthy local communities, then it is the only way.

◘ ◘ ◘

Our path to a better future must also start with a re-write of the relationship between doctors and patients. The age of patients as supplicants or consumers is over and now giving way to a future when we all need to be perceived as assets in our own health and healing. Healing needs to become a joint process with mutual investment between patient and doctor, where a patient can see his or her hopes, beliefs and concerns being taken seriously. Patients were well aware of the strains on health facilities during Covid, but also did not want to come into surgery or necessarily be visited because of the dangers of them contracting the virus. Consequently, their wish to care for themselves, wherever possible, reduced the demand on services. Even in virtual consultations, they were tending to ask what they could do for themselves rather than request a consultation or visit. With the long queues outside our pharmacist, it seems that many patients (or perhaps just mine) are also becoming more interested also in home remedies – mint for gut ache, linseed/flax for constipation, natural yogurt for thrush etc. The more we can create such self-dependence, the more time we will have available in future for those that do need extra professional help.

With Covid, the much higher threshold for face to face consultations or visits meant that each virtual consultation had to allow for greater risk than normal. For instance, if a patient had a chest infection – which might be an ordinary infection or a secondary infection from Covid – we were prescribing antibiotics over the telephone. This would normally be regarded as a medical sin. Tolerating such risk was part of normal life twenty or thirty

years ago so I did not find this difficult, but my younger partners found it extremely stressful as they were used to minimising risk and following guidelines, which did not apply during those uncertain times. Consequently, the more experienced doctors were tending to field non-Covid patient calls, while the younger ones prefer to be the 'hot patient area' doctors for screening/treating Covid patients for which there were clear algorithms. When I entered general practice, the most important skill of a GP then was said to be 'tolerating uncertainty'. For the younger doctor, the aim is to reduce uncertainty to as little as possible. Clearly in such a variable situation as Covid – where the story changed almost every day – this destabilised the younger doctors who were already constantly under fear of litigation and complaints. To some extent, I find that this dilemma was being solved by the patients themselves and by explicitly discussing with them the pros and cons of any action. I.e. – 'I am not sure if you have got X or Y but I think you have got X. There is, however, a risk of you having Y, but the consequences of missing this may be less than the risk of you getting Covid from coming into surgery or my visiting you'. There were several cases in my own surgery that demonstrated this. One was a patient who had a highish PSA (prostatic antigen) suggesting that he might have early prostate cancer. Normally, I would refer him to have an MRI scan, possibly followed by a prostate biopsy possibly followed by treatment. The problem for him was that his wife was being shielded, and the issue was whether the benefit to him of having treatment outweighed the risk of him returning from hospital and giving her Covid. It was quite a long conversation following which he decided to defer a referral for the time being. I supported his decision. Our conversation had been vital as it set out the risks of each option resulting in the patient making an informed choice. A potential problem here is that if you

mention every possible side effect or downside of a proposed treatment, you may reduce its effectiveness and increase fear in the patient. So perhaps there is a level of risk that the doctor has to carry him/herself. Historically, we carried quite a lot of risk and it caused quite a lot of internal anxiety for us. Where does the balance lie? Who knows? What I do believe, however, is that the more investment that a patient has in a decision and the more clear that investment is to both doctor and patient, then the less likely the patient will blame the doctor for the outcome. Especially if doctor and patient and GP practice and community feel that they are part of the same team rather than alien forces out to get each other. Also, the more that patients do for the general practice (e.g. leading walks and talks, health initiatives or providing Covid visors), the more the mutual investment and as in the doctor/patient relationship – the less they are likely to come to blows.

Another very interesting development with Covid has been the dropping of an awful lot of bureaucracy – especially rules around identifying the people who have died and various forms, GP inspections and GP appraisal and certification. We need to learn from these because much of this red tape is unnecessary or at least causes more trouble than it helps. If we can suspend these things during Covid why not at other times as well and re-moralise GPs, who do feel overburdened by the weight of bureaucracy.

Covid has shown us how versatile general practice can be and how quickly it can adapt to changing circumstances. For many weeks there must have been a change every day in my own GP practice whether it be the handling of Covid patients, the equipment we were using, how we divided the surgery up into hot and cold spots and how we cooperated with our local GP practices with whom we developed a Covid rota. This rapid adaptability is because we have very local and relatively

autonomous clinical leadership that can make fast decisions and get rapid local ownership of them. The model of a GP practice manager working with a GP clinical partner or two is very strong, with management getting proper 'real time' medical advice and the combined management and clinical team able to enact and ensure the rapid changes necessary.

It has also shown the importance of general practice (and hospitals of course) in treating and containing a pandemic. It has taught us that when general practice is relieved of unnecessary bureaucratic control and is sufficiently supported and appreciated by its community, then it can thrive. It now needs intelligent love and attention to develop its potential further. The importance of doing so was emphasised by Richard Horton, editor of *The Lancet*, in an interview during Covid 19, who said:

> You cannot have global health security without having individual health security. And what is individual health security? It's a strong primary care system. Primary health care is an absolute foundation for protecting ourselves against this pandemic and any future pandemic. It is the first line defence.

Covid 19 has also been a wake-up call for us to examine and redefine our personal and collective roles in health and healing. We must learn to heal each other. The establishment of the NHS after World War II represented only half of such a redefinition.

The nation decided in 1948 that, whether rich or poor, we should all contribute to a health service that would then enable everyone to get good care for free. The NHS may not be the very best health system in the western world, but it is certainly the most cost efficient and fulfils John Stuart Mill's tenet of 'The greatest good for the greatest number'. But there is a missing

link. The NHS ethos at national level now needs to be recreated locally within our communities. All of us need to be encouraged, supported and enabled to take on a greater role in our own health and the health and welfare of those around us. The seeds are already there. Three quarters of the population volunteer at least once annually. There is an enormous reservoir of goodwill and altruism that still remains largely untapped within our communities because, historically, we have over-professionalised health. The tide is turning: 'Protect the NHS' was one of the key tag lines for beating Covid. Thursday evenings were filled with the sound of applause for our frontline care givers. A paradigm change in society and leadership at local level was needed and we may be seeing the start of that. Then hopefully we can recreate an ethos of social responsibility that still appears to be so strong in Scandinavian countries such as Sweden.

Future general practice, embedded within and connected to its community, should be an intrinsic part of such a future. The NHS provides a unique context for this to happen. This is because the NHS and its clinicians have every reason, financial and otherwise, to want to become part of creating happy and healthy people and communities. That is quite unlike other private medical systems, where clinicians are paid according to the number of ill patients that they see. The NHS could become a world leader, and will be, if we can heal this disparity between its lofty aspirations and the way that these have too often been translated into everyday practice.

◻◻◻

These reflections may seem miles away from the stories in this book. They are not. The mutual kindnesses, the caring, the trust, the humanity and love expressed by my patients and colleagues should become the new foundations of post-modern medicine

and our future health system. They have survived the endless to-and-fro of public policy and targets. They are the very fuel that can heal the divides – restoring relationships, a sense of community and enabling a redefinition of general practice.

We now have a choice of two worlds. There is the 'us' world that I have described in these chapters but there is also another much uglier world. The latter is a 'me' world, where capitalism has turned sour. Where inequalities between rich and poor continue to widen and where a third of our children live below the poverty line. It is a world where some people earn absurdly more than others, while an increasing number sleep on the streets. Where explicit wealth is celebrated and where the meek, the mild and the poor are simply regarded as 'losers'. A world that is creating the angry and the alienated. A world that has lost its kindness.

Part of this healing process may simply require legislation and better leadership. Much of it will need to come from within ourselves and our communities. Much of it can be led, in future, by local doctors, who are motivated and enabled to play a greater role in healing their sick communities as well as their sick patients.

It would be wrong to romanticise the past. There are some parts we need to keep – personal and continuing relationships between local doctors and their patients – trust and the give and take of daily life. There are bits we need to lose – isolated and unsupported doctors, medicine that was not consistent enough and was too much about patching up than prevention. If I had my time again, I would certainly be a GP. It has been the most interesting and rewarding career possible. Yet GPs of my age tell me that we have seen the best days of general practice. It doesn't need to be like that. Two of my children are GPs. I want them and their patients to live happy and fulfilling lives.

This can only happen if their work allows them to form the same satisfying healing relationships that I have been able to make and to now extend their role as creators of healthier communities.

Healing takes time and time was running out. Covid has given us time to slow down, to reflect and to evaluate. It has essentially stopped the clock on the rush and the roar of our everyday lives. It has shown our collective strength – on all levels – locally and nationally, even globally. If we want medicine that is more human and more effective, then we must fight for it, and we must contribute what we can to our communities to make them healthier and happier. There is a developing body of evidence that those who 'give' live healthier and longer lives. Covid has shown us the crucial importance of social connectedness at a time of physical isolation.

Every society should be judged by what it does for its weakest. We are one of the world's wealthiest nations. Restoring the family doctor is partly a question of investment but also a question of will. Do we care enough to make it happen? I hope that my tales have shown that we do. It was Gandhi who said, 'The best way to find yourself is to lose yourself in the service of others'. The future health of ourselves, our communities and the planet itself will depend upon us rediscovering a common humanity. I have witnessed enough kindnesses over my years as a doctor to believe that we can.

◳ ◳ ◳

ACKNOWLEDGEMENTS

First and foremost, I want to thank my patients who made this book possible. I have changed names and some personal details so that they cannot be identified. Whenever I have used inverted commas in speech, it is when I wrote down their exact words at the time.

I also need to thank my partners of the past – Mike, Dell, Nigel, Peter, Neil and Tim – who have been so supportive. Particularly Dr Tim Harlow, who encouraged me to keep a record of my encounters. Thanks also to my present GP partners for their tolerance – David, Andy, Clare, James, Hilary, Fiona, Lorna, Jenny, Ben, Daisy, John, Sue, Beth, Jess, Kieran and our Practice Manager, Kyla.

The well-known cook and writer, Matthew Fort, is largely to blame for this book. After telling him some of these stories, he suggested that I should write them down and was encouraging when I sent him the first manuscript. John Hatt, the well-respected retired publisher, has shown great generosity in reviewing the first draft and provided invaluable advice on how to improve it. Amanda King, Chief Officer of the College of Medicine, kindly sub-edited an early draft. Dr Harry Brunjes, Vice President of the College and Chair ENO, is an old friend from medical school days and has been endlessly generous with his time and expertise

Joanna, my wife, has given her total and unconditional support throughout the years of these tales and also while they were being written. She has confirmed or challenged many of my memories of events.

I am totally indebted to Christine Quinn, who has put this all together from recorded tapes on trains and airplanes, pieces of paper and emails at all hours. She has been patience personified. I also owe a great debt of gratitude to my publishing editor, Lucie Skilton, who worked tirelessly to help me improve the flow and construction of the book as well as providing a wealth of useful comments and additions. Thanks also to Ryan Gearing for his great skilfulness in design and in preparing final proofs and for tolerating endless last minute changes.

Finally, thanks to my wonderful publishers Lord Ian Strathcarron and Simon Perks, who I met quite by accident while attending to a patient with a heart attack on a train between London and Tiverton.

POSTSCRIPT

Much has happened and has not happened in the two years between the first publication and this new paperback edition.

HARD TIMES

As the threat of Covid begins to recede, almost inconceivably, we are now faced with the Russian invasion of Ukraine, spiralling fuel prices and inflation. These have only added to the already unacceptable inequalities in wealth in the UK, which had already been aggravated by Covid. A spate of strikes were symptomatic of this. If you let the incomes of the rich and the poor diverge too far it carries the threat of increasing crime and civil disobedience, as has been seen all too often in other countries that have allowed such inequalities to go unchecked. An increasing underclass of have-nots – especially among our young – is as unhealthy as it is unfair.

Given such climactic events, it is perhaps surprising that nothing effective has been done to address the huge problems in general practice and primary care that I described in the last chapters of this book. In fact, things have got worse because all that unrequired and unmissed bureaucracy that was shelved during Covid has now been restored to further complicate our lives as GPs. The Quality Framework (QoF – representing 25 per cent of our pay to provide local General Practice) is a case in point. It is a huge tick box exercise wasting hours of time and energy and predicated on the assumption that GPs don't know what they are doing and need goals and targets to keep them in check. The Health Select Committee chaired by Jeremy Hunt in 2022 recommended dropping it altogether and provided both an

accurate diagnosis and treatment plan for General Practice. In spite of this the powers that be continue to treat the symptoms of patient and GP dissatisfaction but not the cause. A new imposed contract may have reduced some of the targets in favour of new improved access but it feels like the dying dog is being repeatedly hit with a shovel rather than being helped to get back on its feet. More recently (May 2023) General Practice has been handed a "Delivery Plan for Recovering Access to Primary Care". It is yet another demonstration of how little the NHS understands the fundamental issues facing primary care or the practical steps required to save it. Instead we are regaled with superficial plans to patch up things, including recruitment and retention policies, without radical and fundamental solutions that might restore General Practice to its previous high levels of satisfaction on the part of both patients and practitioners. It seems as though no one is in charge and General Practice continues to fall through the cracks in between NHS England, The Department of Health and the Secretary of State and Prime Minister's offices.

The result is a continuing decrease in the number of GPs over the past ten years that appears, if anything, to be now accelerating. GP numbers will shortly be below the level of twenty-five years ago. There are around 1,000 GPs less than before Covid struck (in spite of promises that there would be 5,000 more) and yet those who are left are providing more consultations per GP than ever. To be precise 6 per cent more consultations overall than pre-Covid in spite of a reduced GP workforce amounting to approximately thirty million consultations a month. Though working harder and being more productive (hospital productivity conversely has fallen), GPs have become the fall guys for poor policy and planning. We are blamed for worsening access, increasing attendance at hospital casualty departments and being unable to provide the sort of personal care that most of us would like. This only contributes to a

feeling of moral injustice and exodus. Neglecting the basic needs of junior doctors and hospitals and blaming GPs for shortfalls in the health service is, I fear, leading to serious disaffection with the NHS on the part of both doctors and patients with the threat that this misery might eventually spill into the consulting room. Meanwhile, government boasts there are more GP trainees than ever but if they don't want to become GPs at the end of their training (as appears to be the case) or choose to go elsewhere where conditions and pay are better (as they do) – what is the point?

SPEAKING PERSONALLY

Have the hopes and optimism of the thirty-two-year-old, who started as a Devon GP on a snowy November day all those years ago at the beginning of this book, been lost as he enters his early seventies? They haven't. I still find my days in surgery uplifting and challenging in a positive way. Things have changed – patients are more demanding and better informed and mental illness is escalating – but that sacred time in the consulting room remains as precious and rewarding as ever. Particularly so as I have retired as a senior partner and can now do surgeries unfettered by much of the bureaucracy carried by full partners in a practice. Predictably, many of those wanting to see me are the complex frail elderly – especially as I begin to deteriorate myself. Equally predictably, I see many men in their fifties, sixties, seventies and eighties with prostate problems and erectile dysfunction. As always, and especially post-Covid people, come with a list.

Colin, a sixty-seven-year-old Scot came to see me last week with a cough and acid reflux. I assumed after ten minutes that the consultation was over until he said, "Of course that wasn't my main reason for coming," and he then asked me to examine a lump on his testicle and check out his pain on sitting due

to having injured his coccyx (tail bone). Ten minutes later he marched to the door and with hand on the open door said, "Oh and I wondered what your thoughts were about Viagra?"

Even that turned out to be less a conversation about treating his erectile dysfunction and more about long term issues in his marital relationship. Keeping consultations to their allotted ten minutes is virtually impossible especially when it has been estimated that as much as 45 per cent of all consultations are for what are termed "medically unexplained" or functional symptoms – meaning there is no conventional medical answer.

Surprisingly, though many of those booking to see me are young people – often sixteen to seventeen-year-olds – with problems ranging from autism, ADHD and stress/depression to an increasing number with sexual identity issues. The services that might see them are flooded with long waits but I am fortunate to have the time to listen and try to understand. But these young lives deserve so much more. A quarter of fourteen to sixteen-year-old school girls are now self-harming as a national statistic. Medicines, GP consultations and any number of psychotherapists are not going to sort this. These are community issues requiring community solutions where General Practice should, and could, play a major role if only the powers that be could begin to understand General Practice and show just a shred of imagination and ambition.

Working less hours in surgery has allowed me to develop, like many other GPs, what is now called a portfolio career. I am Chair of the College of Medicine, which champions an integrated approach to medicine that goes beyond pills and procedures (see Chapter 10) and which anyone – public or professional – can join for £30 a year. I am also co-Chair of the National Social Prescribing Network and an Ambassador for the National Academy of Social Prescription (see Chapter 10). More

recently, I have become Head of the Royal Medical Household and, as the first GP ever to take on this role, it has enabled me, with the support of the King, to ensure parity of respect between primary and secondary care and between medicine and nursing. Indeed I very much I hope that this might be seen as an example for the rest of the NHS, where tribal differences continue to hold sway with hospital medicine still considered to be "the senior service" (Chapter 13). I should add, however, that my career has had equally as many failures as successes. For over twenty years I was a leader in what became known as the "GP Commissioning Movement", which aimed to emancipate frontline GPs and their patients to decide what sort of services were available for them locally in the community and hospitals. Unfortunately, this simple idea, which re-emerged in a number of guises from Primary Care Groups and Trusts to Practice Based Commissioning to Clinical Commissioning Groups became itself bureaucratised and managerialised and finally discarded as Integrated Care Partnerships came into being in 2022.

On an even more personal level, I have metamorphosed from a totally fit late sixty-year-old to my early seventies with several long term conditions. I have witnessed the NHS on the other side as my aneurysm was brilliantly treated, my prostate cancer sorted and my immune system that had learnt over the years to combat all sorts of bacteria and viruses facing me in the consulting room, then finally turned against me. The autoimmune disease Polymyalgia Rheumatica was followed by Giant Cell Arteritis both requiring huge quantities of steroids weakening my muscles and bones and increasing my blood pressure and sugar to levels where those need to be treated as well. Since then it has been a monumental task getting muscles and limbs working again with painful and exhausting exercises. Every cloud as they say… and I have learnt three things from my experiences. The first is how

good the NHS is, at least in Exeter, when you really need it. The second is the crucial importance of keeping fit physically, mentally and socially as you age and the role of exercise, diet and positive relationships. The third is an endless gratitude to be still alive and able to continue to practice. Well actually there is a fourth – such is the frenetic pace of every hospital that as a patient you may move bed almost every day. Each day, you have to order the next day's meal and it can be harrowing as you land in a new bed to have cheese sandwiches for lunch ordered by the previous occupant, while watching the patient in your old bed eating the much desired haddock and spinach pie that you had ordered the previous day. More seriously, I should emphasise that my care was excellent even though I was unknown to staff and given no favours as a doctor. Becoming a number and the patient in bed A was both depressing and refreshing.

HOPE FOR THE FUTURE

Reverting to my Tigger persona, I am now back in action because I believe that all the things that I have written in the last chapters of this book now really do need to happen and happen quickly. Nor do they all require money, people and resources.

A very quick and early win for government and one that will actually save money would be to disband the stifling bureaucracy that prevents us GPs from providing better access and better personal care and continuity. I have already mentioned the Quality Framework, which focuses on central priorities rather than what our patients want or need. Everyone agrees that it must go – as it did during Covid – but no one seems able to make this happen. It detracts GPs from tending to issues that matter to their patients and there is no element in these payments that recognises whether a GP has sorted a patient's particular personal problem nor, indeed, whether that GP has helped to

sort the underlying factors that might stop the patient becoming ill in the first place. Yes, for instance, we might record all sorts of things such as ethnicity, smoking habit and even sexual preference, but making a real difference to the patient's health is of no interest to the centre. David Unwin, a GP in Southport has shown that he can "cure" one third of his patients simply by making a huge effort to help them to lose weight. We have shown this in my own practice, where Ruth, our social prescriber, over ten years ago was able to convert a third of our diabetics and pre-diabetics to no longer being so. The reduction in suffering and huge saving in overall NHS costs are staggering. Dr Unwin's efforts save almost £70,000 a year in drug costs alone let alone the reduced hospital use and debilitating long term effects. Yet unsurprisingly, there is no recognition, incentive or plan for GPs to achieve these results, which are of monumental importance to the health service and the future health of our patients. They simply don't fit the tick boxes of the establishment.

There are many other cost-saving cuts and bureaucracy that we should now focus on. Perhaps it is time for General Practice to be governed not by one national contract but also by being able to make local contracts as happened in the past. For instance, my own GP practice used to have a local contract for minor casualties, another for admitting elderly patients to the local nursing home instead of hospital. Our modern operating room is now unused because we are no longer contracted to do a number of minor operations nor allowed to do so without jumping through bureaucratic hoops. A more sane and locally sensitive system of General Practice would, in these various ways, reduce the burden on hospitals and their casualty departments.

Another way of saving money and time would be to curtail Care Quality Commission inspections, which for GP practices mirror the OFSTED inspections of schools. Hugely expensive

and bureaucratic, they should be confined to those GP practices that everyone knows are struggling. Rather than being punitive, they should be there to support and enable those GP practices to do better. There is a very slow move in this direction but while these laudable inspectors with clipboards go round our GP practices, perhaps the Audit Commission should be assessing their added value? After all, in Nordic countries with successful health services such as Norway and Sweden, there is apparently no equivalent of the Care Quality Commission.

Then finally and perhaps this is a particular grouse as a seventy-one-year-old GP – is the enormous weight of statutory training that wastes time that should be spent with patients, encourages GPs to retire early and deters any of them returning to do the most simple of tasks such as vaccination. Every three years I have to do statutory training in many areas that are mostly neither useful nor relevant to my current working in the NHS as a seventy-one-year-old GP. These include "Preventing Radicalisation", "Equality and "Diversity", "Fire Safety Awareness" and many other areas such as "Confidentiality", "Lifting and Handling", "Safeguarding Children" and "Safeguarding Adults" etc... Each module comes with an examination test where you have to exceed the 80 per cent pass mark. I don't dispute that every GP should know about these things – especially when joining General Practice – what I do dispute is that we need to do them every three years. After all, we only do our driving test once so why am I treated as if I am a GP with memory problems that can't retain knowledge for more than three years? The inability of the NHS to overcome this monster is symptomatic of the huge inertia in the system and its pathological lack of ability to do the best for clinicians and patients.

Many years ago, in response to the stifling bureaucracy in General Practice, a previous government created a Cabinet

Committee on GP Bureaucracy chaired by the late Mo Mowlam with several of us frontline GPs sitting on it. Our Chief Executive had been seconded from Unilever and was able to bang the heads of all departments throughout the Health Service to crush the bureaucratic burden that was then oppressing GPs and preventing them from doing their best for their patients. Since then, neglect and lack of leadership has enabled that bureaucracy to grow to a level where it is simply strangling modern General Practice once again and another Cabinet Committee or leadership from government is now urgently required to address the problem, save money and enable General Practice to do what it does best.

Containing bureaucracy is just a cost-saving start. Recent reform of the health system has created forty-two Integrated Care Partnerships and Boards nationally and the first task for them will be to reverse the continuous drain of money intended for primary care and health, which has historically ended up by fuelling hospital overspends. As I have said earlier in the book, there is an unfairness in the system that allows hospitals to overspend but if a GP practice overspends then it goes bankrupt and out of business. No hospital has ever gone bankrupt! This unfairness in the system has over ten or so years led to primary care falling from some 11 per cent of the NHS budget to nearer 7 per cent. Yet, at a time when Health Service plans (never fulfilled) have emphasised the important role of self-care and community involvement and primary care as the means of a sustainable NHS and preventing overuse of secondary care. It is a deep irony that I am invited to advise other countries, which admire our model of General Practice, at a time when we in the UK are in the process of running it down. This continuing gap between aspiration and implementation means that few of us at the frontline any longer read the grand health strategies of the centre.

Reversing the downward spiral on resourcing primary care,

which is still able to contain 80–90 per cent of problems that patients present with, would be a good start. But only a start. There are some urgent issues that now require attention from government, NHS England and the new Integrated Care Boards and Partnerships.

Being able to provide timely access is as important to GPs as it is to their patients. But we must also focus again on the importance of each patient being able to access the doctor they want and thus provide personal care and continuity – the hallmark of good General Practice in the past. As I have said earlier in the book, there is huge evidence that this is what patients over sixty-five, those with long term conditions and those with serious illness actually want and much further evidence that this is far more cost effective – preventing unnecessary prescriptions and referrals to hospital. Private GP practices are now increasing in demand because those that can afford it want to have a doctor, whom they trust, with whom they relate and who can provide a friendly sounding board and be there for them in times of need. It is embarrassing and demoralising for NHS GPs to find increasingly that they are unable to provide that quality of service. To do so would immensely improve the satisfaction of both patients and their GPs and even with many GPs being part time these days, it is possible to provide such continuity as I have described in previous chapters.

Beyond this, national and local policy with appropriate funding streams should now encourage GPs to become the local implementation arm of public health. We should not simply expect GP practices to pick up all those problems, which are often created outside their remit and which cannot be fully solved without changes in areas such as employment, schooling, housing and the culture of the whole community. We need to be more ambitious in primary care and that will mean giving autonomy

to the new Primary Care Networks (groups of GP practices) to determine their health priorities alongside those of the local authority and the local volunteer and voluntary sector. In that way we can create wholesale cultural change and begin to tackle those big issues of our time from childhood and adult obesity to the decline in mental health of children and young people. I know that my fellow GPs would be up for this and it would help them to regain the idealism and inspiration of my own generation of GPs that joined in the 1970s and 1980s but have been worn down by centralisation, being told what to do and the edicts of population based medicine with its "one size fits all" approach to our patients.

The world and medicine are changing fast. New discoveries including the genome and biome are emphasising individuality. A future interpretation of medicine will need to be far more personalised and start to take in the beliefs, history, culture and hopes of our patients rather than pushing each through predetermined care pathways that are increasingly looking like rat runs. The rapid expansion of social prescription through the Personalised Medicine team at NHS England is a glimmer of hope that there are some at the centre that understand this.

Truth to tell, I have yet to meet any "average", "normal" or hypothetical patient that fits with the diktats and guidance that constantly assault me as a GP. What I do know is that experience, wisdom and professionalism count for nothing in the new claustrophobic system. Surely it is time to create a renewed service that is based on compassion, that encourages us to go the last mile, to step out the box and where appropriate to enjoy the individualism and even the eccentricity of every GP consultation – instead of being eternally frustrated because neither patients nor doctors will ever fit in to those restrictive boxes of linear thinking and which have little relevance to the fundamental reasons why people suffer or heal. This may

threaten the bureaucrats, who would like to control and measure and account for every interaction in General Practice. Many have good motives for doing so but as Moliere states in *The Doctor In Spite of Himself* – "Hell is paved with good intentions". It is time to let local people and doctors decide what is best and allow them to create the wholesale cultural change, which is required for an effective and sustainable NHS.

To me this is all common sense. I cannot understand why the local health organisations, central ones or even government are failing to either comprehend or implement this new interpretation of General Practice. Everyone agrees that the NHS has become a bureaucratic nightmare, so why doesn't someone sort it rather than let the nightmare become worse and worse? Isn't it commonsense that we should look after our young clinicians and that we should respect and trust our experienced clinicians as a default position rather than one, which assumes they need to be told what to do and which saps their professionalism and will to work? Isn't it commonsense that we should make it as easy as possible for GPs to work to and beyond retirement age and return, when needed (e.g. for vaccinations) rather than putting every possible obstacle in their way for doing so? Isn't it commonsense that if you want to improve access to General Practice and personal care and continuity, that you should sit down with those frontline GPs and work out how it can be done rather than persistently whip them with further diktats and unrealistic targets from the centre? British General Practice was once regarded as the jewel in the crown of the NHS and envied by most other countries. Instead of building on this we have allowed it to deteriorate over the last ten years and having destroyed it, we then hear politicians say that GPs should now become employees of the hospitals or that patients should now be able to self-refer to hospitals without seeing their GP. It is a

curious logic that allows a good system of care to hit rock bottom and then declare that this proves that the system wasn't fit for purpose in the first place.

Sadly, it is true that General Practice in some inner cities has probably been broken as a model of care, and the option of GPs employed by the state may become that of last resort. That said, it seems that recruitment, commitment and productivity all fall dramatically, where hospitals have employed GPs.

Elsewhere, it is now imperative that we restore General Practice at its best. That increasingly looks like a partnership model with experienced GPs running the practice, other GPs being salaried – that is GP partners who can attend to their young families without the burden of also running a practice – and locum GPs who can fill in the gaps when, for instance, doctors in the practice fall ill. Allowing local GPs and their practices just a little of the autonomy of the past, which I have described earlier in this book, will unleash the passion and idealism of most family doctors which has been so repressed by falling under the yoke of this top-heavy system. It would recreate a Health Service where doctors want to go the last mile, give the needy patient a little more time or stay on late – and do so with grace and pleasure rather than with increasing cynicism as at present. Emancipating General Practice would enable us to do things that do matter such as curing Type 2 diabetes, not simply treating it, enabling our patients and the community to better look after themselves and their health and concentrating on what matters to them rather than what matters to government and the powers that be.

Where might this renaissance in General Practice come from? I can't see it coming from senior management in the NHS, which in recent years has seemed to neither understand nor respect General Practice. Far gone are the days when senior

managers would literally queue up to sit in my surgeries (with patient permission) in order to find out how General Practice really did work. Will it come from the politicians? Their rapid turnover and focus on the short term make this unlikely to my mind. So, who can change things? I think it is only the combined militancy of patients, people and frontline clinicians acting with a strong unified voice and supported by the media that will enable this to happen. In short, it's up to us.

Is there hope? I believe there is but time is running out.

INDEX